# Direct Metal Sculpture

## Creative Techniques and Appreciation

### Revised and Expanded 2nd Edition

by Dona Z. Meilach

First Edition by Dona Z. Meilach and Donald Seiden

4880 Lower Valley Road, Atglen, PA 19310 USA

OTHER ART-CRAFT BOOKS by DONA Z. MEILACH

**Metalworking:**
*The Contemporary Blacksmith*
*Decorative & Sculpture Ironwork*
*Sculpture Casting* with Dennis Kowal

**Also:**
*Contemporary Stone Sculpture*
*Creating Small Wood Objects as Functional Sculpture*
*How to Create Your Own Designs* with Jay & Bill Hinz
*Collage and Assemblage* with Elvie TenHoor
*Macrame-Creative Design in Knotting*
*Woodworking: The New Wave*
*Contemporary Art with Wood*
*Creating Modern Furniture*
*Papier Mâché Artistry*
*Batik and Tie-Dye*
*Ethnic Jewelry*
*Printmaking*
*Box Art*

And others

**Revised: 2001**
Copyright © 2001 by Dona Z. Meilach
Library of Congress Card Number: 00-104692

Revised layout by Bonnie M. Hensley
Typeset in Broadway BT/Aldine721 BT

ISBN: 0-7643-1254-5
Printed in China

Published by Schiffer Publishing Ltd.
4880 Lower Valley Road
Atglen, PA 19310
Phone: (610) 593-1777; Fax: (610) 593-2002
E-mail: Schifferbk@aol.com
Please visit our web site catalog at **www.schifferbooks.com**
We are always looking for people to write books on new and related subjects. If you have an idea for a book, please contact us at the above address.

This book may be purchased from the publisher.
Include $3.95 for shipping. Please try your bookstore first. You may write for a free catalog.

In Europe, Schiffer books are distributed by
Bushwood Books
6 Marksbury Ave. Kew Gardens
Surrey TW9 4JF England
Phone: 44 (0) 20-8392-8585; Fax: 44 (0) 20-8392-9876; E-mail: Bushwd@aol.com
Free postage in the UK. Europe: air mail at cost.
Please try your bookstore first.

# Contents

# Foreword to the Revised Edition

The prospect of writing a revised edition of a book that proved so popular for at least fifteen years and many printings since it first appeared in 1966 loomed as a daunting task. My co-author of the original book, Donald Seiden, of the Art Institute of Chicago, was too involved in other projects to have time for this new compilation. I thank him for his gracefulness in allowing me to proceed without him, but I missed his valuable guidance. All the original material is credited to his co-authorship.

As I revisited the topic, there was so much more to be covered. The result is this Revised Edition rather than a reprinted second edition. I accept the responsibility for the additional 115 photos from fifty artists gathered from six countries and throughout the United States. My sincere thanks to all who responded to my request for photos. In addition to the new Introduction and Chapter 11 on Public Art, there is a new, expanded color insert and an extensive list of resources including Internet sites.

I am especially grateful to Rod Baer who shared his photos of the creation and installation of his piece *Social Exchange*. Jeffery Laudenslager kindly demonstrated the use of the Waterjet. Thanks to Richard Moore of Seacoast Sheet Metal, Chula Vista, California, for putting his staff to work while I photographed the process. I am delighted to include work courtesy of the Laumeier Sculpture Park in St. Louis, Missouri.

My thanks to those who provided artistic input for selection and, especially, to Sue Kaye whose vast and impeccable background is always on target. I appreciate the cooperation of Stephen Bondi, Christopher Ray, and Willene and Jaqua Russell whose salient comments on the manuscript were invaluable.

My husband, Dr. Mel Meilach, always deserves credit beyond the call of spouse-hood for his enduring patience and support.

Dona Z. Meilach
Carlsbad, California

# Introduction to the Revised Edition

Rereading the Foreword that appeared with the first edition of *Direct Metal Sculpture* in 1966 has an uncanny resemblance to what I can write for this new edition 35 years later. There have been dramatic changes, yet much has remained the same.

The greatest change has been the introduction and impact of technology into the artist's studio. When Spanish artist Julio González began applying welding in the 1930s he inspired a new approach to modern sculptural art. The changes today aren't quite so dramatic, but improved industrial equipment has eased the work and furthered additional exploration. Today's sculptors are facile with such tools as the plasma arc, MIG and TIG machines for welding. Laser jets, waterjets, and computerized ball-milling machines facilitate cutting and reduce the work and time required for construction. Often sheet metal and fabricating companies help accomplish certain tasks. New materials are explored and adapted when they suit the artists' whims and objectives for expressive purposes or for permanence. Computers have altered working methods and marketing sculpture.

A major impact on direct metalworking, as opposed to casting, has come from the blacksmith's shed using almost forgotten tools and processes of the past. In 1966 very few sculptors understood the transformation of form that could be created by traditional forging methods. The blacksmithing renaissance that began in the 1970s led to the ensuing explosive investigation of hot, molten metals for sculpture.

Before the 1970s, the iron forge was confined mostly to farms and industrial processes. When it was brought into the artist's realm, a new generation of people embraced it with an enthusiasm and fervor that has continued to build. The sculpture community now heartily endorses the concept of artist blacksmith. Universities and art schools offer classes in artist blacksmithing. Many artist blacksmiths conduct classes at their own forges. Thanks to the efforts of the Artist-Blacksmith's Association of North America (ABANA) and the British Artist Blacksmiths Association (BABA), the use of blacksmithing for creating art has spread rapidly throughout the world.

Publications dealing with forging processes have contributed to the sculptor's awareness of ferrous metals and how to use them. Reprints of classic texts, publications from Europe, and reports of current trends are easily available in hard copy and on the Internet.

Another influence of the past few years has been the computer and the availability of Computer Aided Design (CAD) software. Sculptors, especially those who work on large public art pieces, can design and plan their work down to the most minute detail before ever putting a weld on a piece of metal. The computer has enabled them to present work to a client before it is built and to solve structural problems before they happen virtually. They can place the design in an existing or proposed environment to see and evaluate its impact. Different shapes, negatives spaces, materials, even the effect of the sun's angle on the appearance of the piece at different times of day can be tested before materials are bought or physical work begins.

Bruce Beasley, Oakland, California, has been wedding art and computers since the early 1990s. He cites

the computer's role for planning and understanding a sculpture before proceeding. He says, "I make my mistakes with electrons and work with real material only when the sculpture is as good as I can make it. This freedom allows me to deal with a level of complexity in my work that would not be possible otherwise."

The Internet enables a sculptor to work with a client long distance. A drawing may be prepared and the project and proposal presented over the Internet. After the project is approved, the sculptor can keep the client apprised of its progress and, using a digital camera or scanned photos, can upload images to the Internet for the client to see. If something appears to be going awry, the sculptor can confer with the client, revise as necessary, and quickly alter anything before it represents a costly reversal.

This capability is invaluable when a sculptor is working with builders and architects on a major project. Should the builder run into a problem on site, video-conferencing can be used to work out a new solution in minutes among the people involved. Without this capability, back and forth messaging, photos of the problem, and discussions, can take days resulting in work delays and mounting costs.

Computer Aided Design capability, combined with new equipment such as the waterjet, can yield formal shapes and surface treatments that would not have been possible before. Jeffery Laudenslager is able to create surface linearity that results in a flat object appearing 3-dimensional and changing as you move about, providing an illusion that is as magical as the sleight of hand done by a magician. He can also replicate shapes quickly, often in minutes, compared to the hours it might take to cut the metal with hand tools or a torch.

Kinetic sculpture is a growing trend. When a piece moves in the wind, it's not an artist's happenstance, or a Calder-like mobile motion. Rather it is the result of mathematical processes that have been made easier with the cooperation of a computer. These may include ascertaining wind movement in relation to the size and weight of the element that will move.

Adopting and learning about new materials and combining them with traditional materials in new ways is not an innovative concept, but with today's technology and greater knowledge about materials, innovation is both a requirement and a result of the way sculptors work. Even when an object is carefully planned down to the last weld or bolt, the sculptor must al-

ways be prepared to innovate. As a project progresses, materials and techniques may pose new problems so that the artist is constantly exploring, learning, posing questions, and finding solutions. Whether artists are welding, forging, hammering, or cutting, they are limited only by methods they do not know or by techniques they have not mastered.

Technology has changed the way many artists work, but what about the forms themselves?

Compare the black and white photos from the first edition of the book with the color examples added for the revised edition. Basic forms haven't changed dramatically; geometric shapes of the cube, the cone, and the cylinder analyzed by Paul Cézanne in the 19th Century are evident. Subjects are still people, nature, animals, objects, abstractions. Sculptures by Theodore Roszak, Reg Butler, Julio González, and David Smith, for example, could easily have been done today instead of 40 to 50 years ago. The innovative forged works by Italian artists Antonio Benetton, and his son, Simon Benetton, that became the catalyst and inspiration for a new generation of artist blacksmiths are still inspiring new generations of artists.

These works have stood the test of time. They remain fresh looking relative to work being done today. Yet added to these now classic forms and subjects, modern artists bring new relationships of shapes, of positive to negative space, and of new surface treatments and combinations of materials. Often these innovations are the result of modern equipment and finishes available.

Mixed with the output of expressive sculpture has been the rise of functional sculpture, or utilitarian objects, that illustrate the same visceral creativity as anything that would be defined as pure sculpture. These may be light fixtures, candelabrum, boxes, bowls and other containers, furniture, and whatever else the artistic mind can conceive. Conversely, the artist often takes such objects and turns them into non-functional sculpture; the pieces by Rod Baer, Los Angeles, California, and Stephen Yusko, St. Louis, Missouri, attest to this facility.

A sculpture created from found objects, a process that's been around since Pablo Picasso's assemblages were labeled art, is still popular. Perhaps more so because of our continuing concern with environmental matters. As industry has flourished, so has its detritus. Alexander Liberman touched this nerve with his soar-

ing painted sculptures built from salvaged steel oil tanks in the 1970s and early 1980s. Today, Tom Joyce of Santa Fe, New Mexico; Italo Scanga, San Diego, California; R. Mike Sohikian, Genoa, Ohio; and Bengt Gustafsson, Tranemo, Sweden; show work that has raised the use of such materials to new heights and impressive concepts. They assemble found objects into visually poetic relationships, as well as rework the materials into fascinating forms.

Another development of the past quarter century, particularly, has been the rise of "Public Art," that has increased art awareness and commissions for sculptors. Public art may be work commissioned for public spaces, also referred to as "art in public places." The works may be funded by public and private moneys. They may be installed in parks, downtown urban areas, business areas, university campuses, highway junctures, or anywhere the public can view them. Under "percent for art" funding programs, moneys must be set aside for such artwork when a new building complex is planned. The concept isn't much different than the proliferation of European art of past centuries and cultures that memorialized a hero, or an event, represented by some mythological being decorating a dramatic water fountain in a town square.

Public art funding has often stimulated highly innovative work used in these settings. It has provided artists with an important outlet for their visions and a source of income. Public art, as it evolved from the National Endowment of the Arts, was initiated in 1967, a year after *Direct Metal Sculpture* was first published. Looking through the original pages of the book, and the absence of large sculptures in public places, sets this trend in historical perspective. The rise of public art has impacted our culture and beautified our environment. To chronicle this development, photos are included in this new introduction and a new Chapter 11 highlighting public art has been added. The color section contains additional examples.

Other directions for art have prospered and changed with the times. Today public art may include a variety of media and forms. Bruce Beasley, whose early work developed around direct metal sculpture techniques has now evolved cast bronze pieces that echo shapes of his earlier work. Several artists assemble elements using varied symbolic materials. Still others evolve symbolism in the elements they choose so that the technique and methods are absolutely subservient to the expression and thought. During the intervening years between the publication of the first Edition of *Direct Metal Sculpture* and this Revised Edition, many trends have come and gone; yet we can trace developments that have appeared, remained constant, and served as departure nodes into new directions.

This Revised Edition gives the reader the opportunity for comparing work of one generation with that of its inheritors and evaluating what has changed, what has remained the same, and what may evolve. The tried and true techniques it presents prevail as the basis for making art, but here one will also find new methodology that can enhance basic forms and expand the visual vocabulary for the sculptor's lexicon.

The following prediction in the original book has come to pass. It is as valid today as it was then: "Continued advances in metal sculpture depend on only two things: increased technological knowledge about metals and tools, which industry is constantly researching, and the creative exploration of the materials and tools by the artist."

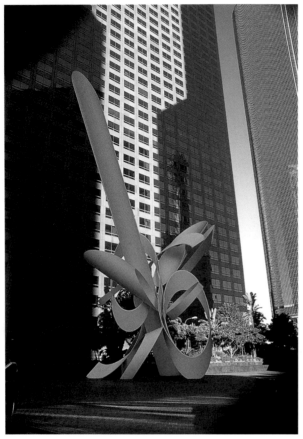

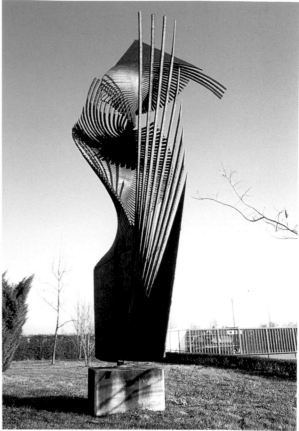

ULYSSES. Alexander Liberman. 1988. Sheet steel, painted white. Liberman utilized oil drum cans and parts of them in many of his sculptures. This piece is installed on the plaza in front of an office building in downtown Los Angeles, California.

*Permission of 400 South Hope Street Associates, Los Angeles, California. Photo, author*

*Top right:* PROGRESSO. Simon Benetton. 1980. Benetton was one of the primary influences in the use of forged iron for large sculptures since the 1970s. 8' high, 2.5' wide.

*Courtesy, artist.*

*Bottom right:* VERTICAL SYNTHESIS. Antonio Benetton. 1962. Antonio Benetton, in Italy, was among the first artists to begin applying blacksmith's techniques to abstract sculpture. His son, Simon, carried on the concept.

*Photo, Stephen Bondi*

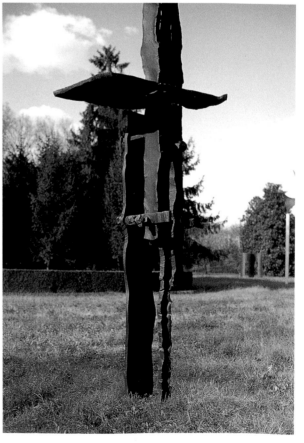

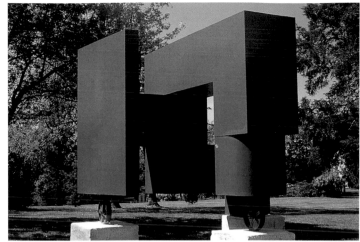

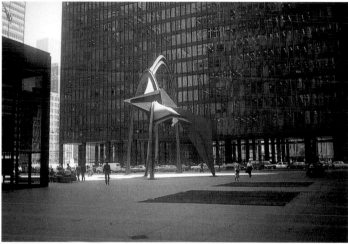

CUBED SQUARE. Jerald Jacquard. 1969. Cor-ten steel and paint. Artists began incorporating industrial materials into their work. Jacquard notes that this piece deals with the theory of physical and mental space. As the viewer walks around the piece, it seems to open and close with certain volumes overlapping. 7.1' high, 8.4' wide, 8.1' deep.

*Courtesy, Laumeier Sculpture Park, St. Louis, Missouri. Purchased with funds donated by Mr. and Mrs. John Grunwald*

FLAMINGO. Alexander Calder. 1974. Fabricated and painted steel. Public art installed in the Federal Central Plaza, Chicago, Illinois. From his "stabile" series. 53' high.

*Photo, author*

VERTICAL MIGRATION Series. Dennis J. Kowal. 1980. Cor-ten steel. Cut, assembled, and welded heavy uprights. 11' high.

*Ravinia Fine Art Sculpture Garden, Chicago, Illinois. Photo, artist*

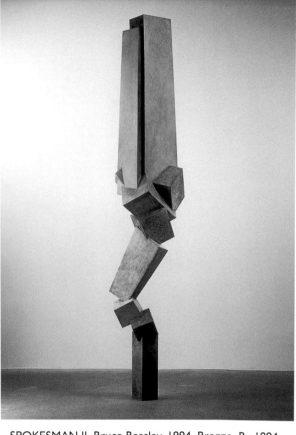

SOLSTICE. William King. 1982. Aluminum on a stainless steel base. In the early 1980s artists began to deal with "installations" that often consisted of a group of sculptures with a single theme. Sometimes they were similar, more often dissimilar, but related. In this series of five stick-like aluminum figures, one walks behind the other in a line. Beginning from the rear, the figures' arms are lowered, the next three are shown with progressively lifted arms, and the front figure stands with arms raised overhead. 21' high, 26' wide, 8' deep.
*Collection and courtesy, Laumeier Sculpture Park, St. Louis, Missouri. Anonymous gift*

SPOKESMAN II. Bruce Beasley. 1994. Bronze. By 1994, Beasley continued to use the shapes that intrigued him, but moved them into gravity defying relationships with space. One of a series. 144" high, 29" wide, 24" deep.
*Photo, Lee Fatheree*

INTERSECTIONS II. Bruce Beasley. 1991. Bronze. Beasley's early works were generally direct metal sculptures constructed of planar crystalline forms acting as building blocks for very complex forms. The forms that evolved are based on simple structures like the cube, and he experiments with variations of an idea using a three-dimensional computer modeling program before creating the components.
*Photo, Lee Fatheree*

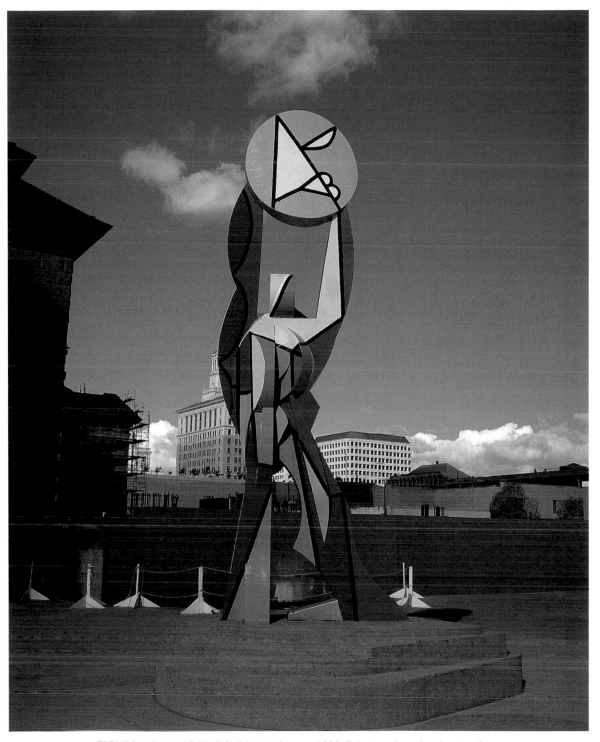

FIGURE HOLDING THE SUN. Italo Scanga. 1988. Fabricated steel and painted
surface design inspired by Piet Mondrian. 27' high, 14' wide, 10' deep.
*San Jose Museum of Art, San Jose, California. Photo, Roy Porello*

ATLANTIC CITY AIR (detail). George Mossman Greenamyer. Painted Steel objects as sculpture. 3' tall figures depict the story of Atlantic City, New Jersey, in a series of narrative public sculptures in front of the Atlantic City Airport.

*Photo, Beverly Burbank*

PRINTER'S CHASE. Tom Joyce. Mild steel with charred books. In Tom Joyce's hand, the object is transmogrified into a new and symbolic form. Joyce found a set of old encyclopedias discarded on the highway. He intellectualized different scenarios dealing with the books as a metaphor for the human body as a repository of information, and the impact of electronic media on our reliability for retaining information in our memories. 7.75" high, 7.75" wide, 4" deep.

*Photo, Nick Merrick*

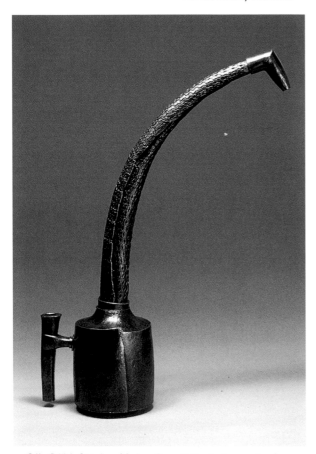

OIL CAN. Stephen Yusko. A realistic, but oversized interpretation of a real object. Steel. The spout is made of forged perforated plate. 22.5" high, 16" wide, 5" deep.

*Photo, artist*

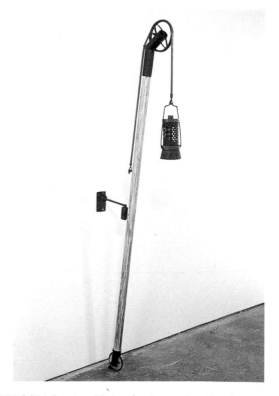

BEACON. Stephen Yusko. Steel, wood, rubber hose, and wheel. Yusko is interested in the interaction of balance/tension, simplicity/complexity, and time/materials. In this piece he deals with concepts that reference a transition from handmade objects to a virtual, often intangible information age. 90" high, 6.5" wide, 24" deep.

*Photo, artist*

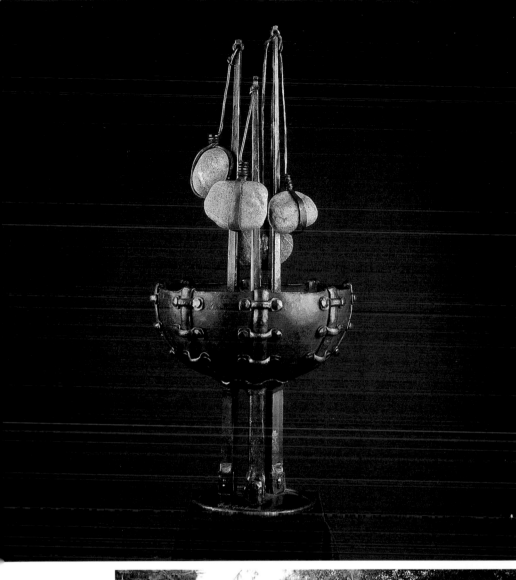

STONE BOWL.
Bengt Gustaffson.
Iron and stones.
*Photo, Anders
Nilsson*

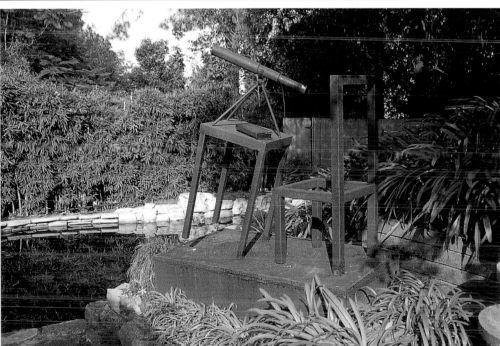

NIGHT FLIGHT.
Rod Baer. Every
object is
meticulously
constructed of
steel, including
the book and the
telescope.
*Photo, artist*

JANE'S HAT. Elizabeth Brim. Inflated, forged and fabricated. Forge welded flowers and hat band ribbon. Actual hat size.

*Photo, Robert Chiarito*

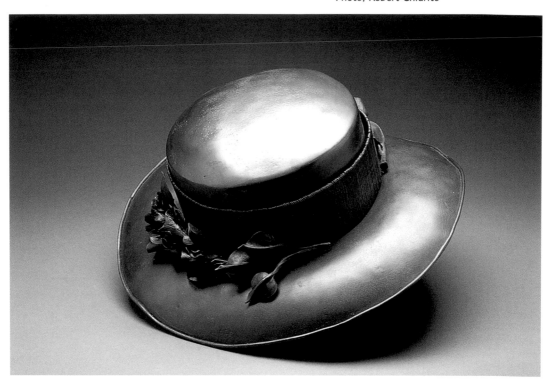

NTLOWMAW/WhY (side view). Janet Goldner. Steel installation. From research in Mali, Goldner used the idea of the ntloma/Y-stick architectural pillar of the Malian adobe house as a pun, but it is also a metaphor for structure, strength, and support. Areas are burned or constructed of scrap steel. 7' high, 8' wide, 25' deep.

*Photo, artist*

LANDING LAMP and POST. Stephen Bondi. Steel, brass, and glass fixture. A functional item with an outright sculptural form is part of a custom made railing and staircase and becomes a public art piece by virtue of its site, 10" diameter.

*Photo, artist*

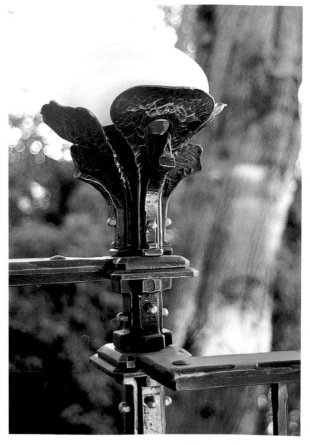

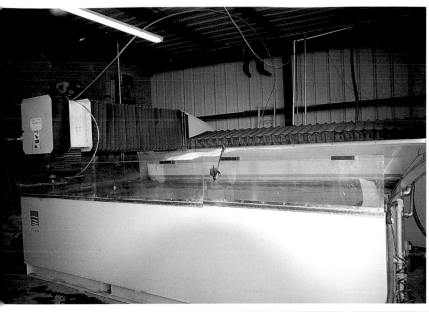

Waterjet Cutting. Devices for cutting sheet or plate metal have become quite sophisticated. The Waterjet is among the most versatile units for cutting stone, wood, glass, plastic, and virtually any material. Among its many remarkable qualities is that it is computer-driven, making design repeatability infinite and scale changes simple. The computer provides extreme accuracy on the largest of projects, + or - .005". Very complicated calculations are accomplished effortlessly. The potential of this magnificent machine is so great that it is up to the artist to explore how it can be coaxed into further satisfying aesthetic ends.

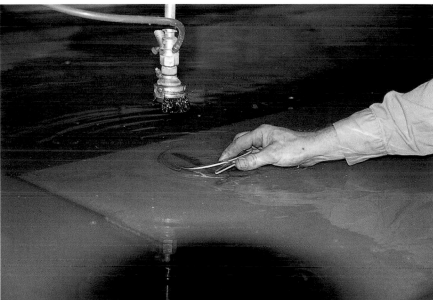

A design is first put into the computer, then using myriad calculations, the computer is set up to control the cut on the metal submerged into the water. A high-pressure water stream containing tiny abrasive stone particles accomplishes the cutting.
*Demonstration by Jeffery Laudenslager. Photographed at Sea Coast Sheet Metal, Chula Vista, California.*

A shape that duplicates a large sculpture but in a smaller scale was cut out in under a minute using the Waterjet at Sea Coast Sheet Metal. The shape can be easily replicated. Cutting such shapes by hand would be a tedious job. Jeffery Laudenslager holds a small version of ARCHIMAGE that he created for guests attending an awards dinner for the sculpture.

*Photo series, author*

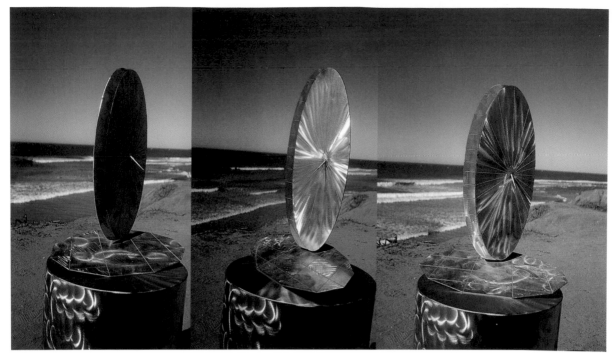

SOLAR DISC (three views). Jeffery Laudenslager. The Waterjet also enables the sculptor to scribe, or incise, lines that will yield an illusionary effect into the surface of a piece of metal. Jeffery Laudenslager's "Solar Disc" is a flat disc but with the proper mathematically spaced lines, the object appears 3-dimensional and the dimensional proportions appear to change as it is viewed from various angles. 21" high, 15.5" wide, 7" deep.

*Photo, Claire Slattery*

INSIDE ARC (three views). Jeffery Laudenslager. Stainless steel using the Waterjet and welding. A very complicated design that required the computer operator to "fool" the machine into visually flattening a 3-dimensional object. Incised lines enhance the design elements. 60" high, 15." wide, 2" deep.

*Photo, Claire Slattery*

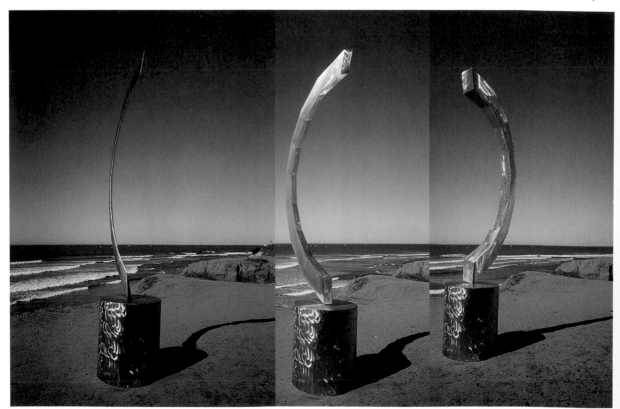

# DIRECT
# METAL
# SCULPTURE

## creative techniques
## and appreciation

WHALER OF NANTUCKET. Theodore J. Roszak. Steel.
*Courtesy, Art Institute of Chicago, Edward E. Ayer Fund*

# What Is Direct Metal Sculpture?

The history of art, like any other history, involves change. Contemporary sculptors are bringing about this change by exploring an entirely new area for artistic communication. They are applying the metals and tools of industry to their work. They are using products manufactured for an industrial purpose and attaching different concepts and meanings to them. The result is a direction in sculpture that is an integral expression of twentieth-century art activity.

Traditionally, sculptures made of metal were shaped into three-dimensional forms by complex casting processes involving several steps and costly materials. When an artist like Donatello created his *David* in the Renaissance period he first had to model the form from an impermanent substance such as clay or carve it from plaster. From this sculptor's model, a mold was made into which molten bronze or lead was poured and allowed to harden. The resulting image could be further refined only by filing and polishing or changing the color of the metal. Any alteration in the basic form would be virtually impossible without ruining the sculpture. Almost all metal sculptures were created by this casting method from primitive times through the early 1900's. And even today, it is still used extensively.

However, the entire outlook of sculpture in metal has completely changed since about 1930. A modern-day Donatello might never see the inside of a foundry or even work in clay or plaster. Many contemporary artists work *directly* with their metals, and these metals are the finished sculpture. The artist may rarely become involved with the casting process. His work usually grows spontaneously as he bends, hammers, or uses heat to add one piece of metal to another.

In working *directly* with his materials instead of casting from a model, the artist has a rich variety of metals at his disposal. He uses raw metals: copper, bronze, silver, lead, iron, steel, and others. He can work with found objects of an unending variety which can be rearranged to give them new meaning. He has but to select his material and choose his tools. He can elect to weld with gas or electricity. He can solder or braze or not use heat at all but simply form shapes by twisting, slotting, or otherwise joining the metals with the tools

DAVID. Donatello. Bronze casting. *ca.* 1430. In creating a design for a casting, the sculptor must always be aware of the potential and limitation inherent in the final appearance of the casting. He can only complete the major portion of the creative involvement in the original model. The casting, done by foundry methods, gives permanence to the object by reproducing and interpreting it in metal. The sculptor who works *directly* in metal often proceeds without a preconceived idea of the limiting possibilities and qualities of the metal he is manipulating. He is free to explore the feel of the material and its relation to space because the technical problems are ones he must solve as he works.

*Courtesy, National Museum, Florence, Alinari Photo*

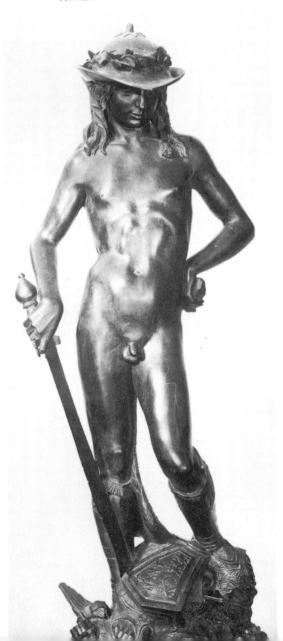

usually found in a home workbench. His choice is based on his own need for expression, experimentation, and exploration. And the field is so unlimited that the selection and experience can be an endless, exciting search. Even as his ideas and concepts change, he may constantly delve into new instruments for his expression.

The student's first efforts with metal may involve bending and forming wires or sheets of metal into sinuous or solid forms. Later, he may want to use the industrial tool that has put sculpture on a new historical path . . . the welder's torch. Whether or not you use the heat of the torch, you can create esthetically acceptable forms by plunging in and beginning, by learning through trial and error. As you work, you will become familiar with the potentials of your materials and tools. Such abstract concepts as space, light, line, shape, and motion, the building blocks of sculptural form, will become the ideas for exhilarating experiences with metal.

These essential elements of good sculpture are presented along with the myriad materials, tools, and techniques. As you become aware of the vast applications of metals, you will observe the rapid acceptance of these direct metal sculptures in art galleries, museums, in industry and in modern architecture. The examples shown throughout the book are meant to give the reader a concept of the growing expressive forces artists are showing with metals. They are not meant to be copied. They are offered as stimulating examples from which the reader can work from his own sensations, personal observations, and experiences.

Classroom in metal sculpture; School of The Art Institute of Chicago, where sparks fly as students experiment with abstract forms.

Students at Carl Sandburg High School, Orland Park, Ill. weld steel rods to build up forms.

These photos will give you an idea of how artists and young students use the welder's torch to build up direct metal forms. Basically, the torch mixes oxygen and acetylene to create the necessary heat for melting various metals. Anyone can handle the tools competently, but proper safety precautions must be stressed.

Continued advances in metal sculpture depend on only two things: increased technological knowledge about metals and tools, which industry is constantly researching, and the creative exploration of the materials and tools by the artist.

## BENDING SIMPLE WIRE FORMS

The methods used to make sculptures directly from metal vary greatly. A novice can create simple sculptures by twisting and bending wire or thin-gauge sheet metal and without using heat. You will soon discover how easily the materials may be manipulated and shaped and the free spontaneous forms which you can express. The only equipment required for these simple sculptures is pliers and a wire cutter. The materials may be hanger wire, stovepipe wire, galvanized steel or aluminum wire of any thickness . . . all readily available in a hardware store.

Wire sculpture is probably the most basic form of all metal sculpture. It is equivalent to line drawing on paper. The wire, in reality, is a line drawing in space and dimension. The form created can suggest volume or motion or both. If you decide to join different lengths and thicknesses of wire together, even the joints can become an interesting addition to the sculpture. Or you can take a spool of wire and use it continuously to make a sculpture that seems to flow without breaks of any sort.

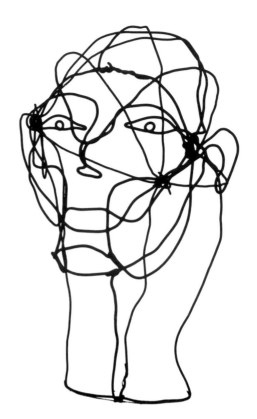

Only pliers were used to bend and join the stovepipe wire that forms this head.

One subject can be given several treatments as you can observe in the wire sculptures of hands. The hand at left was created by joining vertical wires to the round base and curving them to suggest the form. The center hand also joins wire but emphasizes the volume of the sculpture. The hand at the right seems to emphasize the internal bone structure as well as the outline.

*Photos, Institute of Design, I.I.T., Chicago, Ray Pearson, Instructor*

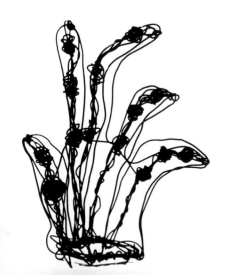

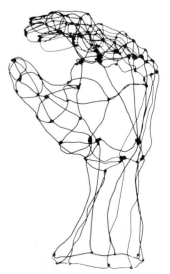

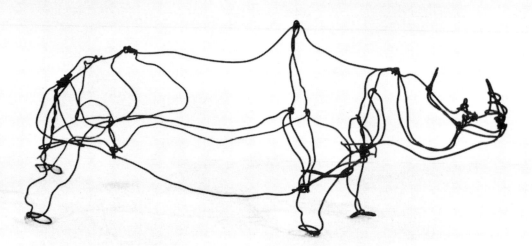

The rhinoceros expresses a strong flowing movement. Later, as you fuse metals with heat, these same linear forms, created with simple thin wire, can be a basis for further exploration with more durable materials.

*Photo, Institute of Design, I.I.T., Chicago, Ray Pearson, Instructor*

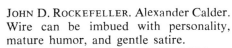

JOHN D. ROCKEFELLER. Alexander Calder. Wire can be imbued with personality, mature humor, and gentle satire.

*Courtesy, Art Institute of Chicago*

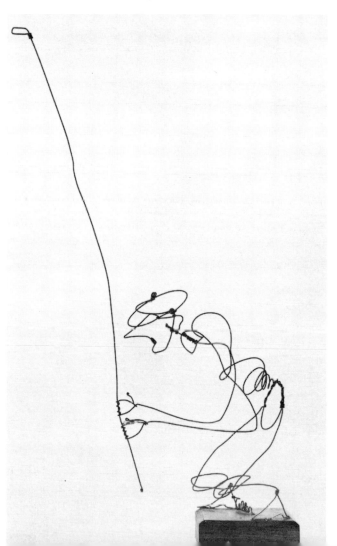

A variety of pliers with various "noses" can be added to the toolbox gradually to help you work different types of wire into the shapes you want. Shown here are clippers and cutters, round nose, needle nose, and electrician's pliers. It is better to use a separate wire cutter than a combination of pliers and cutter. Heavier wires require more leverage, and the single wire cutter is best. These are the tools you can use for bending curves, making spirals, loops, angle bends, twists, splices, and a variety of other joints.

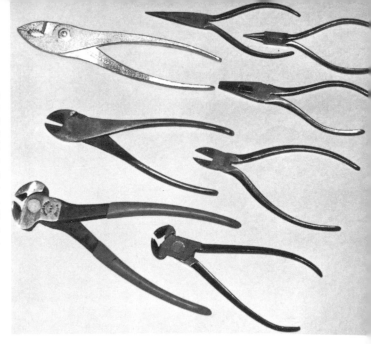

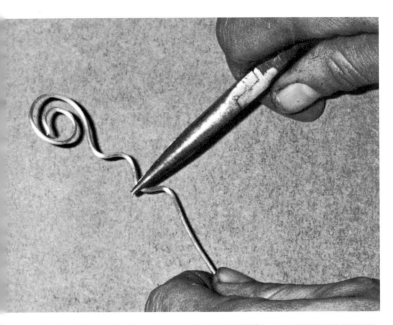

Long-nose pliers will pinch the wire to create spiral and curved forms easily.

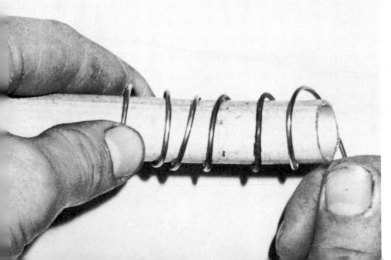

Various shapes can be made by twisting the wire over a preformed object—called a jig—and then removing the shapes that were formed and combining them with many other shapes. Myriad decorative and functional objects are designed in this manner, especially jewelry. Jig shapes are often the basis for more complex forms.

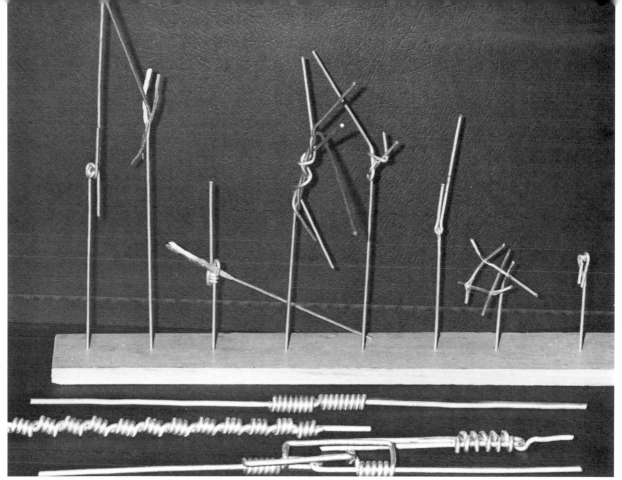

One tends to think of the joint itself as strictly functional. Actually, it becomes an integral and esthetic part of the composition. The type of joint used must be based on a decision of how it will hold the forms together as well as how it looks. In wire sculpture, the creative use of joints becomes a basic consideration, since the joints are plainly seen in the finished forms. Notice how simple loops, splices, twists, and bends are used in the top part of the picture. In the bottom portion, spiral shapes wrapped around wires also can create joints that give a repeat characteristic to a finished sculpture.

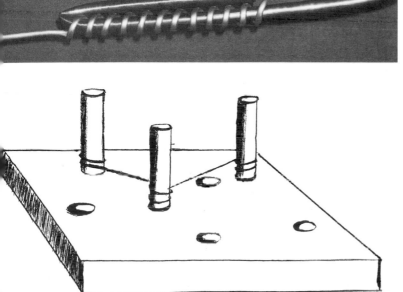

You can make your own jig out of ¼-inch dowels sunk into a piece of plywood. Place extra holes in the plywood so you can move the dowels to create longer and shorter jigs. Winding the results around another wire or tube is also an excellent method of joining one material to another. Be sure to secure all joints by pinching them with pliers.

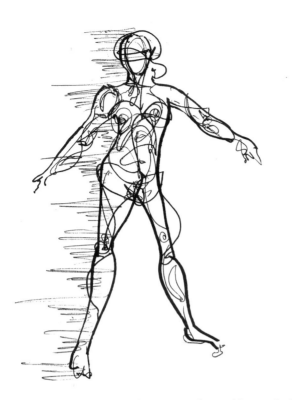

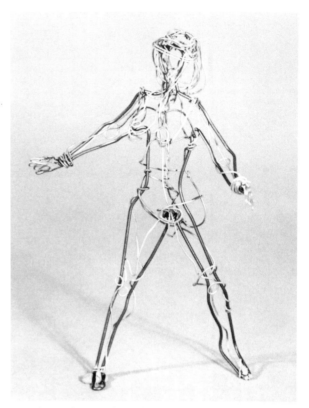

With only wires and pliers, this work illustrates how the relationship between a line drawing and wire sculpture can capture the movement of a figure. In the drawing, the emphasis on action, gesture, volume, and mood is implied in a two-dimensional medium. The wire sculpture accomplishes the same effect except that the result now exists in three dimensions. The fact that a sculpture can be observed from all sides means that the sculptor must concentrate on making the form pleasing, regardless of the angle from which it is seen. Notice how the wire crosses itself and creates open or negative shapes that help define the total volume.

A detail of a sculpture made with various weights of wire shows how the wires are bent about one another and suggest the internal joints and skeletal structure of the human figure.

The person who is excited by the potential of metals may make bent wire forms until he has satisfied his ability to design and create the idea he has in mind. The next step is inevitably working with heat. For then the possibilities of direct metal sculpture are unlimited. Shapes, combinations of shapes, materials and their combinations are as varied as the imagination. Heat enables the artist to build forms that range from delicate stainless-steel wire sculptures to great masses of steel. And in this potential exists the heart and soul of metal sculpture.

For instance, the stovepipe wire forms made with obvious joints can be simplified so the joints are wedded into the flow of the sculpture's lines. They no longer stop the eye or insist that the viewer hesitate as he follows the line of the structure. The simple use of solder makes the geometrical sculpture a sturdier, more flowing composition than those formed without heat.

WAVE-GOER. Konstantin Milonadis. Created from delicate stainless-steel wire which has been carefully bent and soldered. Each wire structure is so perfectly balanced that its movement from light air currents sets the entire sculpture in easy motion. Structurally, it is extremely durable.

*Collection, Mr. and Mrs. Leonard Horwich, Chicago*

The same flowing linear forms of light-weight wire can be given more permanence, more solidity, when they are created from heavier metals and shaped, bent, stretched, and manipulated by applying heat. Notice how line in various sizes, shapes, and directions becomes a growing force and an element which almost seems to slither along. As the heat makes the metal workable, the lines appear to struggle outward, upward, yet in constant control by the artist. These sculptures exhibit tense, almost gravity-defying directions of the metals. Besides their strength of form, the application of heat creates a texture and color which further enhances the visual pleasure. Such forms are impossible to duplicate with other sculptural materials.

STRUGGLING FORM. Joseph Goto. Steel.
*Courtesy, Allan Frumkin Gallery, Chicago*

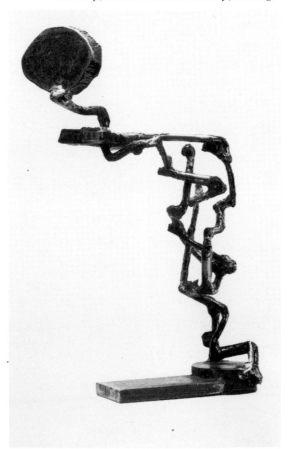

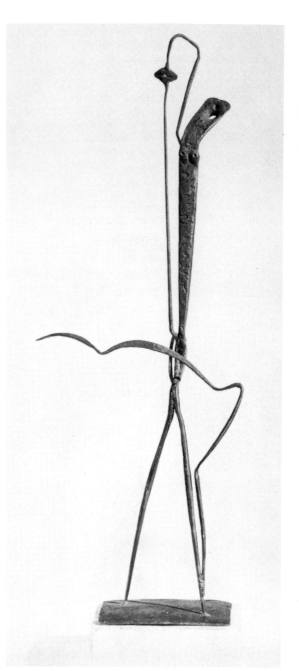

PERSONAGE. Reg Butler. 1950. Iron.
*Courtesy, Smith College Museum of Art,
Northampton, Mass.*

Traditionally sculpture has been considered a three-dimensional work of art formed by carving, modeling, and casting or giving a recognized art material such as stone or wood a meaningful form. Direct metal sculpture, like modeling, is considered an "additive" process by which the artist adds one form to another by building up, or constructing, with his materials. It can also be a "subtractive" process by which the artist takes away or "subtracts" material to create his sculpture.

These works, while digressing from the typical sculptural forms, are still sculptures because they fulfill all the qualities of this art: they are seen from many sides, they have formal coherence, mass in space, and all the academic necessities. They also contain the elements that a successful sculpture must exhibit: definite emotional attributes, a sensuality and expressiveness of the artist's vitality.

Artists are quick to recognize this ability to express themselves in metal. According to art historian Herbert Read, about four-fifths of all contemporary sculptures shown in commercial galleries are made of metal of some kind. Frequently, artists who sculpt with metal describe their works with such phrases as ". . . a sculpture bursting forth into space is comparable to an organic creation of nature . . . a plant, a tree, a human being." Or, "Iron gives me a feeling of harshness and strength which is felt even in the soft point of the sculpture."

LISEUSE. Jacques Lipchitz. 1919. Bronze. The traditional bronze casting, while altering its shape to conform to the Cubist ideal, presents a solid, closed-in feeling imposed by the nature of casting from an original model.

*Courtesy, Art Institute of Chicago, gift of Maymar Corporation*

LINEAR CONSTRUCTION NO. 4 IN BLACK AND GREY. Naum Gabo. 1953. Aluminum and stainless steel. Notice the openness and inner pattern the artist has achieved by using metals as his external form and wires to create the gracefulness within the outline.

*Courtesy, Art Institute of Chicago, gift of Mrs. Suzette Morton Zurcher*

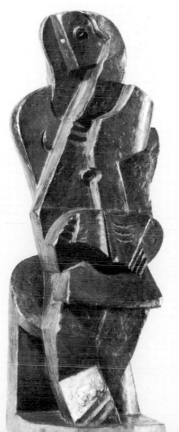

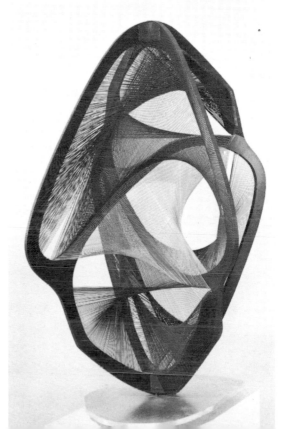

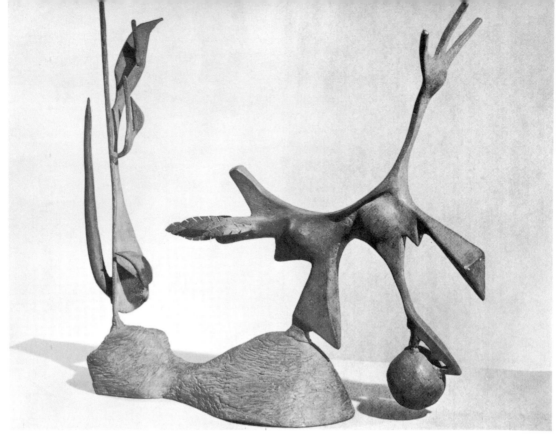

BEACH SCENE. David Smith. Steel. Beginning in 1933, Smith became the first American sculptor to work consistently in welded metals and is largely responsible for others turning to this medium. "The metal," he said, "possesses little art history. What it possesses are the history of this culture: power, structure, movement, progress, suspension, destruction, brutality." His themes have symbolic references. He takes advantage of the inherent texture of his materials.

*Courtesy, Art Institute of Chicago*

The artist today is concerned with creating a sculpture that may have a pent-up energy, a power, an intense life of its own, independent of the object it may represent. When a work has achieved these qualities, the artist is not necessarily interested in connecting the word "beauty" to it. Today's sculptor often seeks to exploit the crude qualities of the raw material as well as the sleek, finished aspects we are more accustomed to seeing.

It is difficult to say exactly when this change took place in artistic thinking, or even what artist or artistic movement is directly responsible. After World War I, all art began a break from what might be called traditional realism. A fresh analysis of form and expansion of valid subject matter and materials were

explored. Perhaps it was simply the fever of twentieth-century art, more dominated by a movement of diversity and versatility than by the actions of any one group.

Yet we do know that a group of Russian artists who called themselves "Constructivists" emerged about 1914. They applied engineering techniques to their constructions of art. Thus the objects they made were called "constructions."

But it was probably Julio Gonzalez, a Spanish sculptor working in Paris, who began the exploration into the use of industrial equipment—the oxyacetylene torch—and applied it to metal constructions. In the 1930's he showed Picasso his welding techniques, and Picasso, with his unbridled inventiveness, immediately

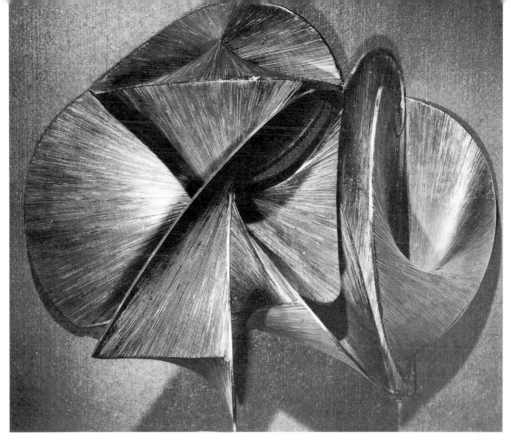

CONSTRUCTION DYNAMIQUE. Antoine Pevsner. 1947. Brass and bronze. Tremendous impetus was given to direct metal sculpture when other artists saw the exquisite refinement and moving surface areas that could be obtained. Pevsner's style is personal and distinctive.

*Courtesy, National Museum, Paris*

accepted this factory tool as an adjunct to his already bulging box of artistic equipment. Between 1930 and 1932, he created almost fifty pieces that varied greatly. He used such objects as a strainer, bolts, and screws. They mysteriously took their place in these constructions, convincingly coming to life with a new personality. The suggestiveness of their origins was like a witness to the transformation Picasso created of them. They were a challenge to the identity of anything and everything.

Couple this challenge of identity to the development toward abstract expressionism in painting and you have some idea of how the growth of metal sculpture evolved. Was it simply time for something new? It doesn't matter. What does matter is that the artist found another means of expressing himself, a means that was compatible with the machine age and industrialization. For metal sculpture often has a mechanized, machine-like appearance.

The burgeoning of metalwork soon became apparent as many artists embraced the medium for a variety of reasons. They found they could discover symbols in metal which depicted the emotional and intellectual ideas they wished to express. The availability and characteristics of the metals themselves offered unlimited potential. Using industrial equipment, which was also easily accessible and not too expensive, metal could be cut, welded, cast, polished, or patinated, and the final result would have a durability that exceeded all but the hardest

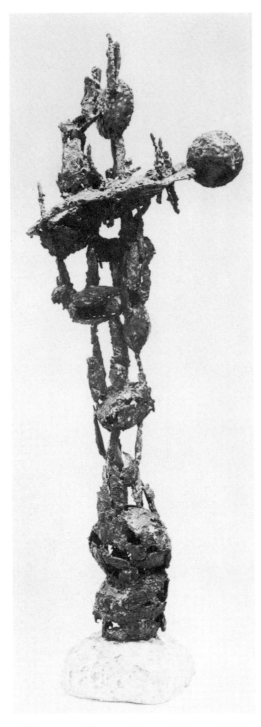

JERICHO II. Bernard Rosenthal. 1963. Bronze and brass. Here, the vertical movement has the feeling of a definitely planned block upon block growth rather than as shapes growing awkwardly, yet naturally. The precarious balance of the units adds a note of tension.
*Courtesy, Kootz Gallery, New York*

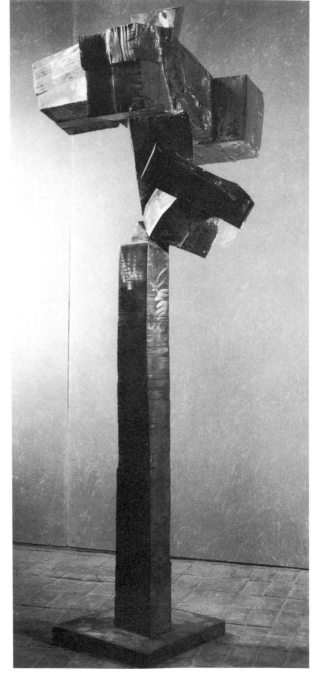

HANGING TREE. Don Seiden. 1964. Bronze sections cast and then welded. The warm tones of bronze combine with a richly textured surface in this sculpture that seems to grow upward in an awkward, organic fashion.

WOMAN. Reg Butler. 1949. Forged iron. The ability to shape metal into stressful, linear forms is made possible by the welder's torch.

*Courtesy, Tate Gallery, London*

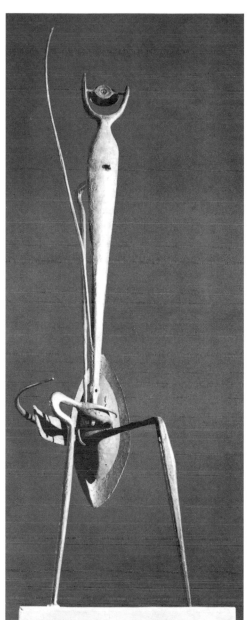

COLUMN. Naum Gabo. 1923. A combination of plastic, wood, and metal was one of the early results of artistic experimentation with new technological materials.

*Courtesy, Solomon R. Guggenheim Museum, New York*

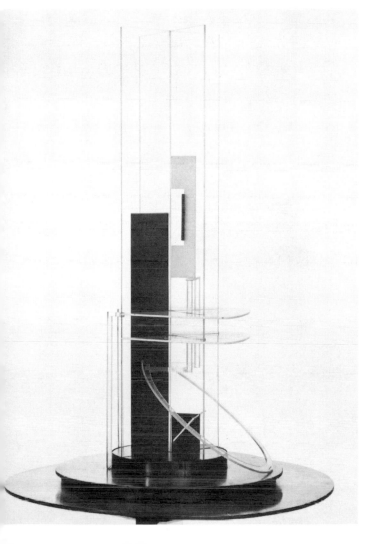

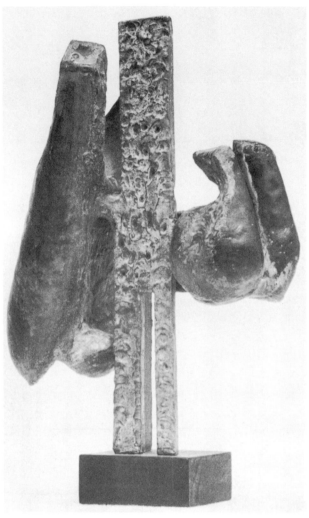

WILDERNESS TREE. Raymond Jacobson. Steel. The textured organic forms that can be created with metal cannot be duplicated in any other material. These forms appear to grow from inside outward.
*Courtesy, Bertha Schaefer Gallery, New York*

Theodore Roszak, and later, Richard Stankiewicz and others brought the field of metal sculpture into such a flourish that it is tentatively dubbed, "The Iron Age" by art historians. The artists who are making this history are brought together in this book.

Certainly the Iron Age sculptors have been influenced greatly in the creation of form and use of space by traditional sculptures. But they often digress from the solidity of traditional shapes to create more "open" areas and more "organic" forms. The openness and the thin, delicate-looking structural innovations are not feasible in the casting process. Yet artists who work with casting methods are being profoundly influenced by the new shapes and forms emerging from the metal sculptor's hands. By experimenting with new casting techniques and combining casting with direct metal work, a new vocabulary of form and concepts has evolved. This contemporary activity by sculptors seems to grow much as an individual piece of sculpture appears to grow under the heat of the torch.

To understand, appreciate, as well as create sculptures, you will want to become familiar with some of the materials and the concepts. Much of the involvement is the ability to recognize the varied visual effects of raw metal and how the artist uses the metal's inherent qualities to create form.

For instance, copper is a warm, reddish-brown metal. Brass, an alloy of copper and zinc, has tones ranging from red to yellow and is brighter than copper. Bronze looks very much like brass. Both metals can be given additional color tones by using acids. Their textures can be altered considerably by overlaying other metals on them or using different heat intensities to change the colors and textures. These metals can be manipulated in a variety of ways limited only by the unique characteristic of each metal.

stones. As one sculptor said: "Metal is so docile, it will submit to any formal conception the creator may have. Yet it will stand as sturdily as a bridge or building and last even longer."

As industry continued to improve the welding apparatus, and the equipment dropped in price, the tools interested many young sculptors. By 1940, men like David Smith,

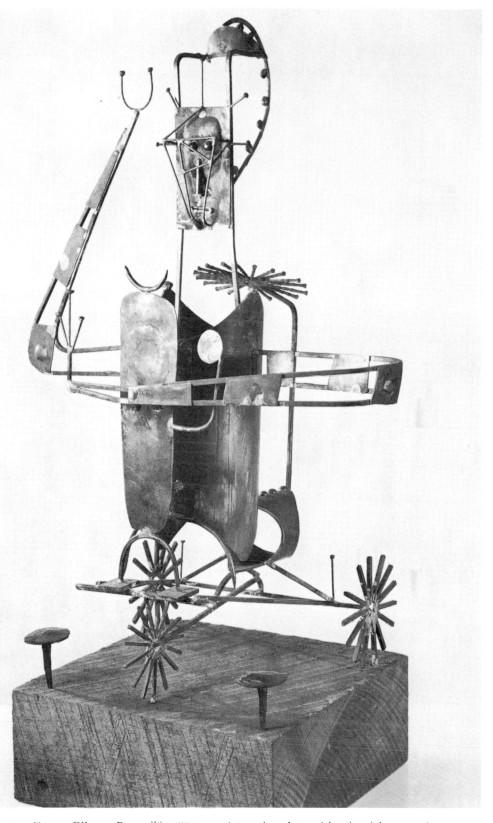

TRYCYCLE. Carter Gibson. Brass. This lineal sculpture is enhanced by the richness, color, and reflections inherent in brass.

*Courtesy, Devorah Sherman Gallery, Chicago*

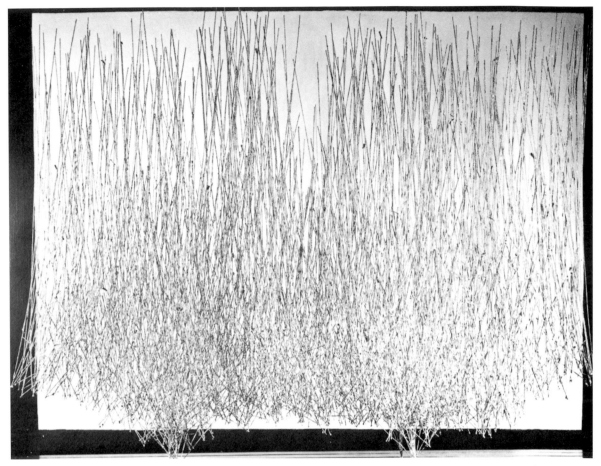

UNTITLED. Harry Bertoia. Music wire, brass, and bronze. The smooth and highly polished surfaces are appealing in design, color texture, and the richness of the brass and bronze.

*Courtesy, Fairweather Hardin Gallery, Chicago*

Today, steel, stainless steel, and steel alloys vary so much that only experience and constant attempts to identify the products will familiarize you with their varying possibilities. A rough steel has individual marks and textures, but polishing and grinding, for example, will change the appearance and feeling entirely.

Aluminum is fairly easy to identify because it is usually silvery-white. Lead is softer than other metals, yet its weight often prevents sculptors from working it into large forms. Wrought iron can be welded and forged. Cast iron can range in color from bright to light gray. It can be welded but not forged because it is too brittle. Magnesium, nickel, gold, and silver are often combined in metal-work, and the artist is constantly trying new materials and combinations of them.

The field of metal sculpture is destined to grow as more artists and craftsmen, teachers and students realize the dynamic expression of metal. But it isn't enough to put together pleasing shapes and academically accepted forms using the best possible techniques. The sculptor today is seeking to use the latent, inherent qualities of metal to state a vitality that comes from the deeper level of the unconscious. The artist, standing on a new frontier with the materials of our mass-production society, has the opportunity of creating individuality.

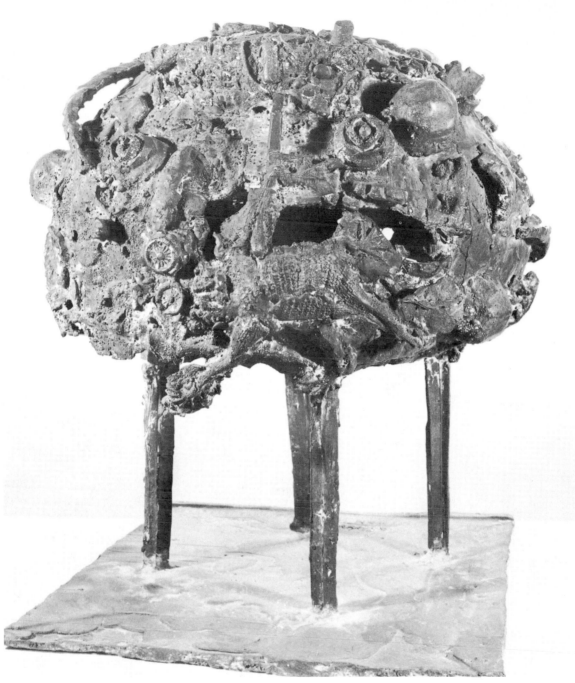

FROG EATING A LIZARD. Eduardo Paolozzi. 1957. Bronze. By the late 1950's, artists developed other ways of handling castings so they were no longer solid masses. Then they were able to utilize some of the open space ideas put forth by the direct metal sculptor. In fact, some of the castings begin to resemble direct metal work in their forms, in their texture, and even in their abstract ideas.

*Courtesy, Martha Jackson Gallery, New York*

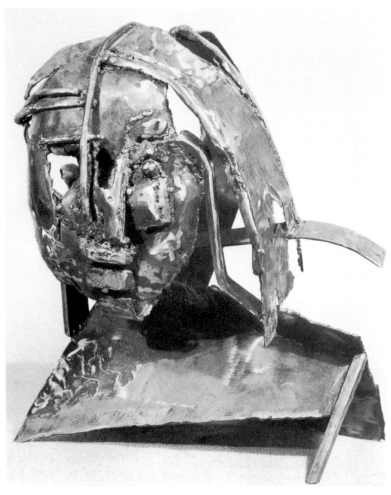

HEAD. Larry Rivers. 1957. Welded steel. Often steel that has been ground in some areas and polished in others has a direct relationship to painting. It gives subtle suggestions of light and shadow, rough and smooth areas which blend to give the feeling of a vital, growing form. The head is a recognizable image which allows some openness for contrast and vitality.

*Collection,*
*Museum of Modern Art,*
*New York*

MORNING (detail). Joe Clark. A feeling of contrasts is achieved by the rough and smooth textures of hammered sheet metal with welded strips.

*Courtesy of the artist*

## WHAT IS DIRECT METAL SCULPTURE?

Because metal sculpture is partially an outgrowth of industry, the manufactured fragments of our civilization are of particular concern to the metal sculptor. The visual and ethical aspects of a society which creates useful objects that wind up in junkyards because of forced obsolescence are major subjects in sculpture today. The artist comments on this problem in a variety of ways.

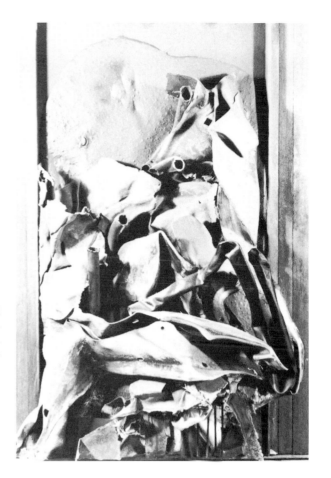

NEW TERRAIN. Harry Bouras. 1964. Waste is used to create beauty. The forceful "landscape" is composed of junk materials, but the result is an orderly control over light and shadow as well as materials.

THE LAST YOGI. Ken Fadem. Steel. A parody is created by using prefabricated objects welded together to suggest a very threatening bed. The irony is apparent, but what better choice other than metal could have expressed this idea?

*Courtesy of the artist*

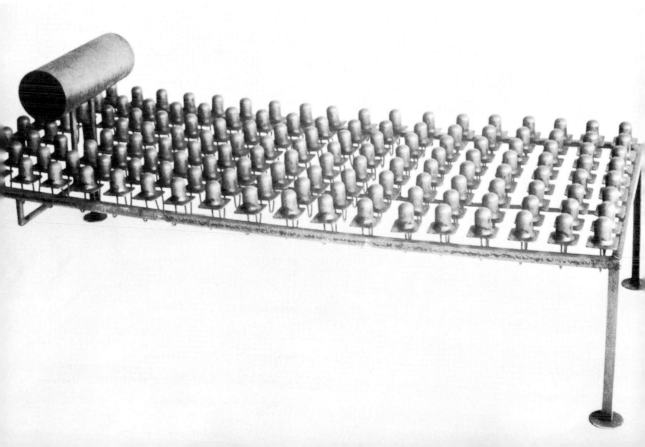

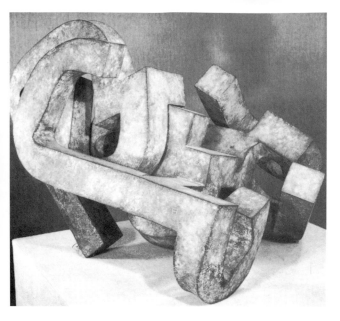

## WHAT IS DIRECT METAL SCULPTURE?

A contrast of the appearances of the sculptures on this page will help you recognize some obvious differences in metals and how their individual qualities result in various effects.

MODULATION OF SPACE II. Eduardo Chillida. 1963. Forged iron. The gray of the iron, the forge marks, the tense turns and the strength of the material are qualities easily recognized. Here the physical properties of iron are emphasized by the shapes.

*Courtesy, Galerie Maeght, France*

MAN WALKING. Isamu Noguchi. 1960. Aluminum. The abstract symbol of a man is cut and welded in aluminum. The light and dark places are important in expressing volume.

*Courtesy, Art Institute of Chicago*

HAMMERED LEAD TORSO. Albert Vrana. By hammering out the form, the artist has illustrated the malleability of lead. A sheet of ⅛-inch lead was suspended from a ceiling beam and hammered from front and back. The lead was heated with a blowtorch periodically to keep the material from cracking during this process.

*Courtesy of the artist*

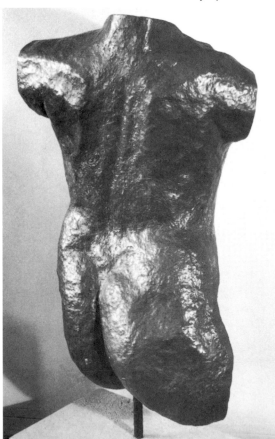

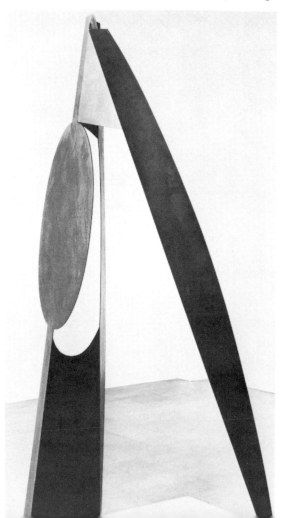

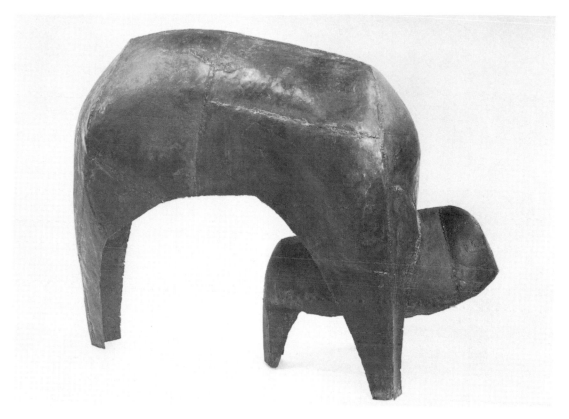

ANIMAL AND YOUNG. David Hayes. 1957. This forged steel form has a feeling of unchanging and universal stability. Through the use of simple, repetitive shapes, the artist has captured the essential message of continuity in nature.

*Courtesy, Solomon R. Guggenheim Museum, New York*

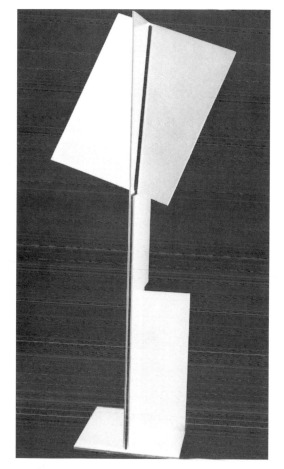

MARKER. Robert Murray. 1964. Steel painted white. Here a different kind of permanence is suggested. The sculpture moves away from nature and has a shape akin to the permanence associated with urban life. The simplicity of the form and the vertical movement use the structural aspects of steel to good advantage.

*Courtesy, Betty Parsons Gallery, New York*

Metal, in a broad sense, implies permanence. The strength and durability of metals are elements which some sculptors find exceedingly compatible. To these basic qualities can be added shapes, images, textures, and colors which are an expression of permanence in their own way. The consistency of the expression combined with the materials can result in stable sculptural forms.

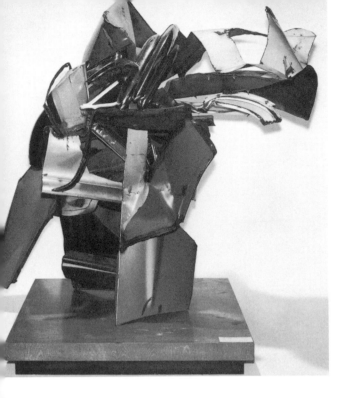

SWEET WILLIAM. John Chamberlain. 1962. This approach to metal sculpture evades a suggestion of intentional craftsmanship. It is created by hammering and compressing scrap materials, such as automobile bodies, into informal conglomerates.

*Courtesy, Los Angeles County Museum of Art*

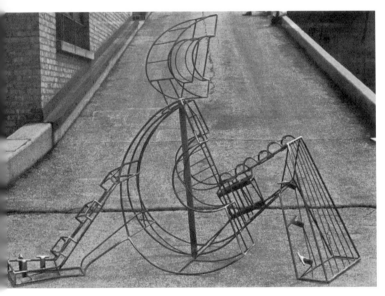

GUITAR WOMAN. Ron Dahl. Directly opposed to the almost haphazard arrangement of John Chamberlain's informal shapes is this carefully constructed sculpture. The artist has built a sturdy steel armature which can support the weight of the cement. Some of the armature is allowed to show through and neatly define the edges of the sculpture.

*Courtesy of the artist*

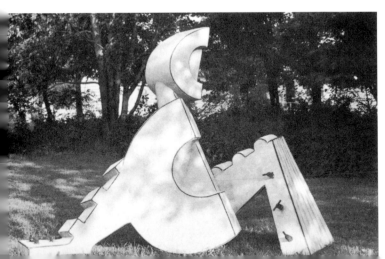

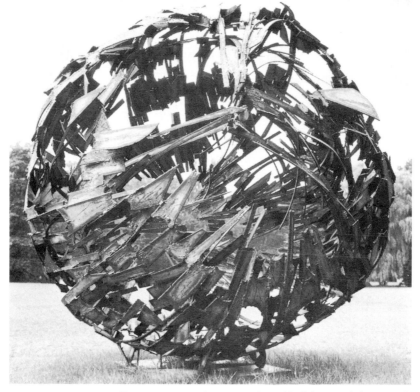

ENTELECHIE II. Friedrich Werthmann. 1960. Welding stainless steel
into open-space construction requires tremendous discipline by the
artist, who must create an almost undisciplined fragmented feeling.
The *London Times* described this work as suggestive of natural forms
and then "like so many new freedoms, this (the transcendence of en-
gineering dictates) tends toward chaos. It is the organization of chaotic
matter, rather than the creation of formal structures, which gives the
sculpture its power."

*Courtesy of the artist*

LARGE WING FORMS. Richard Hunt. 1964.
Welded steel. In many instances the over-
coming of "formal composition" on "engi-
neering dictates" is accomplished in a more
solid closed form. The forms enclose space
and become a mass which retains great free-
dom of movement, and the elements are
presented in a logical, forceful manner.

*Courtesy of the artist*

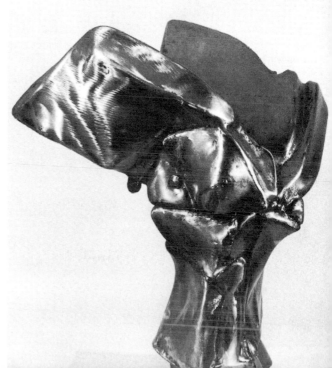

28

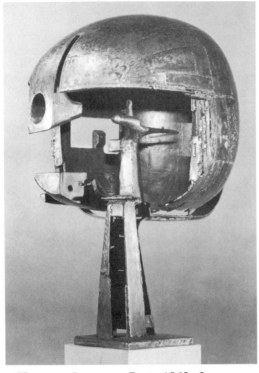

HELMET. Laurance Burt. 1962. Iron.
*Courtesy, Tate Gallery, London*

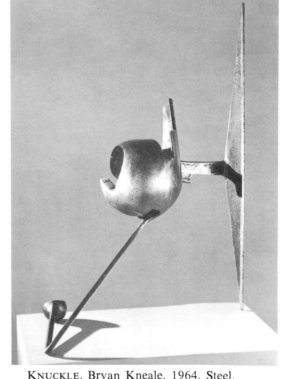

KNUCKLE. Bryan Kneale. 1964. Steel.
*Courtesy, Tate Gallery, London*

LA SOEUR DE L'AUTRE. César. 1962.
Iron.
*Courtesy, Hanover Gallery, London*

RHYME CONTEST. Berto Lardera.
*Courtesy, National Museum Service, Paris*

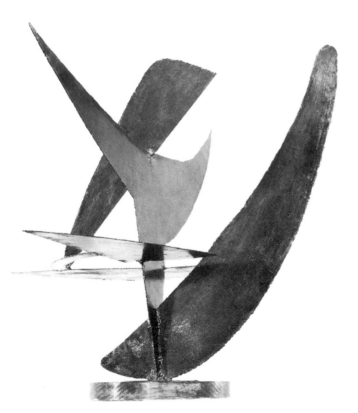

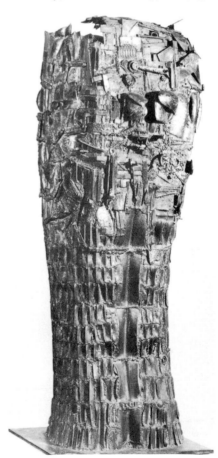

Engineering concepts and the suggestions of the influence of the Machine Age are apparent in these four sculptures.

Whether a student is limited to one technique or has free rein, he often creates objects, realistic or abstract, which have a logic and spontaneity about them.

VEST AND TIE. A collaborative effort of students Andrew Kainass and Dan Wrobliewski. In both items the metal was manipulated and joined without the use of heat. Sections were slotted, stapled, or folded together. The aluminum tie and copper sheet vest indicate some of the versatility of the metals.

*School of the Art Institute of Chicago,*
*Don Seiden, Instructor*

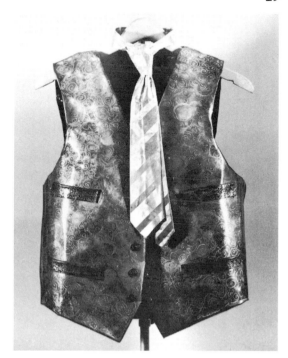

SPIDER WEB. Jack Schmitt. The soldered wire web suggests the same qualities present in a real web. Combining the web with an old window effects a realistic atmosphere.

*School of the Art Institute of Chicago,*
*Don Seiden, Instructor*

FREE FORM. Hand-formed aluminum rubbed and polished to a high gloss.

*Institute of Design, I.I.T., Chicago,*
*Ray Pearson, Instructor*

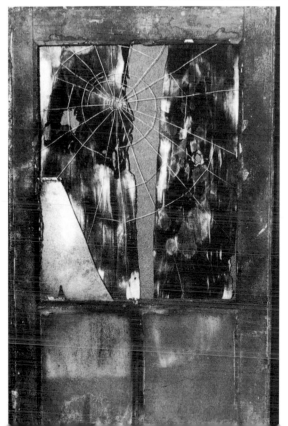

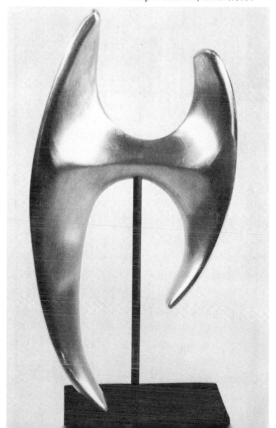

# Metals-Equipment-and Their Use

We have already mentioned a few of the qualities of metals. But metals have a wide and diverse range of properties. The artist must learn which metal will serve his specific purpose best. He must choose the technique that will most effectively shape that metal to his personal vision.

This involves a working knowledge of the characteristics of the different metals and the equipment to use with them. It is logical to begin with one easily accessible, inexpensive material; learn its properties and apply the techniques that you have available until you are familiar with the metal and the tool. Then gradually broaden your experience by trying new materials and applying different techniques. Possible results are as varied as the words you use. From only twenty-six letters, myriad combinations can be made to result in what you wish to say. From only a few metals and alloys, combined with a few basic techniques, you can make unlimited statements in metal sculpture.

Remember that your initial exploration into metal sculpture does not require any complex technical information. If, however, you choose to continue working, a deeper understanding of the technical aspects of the materials and tools will be essential.

### The Families of Metal

Metals can be categorized into two basic families: pure metals and alloys. In the alloy family there are about ten thousand offspring which basically fall into two other classifications: ferrous and non-ferrous.

## Pure Metals

A pure metal is one that remains in its elemental stage without the addition of any other materials. Iron, gold, copper, silver, lead, aluminum, and many others are among those which are on the chemical chart of the 92 basic elements found in the earth's surface. The pure metals cannot be broken down into other elements, but they can be combined with each other and with other materials.

## Alloys

When two or more pure metals are combined and their basic properties are altered, the result is called an *alloy*. These combinations are created for many purposes. Many pure metals are of little use because they are too soft or rust too easily or because of some other mechanical or chemical drawback. Fortunately, they are more useful when combined with other metals in alloys. For example, brass is an alloy of two pure metals, copper and zinc. Bronze is an alloy of copper and tin. Both brass and bronze are far superior for many purposes than the parent metals. Although gold, silver, and iron are pure metals, they are rarely used in their original state. Other less expensive and more readily available metals are mixed with them, and the resulting alloy is less expensive, harder, and longer wearing. The added metal will also affect the color of the pure metal. By changing the formulae of the metal mixtures, an almost endless variety of alloys can be obtained.

How are alloys made? Usually the base metals are melted, and their molecules intermix in the molten state and become the alloy. Some alloys can be combined without melting by beating the metals together until they form a single uniform mass. Sometimes the union of a metal and a non-metal will form an alloy: for example, steel, which is composed of iron, carbon, and other materials. All metals cannot be combined into alloys because of the incompatibility of their basic molecular structures. But once an alloy has been created, it has metallic properties in appearance and action. Generally the alloy is harder, easier to fuse, but less malleable than the original pure components.

In the alloy family there are two additional classifications: *ferrous* and *non-ferrous* metals. Ferrous comes from the Latin word *ferrum* meaning "iron." Therefore a ferrous metal is simply an alloy which contains iron as one of its components, such as steel, mentioned above. A non-ferrous metal does not contain any iron. Examples of non-ferrous (non-iron-bearing) metals are copper, bronze, brass, gold, silver, and aluminum.

Both ferrous and non-ferrous metals are used by the sculptor and may be combined in the many ways illustrated throughout the book. In sculpture, the special qualities which determine the artist's choice of metal involve esthetic considerations as well as strength, durability, reaction to heat and weather, hardness, and ease of shaping.

## Ferrous Metals—Iron and Steel

Iron is a silvery-white metal in its pure state and is obtained from certain kinds of rock, or ore. The ore actually contains very small amounts of iron. Therefore the production of iron involves melting iron ore and adding coke and limestone in a blast furnace in a process that frees the iron from the ore.

The coke and limestone do not become part of, or alloyed with, the iron. They are simply agents that initiate and help bring about a series of chemical reactions that result in the

freeing of the iron from the ore and other impurities. Even then, the product is not pure iron. It still contains about 5 percent of carbon and smaller amounts of other elements.

All this iron produced in a blast furnace is called *pig iron*. The name comes from an early method of shaping iron into long bars called pigs. The molds for these bars were arranged around a main channel like a litter of small pigs around the mother; hence the name. Pig iron is used to make two other kinds of iron: *cast iron* and *wrought iron*. Pig iron and wrought iron are soft, easy to hammer and shape when they are heated. Cast iron is more brittle, conducts heat more rapidly, and is more difficult to weld than the other two.

However, only a small percentage of all pig iron produced today is used as pig, cast, or wrought iron. Mostly it is used to make *steel*. Steel is a mixture, or *alloy*, of iron with definite amounts of carbon plus other materials in varying amounts, depending upon the use for which the steel is needed. Steel is stronger than iron and can be shaped into many more useful products. There are literally thousands of different forms of steel produced today that differ from one another because of the kind and amount of chemical elements added or because of the way they are processed. A single automobile has as many as 150 different alloys in its parts. However, steel can be divided into three general classifications: *carbon* steel, *alloy* steel, and *tool* steel.

Carbon steel is composed of iron and less than 1 percent carbon and is most widely used in the manufacture of almost all modern steel products. It is also produced for mixture with alloy steel.

Alloy steel contains some carbon, but its properties (and its name) depend on other chemical elements added. For example, the addition of chromium to the carbon steel results in stainless steel—an alloy that is tough, durable, and rust-resistant—properties that

make it a favorite among sculptors. The addition of nickel increases toughness and resistance to heat and acids; manganese increases strength and resistance to wear; molybdenum increases strength and resistance to heat; tungsten retains hardness at high temperatures; vanadium increases strength and resiliency or springiness. There are many other elements and materials which can be used for various purposes, but these are the most common.

Tool steel is a fine-grade steel used for tools. Some tool steels are made with only iron and carbon. Others may have large amounts of several alloys added, depending upon the tool to be manufactured.

To the metal sculptor, alloy steels are extremely popular because they have desirable qualities, are readily available and relatively inexpensive. Iron is more expensive than steel, although both can be found in junkyards as scrap metal. The artist also likes the versatility of these steels because most can be soldered, brazed, and welded using almost any type of rod except aluminum alloys (see rods, Chapter 2).

The melting points of iron and steel are similar, yet different types vary considerably in their workability. Steel melts between 2500 and 2700° F. Pig iron melts at 2800° F. Both are white in color when molten. However, cast iron melts at 2100° F., is very brittle, and conducts heat rapidly. This conductivity often requires the welder to preheat the entire surface before he can weld only one part, since it is very difficult to concentrate the heat if the metal is cold. If a small piece of material is used, a torch may supply the necessary overall heat. For a larger piece of metal, a gas or charcoal brick oven may be necessary.

Wrought iron is relatively soft and is most often used for forging. It melts at about 2800° F. It does not conduct heat as rapidly as cast iron, therefore welding can be done without preheating.

Iron and steel are particularly susceptible to corrosion, or rusting, which tends to destroy the material over a period of time, depending upon the weather and moisture to which it may be exposed. Many methods have been developed to protect the metal from corrosion. Small amounts of copper added to the molten steel will retard or prevent rusting. Paint, oil, or similar rust-resistant coatings are not permanent and require that the metal be regularly recoated and carefully maintained. A coating of zinc on steel or iron, called "galvanizing" does make metal rust-resistant for long periods of time. Galvanized steels can be welded, but noxious fumes are emitted from the melted zinc which can cause coughing and physical complications. Proper ventilation is essential, but even then, welding directly on galvanized steel is not recommended. A safer procedure is to have steel galvanized *after* the sculpture is completed.

Stainless steel, because of the addition of chrome, is highly rust-resistant. COR-TEN steel forms an original rust coat which prevents further corrosion from oxidation. Of course, the sculptor seeking unique effects may choose to use a corrosive steel, let it oxidize to a certain state, then apply a rust-resistant covering. In this way he utilizes the color and texture of rust as part of the sculpture's esthetic surface.

## Non-Ferrous Metals

Some of the more common non-ferrous metals (without iron content) used by the sculptor are copper, brass, bronze, aluminum, and lead. The craftsman who creates small sculptured jewelry may use gold and silver, but the cost of these materials makes a large sculpture prohibitive.

## Copper

There are two kinds of copper, deoxidized and electrolytic. Both possess a distinctive reddish color when they have just been cut. Deoxidized copper is free of oxygen and will weld easily without loss of strength. Most of the copper used in the form of tubing, sheet, and rod is deoxidized. Electrolytic copper contains a small percentage of oxygen which causes it to weaken when it is welded. It is used when strength is unimportant.

Both kinds of copper are relatively soft and easy to bend. They become reddish in color when they are chilled or quenched rapidly with cold water. When heated, they will take on various colors such as blues, greens, and browns. The artist can control, to some extent, the oxidation which causes these changes of color by rapidly applying heat or various acids. Slow oxidation will take place from weathering over a period of time from weeks to years. Even a highly polished surface will dull with time.

Copper can be welded by *fusion welding*. This means that two pieces can be joined by melting them and putting them together while molten and without the use of a brazing or filler rod. But it may also be brazed, which involves the soldering technique (the addition of another metal flowed into the joint which secures it much like a glue). When the color of the metal is not to be altered at the joint, a deoxidized copper rod or a phos-copper rod is used for brazing. If color is of no concern, then a bronze rod can be used. Fusion welding results in a consistency of color since the same metal is flowed together. Copper requires about 1960° F. to reach a molten state, and it turns a lemon-yellow color. The color changes with various cooling methods, as already mentioned. Often these changes are unpredictable and difficult to duplicate, which is part of the beauty of working with copper.

## Brass

Brass is an alloy that combines copper and zinc. The zinc content ranges from 10 to 40 percent, depending on the need for hardness in the material. In any proportion, however, brass is always harder than copper. Brass will melt between 1600° and 1900° F. The molten metal is a salmon color at lower temperatures and orange at higher temperatures. Brass is an extremely malleable metal and can be formed into thin sheets, cast, and drawn into wire form. Many sculptors avoid welding brass since the melting zinc content produces gasses that can be dangerous. Brass, when used by the sculptor, is usually silver-soldered or brazed with bronze rod.

## Bronze

Bronze is probably the most important metal in the history of sculpture. It has been used since ancient times in cast art work. The material is composed of copper, about 90 percent, and tin, about 10 percent. This ratio of the alloy is used mostly in casting and for direct metal work. Bronze is harder and more resistant to wear than either copper or zinc. Molten bronze is smooth flowing, and when used for casting it is capable of reproducing fine details from a mold. Bronze is an excellent conductor of heat, and, like brass, is often soldered and brazed rather than welded. The reason? In welding it is difficult to keep the heat of a torch concentrated in one area owing to the conduction of heat all over the surface of the metal. Bronzes melt at anywhere from 1300° to 1900° F. and range in color in a molten state from dull red to orange as the melting point goes higher. Bronze and brass can be hammered and forged into shapes, fused by brazing or welding, or cut by saws and shears, depending upon the thickness of the metal.

## Aluminum

Aluminum is a low-melting metal which flows at temperatures between 900° and 1250° F., depending on its alloy. The use of aluminum in sculpture has been restricted because of certain difficulties it presents in fusion. It is extremely weak when hot and often collapses suddenly. Aluminum does not change color under heat. It is best handled in thin sheets using a soldering technique with special flux and rod. (See fluxes and rod charts at the end of this chapter.) For heavy aluminum sheets and rods 1 inch to 4 inches in thickness, arc welding techniques are often preferred. Because aluminum is extremely lightweight, it enables large sculptures to be transported easily. This metal conducts heat even more rapidly than copper. Aluminum is less resistant to corrosion than bronze and copper but more than steel, which makes it a valuable material for outdoor sculpture.

## Lead

Lead is an extremely soft, malleable metal which is used as a component in many alloys such as solders and typesetting metal. Lead in a natural state melts at about 625° F., and when alloyed its melting point ranges from 150° to 600° F. It is a very poor heat conductor, extremely heavy in small amounts, and is usually welded without the intense heat necessary for other metals. Often a soldering iron is sufficient to fuse lead. Lead will not corrode but will turn darker in color with time. Prolonged exposure to lead fumes can cause lead poisoning, which is sometimes fatal. Proper ventilation and utmost safety precautions must be used when working with lead or its alloys.

All of the metals mentioned above are available in many forms: bars, rods, sheet, tub-

ing, and wire. Metal suppliers have great ranges of sizes, thicknesses, and shapes in all of the materials. The scrapyards often have fragments of articles made from any of the metals, both ferrous and non-ferrous.

## Color and Patina

The color of metal in its natural state is often changed by the sculptor for esthetic reasons. Color changes take place through oxidation over a period of time, but rapid oxidation can be accomplished through the use of various experimental techniques that involve tools, heat, and acids. The control of these color changes rests with the inventiveness and creativity of the sculptor. Many formulae are available to the artist for patinas on metal, but only experimentation and timing in regards to the amount of acid or heat will produce results that satisfy the individual artist.

The ferrous metals range in color from bright to dark gray. Steel, in an unfinished state, is a dark to medium gray color which turns bright gray when polished or machined. This material cannot be permanently changed in color except through oxidation, which changes the natural patina to rust. Cast iron ranges from bright to light gray and also changes to orange and red with corrosion. A blue-black color can be achieved on steel by the use of a hot solution of 10 grains of sodium thiosulfate to each ounce of water. To prevent rust, sculptors have painted, oiled, and sprayed their sculptures with various lacquers and plastic materials.

Raw copper is a brown-red but will turn cherry red when heated and chilled quickly or when fractured. Heating with the torch produces a variety of color in greens, blues, reds, and yellows which will remain if the metal is coated with wax, lacquer, or other finish. Over time and with weathering, the copper will oxidize and eventually turn to deep dark browns and blacks. To turn copper black or deep brown quickly, try a solution of ammonium sulfide, 1 ounce to 1 pint of water. Apply this solution cold. For a green antiqued patina on copper, mix 1 ounce acetic acid and 4 ounces of copper nitrate in 1 quart of water.

Brass ranges in color from reds to white yellow on a polished surface. On an unfinished surface, the yellows are mixed with greens and browns caused by oxides which form on the surface. Heating the metal with a torch and slow cooling will produce these same changes through fast oxidation. To antique brass, simply cover it with a solution of antimony chloride and allow to dry. To turn brass green, apply this solution cold: ½ ounce iron sulfate, ½ ounce copper sulfate, ½ ounce ammonium carbonate in 1 quart of water.

The color of bronze in its raw state resembles that of brass. On a finished bronze surface, the color ranges from various reds to yellows. The unfinished surface also takes on the oxidation colors of green, brown, and yellow. Bronze, like brass, will turn black with age and weather but can be patinated and, with protection, retain the patina. To turn bronze from deep blue to black, apply a solution containing 2 ounces of ammonium sulfide to 1 quart of cold water. For a blue-green color add ¼ ounce sodium thiosulfate and 2 ounces of ferric nitrate in 1 quart of water and apply with a brush after heating the solution to a boiling point.

The color of lead on an unfinished surface ranges from white to dull gray and darkens with age. Aluminum is a silvery-white metal when polished or when broken or fractured. It is a light gray on an unfinished surface.

The cleaning of scale and accumulations on copper, brass, and bronze can be done as follows: immerse the metal in a pickling solution of 1 part sulfuric acid to 9 parts water for a few minutes. Then the metal can be buffed with a buffing wheel or by hand after rinsing and drying.

## WELDING FOR SCULPTURE

Although wire bending and other techniques for joining metals can be accomplished without heat, the vast potential of direct metal work depends upon the application of heat. The major methods for heating and joining metals borrowed from industry are soldering and welding. The soldering iron is an electrically operated tool with a point that heats up and is applied to metals which require a relatively low melting point. A melted solder is used which is applied to the joint of the metals to be joined. When cool, the solder adheres to the metals much as glue holds two surfaces together. Solder is a simple but important technique, which is fully described in Chapter 3.

Hard soldering or brazing, also described in Chapter 3, depends on more heat, since the metals, like silver or bronze, melt at higher temperatures than the lead used in soft soldering. In the case of hard soldering, the heat source comes from either an air-acetylene or an oxyacetylene unit.

The *air-acetylene* unit requires only one tank of compressed gas, in this case, acetylene gas. The gas is automatically mixed with air which enters through the torch tip, and when ignited produces a flame capable of working with metals that require up to about 2500° F. It is, therefore, used on thinner metals with a lower melting point.

The *oxyacetylene* unit requires two tanks of compressed gases: one tank of oxygen and one tank of acetylene. When ignited, these can create heat over 5000° F. This is sufficient to melt most metals, even those that are very heavy and thick. The mixture of gases in the torch of the oxyacetylene unit depends on the operator, who adjusts the amount and pressure of oxygen and acetylene by manipulating the torch, tank valves, and gauges. The air-acety-lene unit mixes the proper or consistent amount of each gas automatically. Either unit may be used for hard soldering, but welding, requiring higher temperatures, can be accomplished only with the oxyacetylene unit. Welding can be used interchangeably with soldering, depending upon the metals to be fused. The torches of the welding units have a number of tips that control the size of the flame or may be used for cutting metal. Besides the oxyacetylene unit, an arc welder, which works by electricity rather than gases, is also becoming increasingly popular. Other gases may be used with oxygen in place of acetylene to produce different types of flames for a variety of purposes. These gases are propane, butane, methane, euthame, and mapp.

Welding for sculpture requires the same setups, safety precautions, and handling of the equipment as does commercial welding. But here the similarities cease. The sculptor uses the welding operation in a constantly experimental way to bring out certain qualities of the metals he chooses for esthetic expression. He uses the welding torch almost as though it were an extension of his hand as he sets about to shape the materials of his art form. With only a little experience, amateurs and professionals alike use the torch as comfortably as any other tool for producing sculpture. However, for the torch to become an almost automatic part of the creative process, you must become familiar with the equipment and the operating procedures.

Oxyacetylene Equipment and Working Area

Basically, welding equipment consists of a torch (also called a blowpipe) and tanks of oxygen and acetylene. An initial kit for welding can be purchased from any welder's

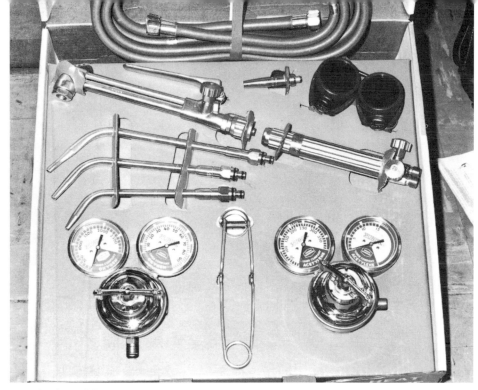

A basic welding kit consists of the torch, goggles, an igniter, various sized tips, pressure regulators, cutting attachments, and hoses. Items may be bought individually as well as in kits.

Oxygen and acetylene tanks, with torch and hoses attached, are chained on to a portable carrier.

Air-acetylene unit composed of acetylene compressed gas in one tank and torch which allows air to enter and mix with the acetylene automatically.

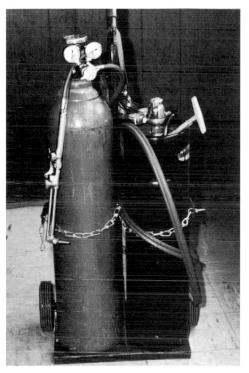

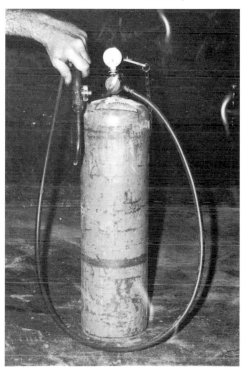

supply house or ordered through one of the large catalog merchandisers. At the time of this writing, the price of about $150 per kit is much less than it was only five years ago, and it will continue to drop as more kits are manufactured and sold. The initial kit includes the torch, goggles, an igniter or sparker, various sized tips, pressure regulators, cutting attachments, and hoses.

The kit and price do *not* include the two tanks, or cylinders, of oxygen and acetylene. Usually these are rented or purchased from the same supplier. The supply company also refills the tanks when the contents are used up, and the cost of refilling with these gases is very reasonable. Refilling varies, depending upon how often the tanks are used, and tanks do come with various capacities. With an assortment of attachments and two torches, more than one person can work from the same tanks at the same time, and people often share the cost of the entire unit. In an art classroom this ability to share tanks is a prime consideration.

Setting up the welding area properly is important. It should be free of flammable materials and have adequate ventilation. Preferably, it should be used only for welding and no other purpose. Precautions against the possibilities of fires should be taken. This implies that:

1. Proper clothing should be worn. Clothing should cover the body thoroughly so falling sparks cannot burn the skin. Highly flammable fabrics should not be worn.
2. No combustible material should be in the welding vicinity.
3. A fire extinguisher, sand, or water should be handy. A first-aid kit with burn ointment should also be nearby.
4. Never use oil or grease on welding apparatus. It is highly flammable.
5. Do not use faulty equipment or equipment

in need of even minor repairs.
6. Test for gas leaks frequently by putting soapy water on various gas connections. If water bubbles, there is a leak.
7. Read carefully all instruction booklets provided with new equipment, and follow all suggestions for care and maintenance.
8. Cylinders of gas should be stored upright and chained in place to prevent falling.
9. Cylinders should be moved from place to place in a portable carrier or rolled in a semivertical position very carefully.

The welder should work on a steel table covered with either a grid, firebricks, or asbestos board. The floor should not be wooden or made of any material that could be flammable. Concrete or stone floors are excellent. The area surrounding the welder should be free of flammable materials and protected by asbestos wall or non-combustable canvas. When many people are working in one area, it is good safety practice to surround each welder with portable asbestos screen cubicles or permanent protected welding areas. The danger of fire is greater when welders are involved in cutting metal with the cutting torch, since many more sparks are present than in ordinary welding. It is important that the sparks be contained in the welding area by blocking them with the asbestos protective material around the welder.

## HOW TO OPERATE THE EQUIPMENT

The principle of the torch and equipment is simple. The gases from the two tanks pass to the handle of the torch where they are mixed, then admitted through the nozzle and tip. At the tip, they are ignited by the sparker, and the valves control the amount of gas from each hose, which results in the flame.

Adjusting and lighting the torch may vary with different designs of apparatus, but gen-

erally the procedures for setting up and operating most equipment are similar.

1. Secure the two cylinders (oxygen and acetylene) so they can't tip over.
2. Remove the caps. Open the oxygen valve slightly. It will release oxygen with a hissing noise and thus blow away any dust around the valve seat.
3. Attach the oxygen regulator to the oxygen cylinder, and tighten the connection nut with an open-end wrench. Oxygen connections have right-hand threads.
4. Repeat the above operations on the acetylene cylinder. Acetylene connections have left-hand threads.
5. Connect the green hose to the oxygen regulator and the red hose to the acetylene regulator. Threads on these connections are also left-hand for acetylene and right-hand for oxygen. Use open-end wrenches for all connections and *don't force anything.*
6. Attach the red hose to the acetylene valve inlet on the torch and the green hose to the oxygen valve inlet.

Now with the equipment properly set up, you are ready to mix the gases. Open the hand wheel at the top of the oxygen tank a half turn. Then turn the oxygen regulator pin to the right until the proper pressure is registered. The pressure on the other cylinder regulator will register about 2,000 pounds when the tank is full. This will register as soon as the cylinder wheel is opened. The working regulator will register when the adjusting screw is turned in. The proper pressure will depend on the thickness of the metal to be welded (see Chart No. 1). Average pressure on the oxygen is between 5 and 10 pounds. Approximately the same pressure is used on the acetylene gauge. Next open the top of the acetylene cylinder one half turn and adjust the pressure regulators in the same fashion.

After choosing the tip and welding nozzle, they should be fitted into the torch. (The correct tip varies with the thickness of the metal—see Chart No. 1.) These fittings should be tightened by hand in most cases. Now partially open the oxygen valve on the torch, and adjust the oxygen regulator until it reaches the desired pressure. Then close the valve. Do the same on the acetylene valve and regulator. When the valves are closed, the pressure rises slightly, and all welding and cutting charts show flow pressures with valves open.

How to Operate the Torch

1. Hold the torch in one hand, the igniter in the other.
2. Open the torch acetylene valve one half turn and the oxygen valve slightly. Then ignite the gas by squeezing the igniter (or sparker) until the spark ignites the acetylene. The igniter is held at the tip of the torch as it is squeezed. It has a removable flint which needs replacing when it wears out and fails to produce a spark.
3. Keep opening the acetylene valve on the torch until the flame leaves the tip end. (If there is smoking, add a little more oxygen.) Then reduce the flame until it comes back to the tip.
4. Open the oxygen valve more until a bright inner cone appears on the flame. The point at which the feathery edges of the flame disappear and sharp inner cone is visible is called a *neutral* flame. This is the flame most commonly used for welding procedure. An *oxidizing* flame is a pale blue color without the clearly defined inner cone that the neutral flame has. The *carburizing* flame is the flame that is produced before the neutral flame is reached. It is distinguished by the long carburizing feather (see drawing).

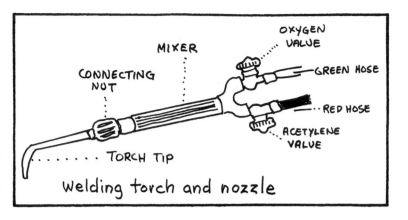

Welding torch and nozzle

Labels: OXYGEN VALUE, GREEN HOSE, RED HOSE, ACETYLENE VALUE, MIXER, CONNECTING NUT, TORCH TIP

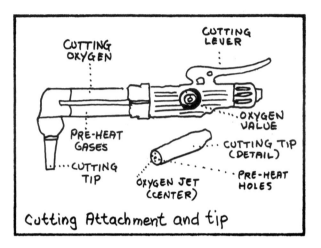

Cutting Attachment and tip

Labels: CUTTING OXYGEN, CUTTING LEVER, OXYGEN VALUE, PRE-HEAT GASES, CUTTING TIP (DETAIL), PRE-HEAT HOLES, CUTTING TIP, OXYGEN JET (CENTER)

# HOW TO OPERATE THE TORCH

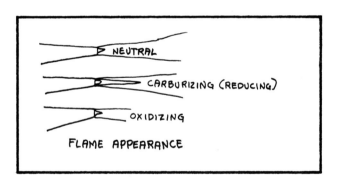

NEUTRAL

CARBURIZING (REDUCING)

OXIDIZING

FLAME APPEARANCE

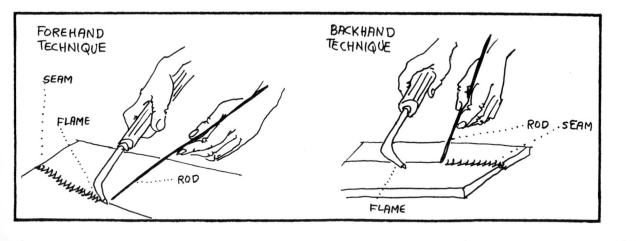

FOREHAND TECHNIQUE

SEAM, FLAME, ROD

BACKHAND TECHNIQUE

ROD, SEAM, FLAME

With the neutral flame established, you are now ready to weld. Put on goggles to protect your eyes against sparks and infrared rays, which can be dangerous. There are two main techniques commonly used in welding: the forehand and the backhand methods. Both have advantages.

In the forehand technique, the welding rod precedes the tip of the torch in the direction in which the weld is being made. The heat and the molten metal are distributed uniformly by moving the tip and the rod in opposite directions.

In the backhand technique, the torch tip precedes the rod in the direction of welding. The rod is placed in the flame between the tip and the weld. There is less manipulation in backhand welding since the rod can be merely rolled from side to side in the molten puddle. The forehand technique is usually used with metal up to ⅛-inch thickness because there is better control of the puddle. Backhand welding is often used for thicker material because better fusion results and it is faster.

### To Shut Off the Unit

When you stop work, turn off the torch by closing the acetylene valve first and then the oxygen torch valve. This will prevent excess smoking from the acetylene flame. Then:

1. Close the oxygen cylinder valve.
2. Open the torch oxygen valve until all pressure goes down to zero.
3. Turn the adjusting screw on the oxygen regulator loose.
4. Close the torch oxygen valve.
5. Close the acetylene cylinder valve.
6. Open the torch acetylene valve until all pressure goes down to zero.
7. Turn the acetylene regulator screw until loose.
8. Close the torch acetylene valve.

Now the unit is secure, and you may remove the regulators if you wish.

### CHART #1—WELDING TIP SIZE AND PRESSURE * (RECOMMENDED FOR SCULPTURE)

| TIP SIZE | THICKNESS OF METAL | OXYGEN PRESSURE | ACETYLENE PRESSURE |
|---|---|---|---|
| # 1 | 3/64"–3/32" | 4 | 4 |
| 2 | 1/16"–1/8" | 5 | 5 |
| 3 | 1/8"–3/16" | 7 | 7 |
| 5 | 1/4"–1/2" | 5–12 | 5–15 |
| 7 | 3/4"–1 1/4" | 7–16 | 7–15 |
| 9 | 2"–2 1/2" | 10–20 | 9–15 |
| 12 | 3 1/2"–4" | 14–28 | 12–15 |

### CUTTING DATA—TIP, PRESSURE, METAL THICKNESS

| TIP SIZE (medium) | THICKNESS OF METAL | OXYGEN PRESSURE (maximum) | ACETYLENE PRESSURE (maximum) |
|---|---|---|---|
| # 1 | 1/2" | 35 | 5 |
| 2 | 3/4" | 40 | 5 |
| 3 | 1 1/2"–2" | 55 | 7 |
| 4 | 4" | 65 | 8 |

* Oxweld tip sizes.

### Cutting

Thin sheets of almost all metals may be cut with a tinsnips, but when cutting thicker pieces of ferrous metal, the torch is an indispensable aid. Non-ferrous metals cannot be severed with the cutting torch. These can be separated by melting but not with a normal cutting torch operation.

To use the heat of the torch for cutting metal, remove the welding head from the torch and replace it with the cutting attachment. Select the proper cutting tip and place it in the attachment. Tighten the connection nut by

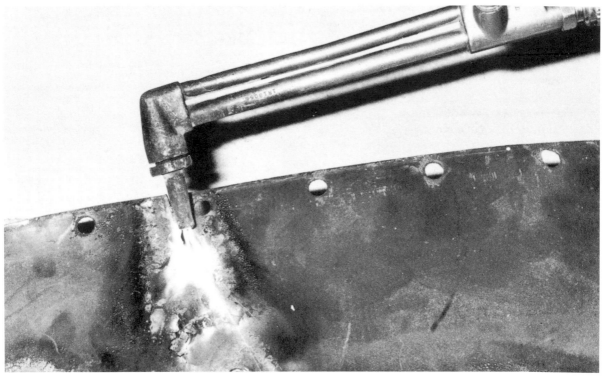

Cutting with the torch. The angle at which the torch is held determines the type of cut. If the torch is held vertically, a narrow vertical cut will result. If the torch is slanted, a beveled cut will result. The speed of the cutting is important. If you move the torch too quickly, you lose control of the line of the cut. Moving too slowly may cause the metal to re-fuse behind the torch. The slag that results is more resistant to heat and more difficult to recut.

hand. Next, open the torch oxygen valve and keep it open while you are cutting. Press the oxygen lever down, and adjust the oxygen pressure to the desired amount. Release the lever. Now adjust the acetylene to about 5 pounds pressure. To ignite, open the oxygen valve on the cutting attachment, then open the acetylene valve and strike the sparker. Readjust the acetylene pressure to 5 pounds. Now open the oxygen valve on the cutting attachment a full turn. Press down the lever, and adjust the flame to neutral with the acetylene valve.

With the neutral preheating flame, direct the torch on one spot of the metal where you wish to begin the cut. When the metal turns bright cherry red, depress the cutting lever *slowly*. When the cut has started, continue to move the torch in the direction you wish to cut. Take your time, and keep the tip out of the molten metal.

The principle of flame cutting involves a preheating of the metal to its kindling temperature and then rapidly oxidizing it with a jet stream of oxygen which leaves a narrow slot or *kerf* in the metal. The energy of the jet stream also washes away much of the molten metal which finishes the cut. This operation is rapid oxidizing which is basically what happens when

metal rusts, only much faster. The oxidized metal runs off in the form of "slag" (oxidized molten metal).

### Backfire and Flashback

The words "backfire" and "flashback" are commonly used and often misused. These two situations occur during oxyacetylene welding and should be understood. "Flashback" describes a phenomenon that exists when the flame flashes back into the mixing tube and sustains itself there. This can happen when the tip is kept in a confined space for too long, preventing the tip and the mixer from being cooled by air. A shrill hissing sound accompanies flashback. It can be extinguished by shutting off the oxygen because the flame cannot burn without it. If flashback occurs too often, it is possible that your torch is in need of repair.

"Backfire" is a loud "pop" or a rattle caused by any of these reasons: (1) shutting off the acetylene first and tnen the oxygen; (2) touching the work with the tip; (3) operating the torch at too low an acetylene pressure; (4) a loose tip; (5) dirt on the tip or head; (6) overheating the tip.

### Important Don'ts

1. Don't use oil or grease around apparatus.
2. Don't convert the oxygen regulator into an acetylene regulator.
3. Don't stand in front when opening cylinder valves.
4. Don't open acetylene cylinder valve more than one turn.
5. Don't test gas leaks with a flame. Use soap and water.
6. Don't force connections.
7. Don't neglect or ignore fire precautions.
8. Don't weld or cut without wearing goggles.
9. Don't do repair work on your equipment. That is dangerous. Send it back to your supplier.
10. Don't let sparks fly on the rubber hoses; they may burn. Hoses should be inspected regularly for leaks by immersing them in water. If bubbles appear, a leak exists, and the hose should be replaced.
11. Don't misuse your tools and equipment. They will serve a long time if properly cared for.

Good weld

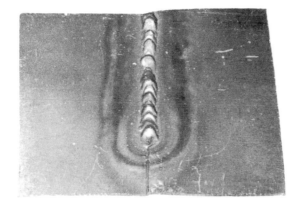

Bad weld

A good weld should be fused throughout the seam. The edges on the surface should be composed of small beadlike forms placed evenly, one next to another. There should be a minimum of waste, called slag, on the seam. The photo below illustrates the difference between the appearance of a good weld and a bad weld. A special "slag" hammer may be used to clean off excess slag.

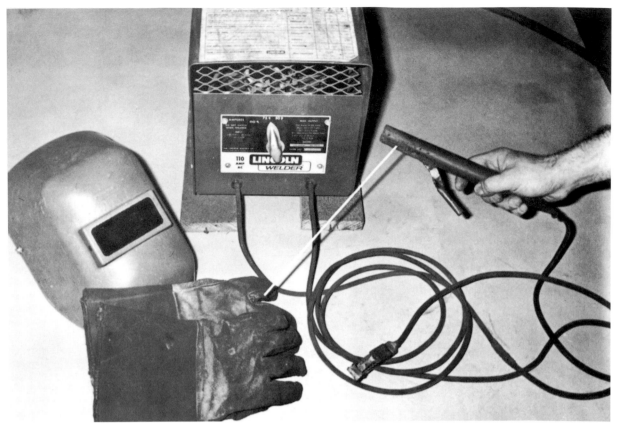

Arc welding equipment. Gloves, mask, electrode, generator.

Other Welding Methods

Oxyacetylene equipment is most widely used by sculptors today because it gives the kind of control normally required for most modeling. However, for various other advantages, the sculptor may also choose to weld with an electric arc welder or with inert gases like helium or argon. These units can achieve a deeper penetration and a faster welding speed, particularly on heavier metals. In arc welding, the intense heat is formed by an electric arc created between the electrode held by the operator and the metal. The arc melts the metal almost instantly, and fusion takes place by the movement of the electrode. Arc welding produces a more intense light, more sparks and infrared rays than in oxyacetylene welding. Therefore greater body protection and face shields are required. The goggles are much darker.

Inert gas welding is still used mainly for industrial purposes. The principle involves the use of the electric arc with an inert gas such as argon or helium. The gas actually pushes the air away from the joint, shielding it and thereby preventing oxidation. This transparent shield enables the operator to see the fusion zone and allows him to make neater and sounder welds. One advantage in inert gas welding is that with certain metals, aluminum for example, there is no need of flux, and fast, deep welds occur with more economy.

METHODS OF BUILDING UP WELDED FORMS

The different methods that sculptors use for building up forms by welding briefly include three basic approaches:
1. Constructing with rods to form a skeletal structure. The rods may be welded close

When two rods are welded together, some metal is lost in the process because they are both melted. Therefore, a steel welding rod is used to "fill in" this lost metal. It is melted along with the parent metal to keep the size of the joint uniform with the thickness of the original rods. The welding rod is always used when the thickness and strength of the joint should be consistent with the metal being welded. Welding rods are used with simple joints and in seam welding with sheet metal. Notice that the work is done on an asbestos board.

A rod may be attached to a piece of sheet metal. The rod, which is thicker, requires more heat so that fusion will take place quickly.

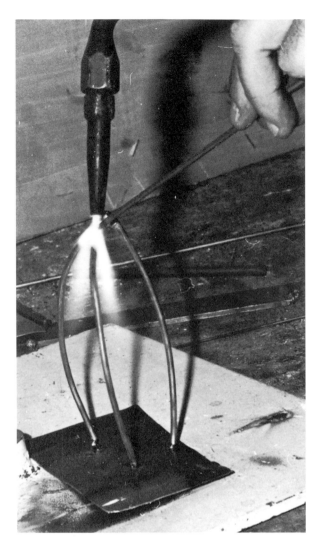

together to form a continuous surface texture unique to welded sculpture. Or they may be placed far apart to give an open feeling.

2. Constructing with sheet metal hammered and welded. This involves cutting out shapes with the welding torch and joining them along edges. Referred to as "seam welding," this technique may be compared to sewing fabrics where the patterns are cut out and seamed. Sometimes the metal flat shapes are hammered into rounded concave and convex forms first, and then joined by welding.

3. Using prefabricated shapes as in "junk" sculpture. Objects and parts of objects are welded together without changing their original shapes.

There are many variations and combinations of these techniques, depending upon the versatility and inventive thinking of the sculptor.

**HEATING, BENDING, JOINING.**
Heating the rods makes them pliable enough to be bent easily. The rods are fused to begin to form the volume of a piece of sculpture.

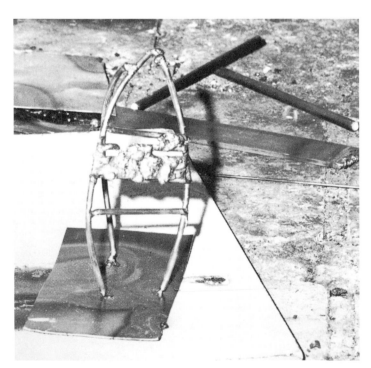

By fusing many rods closely together in one area, you begin to create a solid surface. Notice how a texture also begins. This entire area will be made solid, building up a basic structure of rods. Some of the rod structure may show through, or parts may be covered with sheet metal in the final piece.

Form continues to grow by additions of rod and sheet structure.

## CHART #2—WELDING AND BRAZING ROD DATA

| ROD NAME AND NUMBER (recommended) | PURPOSE AND QUALITIES |
|---|---|
| Oxweld #1 High-Test Steel | For welding steel. Resistant to shock, vibration, and corrosion. |
| Oxweld #7 Drawn Iron Rod | Welding iron or steel. Nearly pure iron. Free running, for metals not over ¼″ thick. |
| Oxweld #9 Cast-Iron Rod | Welding cast iron. Fine-grained and strong. Needs flux. |
| Oxweld #28 Columbium Bearing 18-8 Stainless Steel Rod | For welding stainless steel. Flux required. |
| Oxweld #14 Drawn Aluminium Rod | For welding pure aluminium. Flux required. |
| Oxweld #25 m Bronze Rod | For brazing ferrous and non-ferrous metals. For welding bronze, brass. High strength, resistance to wear, and running ease. Flux required. |
| Oxweld #19 Cupro Rod | Free flowing phosphor-bronze rod for copper. No flux required. |

These rods are available in diameters ranging from ⅟₁₆″ to ⅜″

## CHART #3—WELDING FLUX DATA

| FLUX | PURPOSE | USE |
|---|---|---|
| Brazo | To remove and prevent oxidation. | Brazing steel and cast iron. Fusion welding of brass, copper, bronze. |
| Ferro | Removes silicon dioxide which causes porosity. | Fusion welding of cast iron and cast steel. |
| Oxweld Aluminium | Reduces oxidation. | Fusion welding of aluminium and alloys. |
| Eutectic 190 | Reduces oxidation. | Soldering aluminium. |
| Cromaloy | Removes heavy oxides. | Fusion welding of high chromium alloys like stainless steel. |

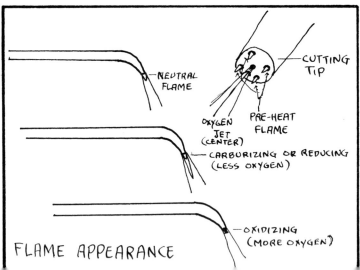

FLAME APPEARANCE

## CHART #4—WELDING, SOLDERING, AND BRAZING DATA
### FERROUS METALS

| METAL | SURFACE APPEARANCE (unfinished) | RECOMMENDED WELDING METHOD | HEAT SOURCE | OXYACETYLENE FLAME ADJUSTMENT | RECOMMENDED ROD | FLUX | MELTING POINT (approx.) |
|---|---|---|---|---|---|---|---|
| Ordinary Steel | Dark gray | Fusion | Oxyacet. | Neutral | Steel or iron | None | |
| | | Solder | Soldering Iron | Automatic | 50% lead or silver | Paste * Borax | 2700° F. |
| | | Braze | Air or oxy-acet. torch | Slightly oxidizing | Bronze rod | Brazo | |
| Stainless Steel | Bright gray | Fusion | Oxyacet. | Neutral | Stainless steel rod | Cromaloy | 2550° F. |
| Wrought Iron | Bright gray | Fusion | Oxyacet. | Neutral | High-test steel | None | 2800° F. |
| Cast Iron | Dark gray Surface shows texture from mold. | Fusion | Oxyacet. | Neutral | Cast iron | Ferro | 2100° F. |
| | | Braze | Oxyacet. | Slightly oxidizing | Bronze | Brazo | |

Soldering paste to be used for lead soldering and borax for silver soldering.

## CHART #5—WELDING, SOLDERING, AND BRAZING DATA NON-FERROUS METALS

| METAL | SURFACE APPEARANCE (unfinished) | RECOMMENDED WELDING METHOD | HEAT SOURCE | OXYACETYLENE FLAME ADJUSTMENT | RECOMMENDED ROD | FLUX | MELTING POINT (approx.) |
|---|---|---|---|---|---|---|---|
| Aluminium | White to bright gray | Fusion | Oxyacet. | Slightly carburizing | Aluminium | Ox-weld aluminium | |
| | | Braze | Oxyacet. | Slightly oxidizing | Aluminium | Eutectic 190 | 1200° F. |
| Brass | Red to yellow smooth | Fusion | Oxyacet. | Oxidizing | Bronze | Brazo | |
| | | Braze | Oxyacet. | Slightly oxidizing | Bronze | Brazo | 1700° F. |
| Bronze | Red to yellow smooth | Fusion | Oxyacet. | Neutral | Bronze | Brazo | |
| | | Braze | Oxyacet. | Slightly oxidizing | Bronze | Brazo | 1600° F. |
| Copper | Degrees of reddish brown to green | Fusion | Oxyacet. | Neutral | Copper | None | |
| | | Braze | Oxyacet. | Slightly oxidizing | Phos-copper | None | 2000° F. |
| Lead | White to gray, velvety and smooth | Fusion | Soldering iron | Automatic | | | |
| | | Fusion | Air or oxy-acct. | Neutral | Same as base metal | None | 600° F. |

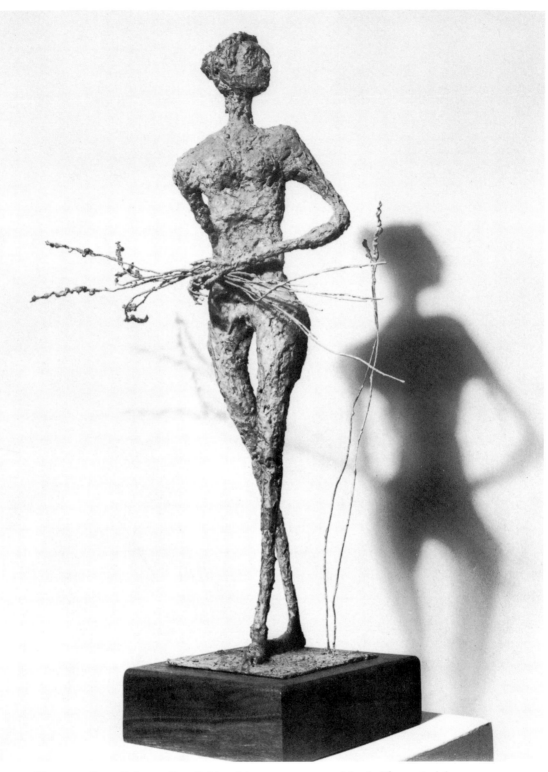

HARVEST. Jean Schonwalter. Soldered brass, copper, and lead. The materials were over-
laid to build up a form using the soft soldering technique with the heat of a flame rather
than a soldering iron.

*Courtesy, Cober Gallery, Inc., New York*

# Soldering and Brazing

From wire bending, it's a simple step to working with sheets of brass, copper, bronze, and other thin metals. Anyone can shape such metals with only a pair of pliers. The metals may be joined by bolting, screwing, slotting, or folding them one into another. But sculptures can be made more permanent by fusing the joint with heat, a method which becomes a more challenging art medium.

Soldering and brazing utilize a minimum of heat. They may be used on a great variety of metals that tend to melt too rapidly from the more intense heat produced by a welding torch. The materials required are inexpensive and as easy to use in a home workshop as in an artist's studio.

You can permanently join two pieces of relatively thin metal by melting down another metal (solder). The melted solder flows onto the pieces to be joined, hardens, and fuses them together. The method is much like using glue to put together two pieces of cardboard.

The solder always melts at a lower temperature than the metals which are being joined.

Soldering and brazing are also valuable for coating other metal surfaces to obtain different colors and textures. The coating tends to make the base metal more durable because it retards or prevents corrosion. However, the heat of the soldering iron or the air-acetylene torch (used in brazing) is not hot enough to cut or shape metal as in a welding procedure.

There are two types of soldering procedures: (1) soft soldering, and (2) hard soldering, which is also called silver soldering.

In soft soldering, a solder of lead and tin is used that has a low melting point between 400° and 700° F. Hard soldering requires a silver solder that melts at temperatures ranging from 1160° to 1500° F. In both cases, the solder fills the space between the two pieces to be joined and thus holds them together. Often the solder joint is stronger than the base metal.

Brazing is also a form of hard soldering.

A brazing rod, also called a braze filler rod, is used for fusing. The brazing rods also melt at a lower temperature than the metals to be joined. They are made in several alloys for use with different metals. The melted rod flows into the joint and hardens as it cools, thereby creating the fusion. Brazing is sometimes confused with braze welding, where the joints of the parent metal as well as the filler rod are in a molten form. Brazing lacks the deep penetration that welding has; it relies on the adhesion and strength of the filler material. Brazing is preferable to soldering when a stronger, more durable joint is required.

## SOFT SOLDERING

There are two basic soft soldering techniques. One uses the heat of the electric soldering iron; the other uses an air-acetylene torch. The soldering iron has a tip which heats up. When the tip is applied to the solder, the solder melts but the parent metals do not. Only lead and tin solder have a low enough melting point for use with the solder iron. All other metals require a flame.

The air-acetylene torch is an instrument which combines air and acetylene gas to create a flame which is emitted from a torch or blowpipe. Only a compressed acetylene gas tank is required because the unit uses the air which comes through the torch tip to combine with the gas. This unit cannot generate a flame with the intensity of heat that a combination of oxygen and acetylene produces, but the heat that is generated is sufficient for any soldering or brazing operation.

There are five important points to remember for good soldering, whether you use the soldering iron or the torch.

1. A clean hot source of heat. Be sure the soldering iron tip is free from grease. The flame should be properly adjusted so no carbon deposits appear.
2. Clean metal surfaces.
3. Proper flux and solder for the metals being joined.
4. Careful heating so the solder will flow and not set too quickly.
5. Deep penetration of solder into the joint.

The most commonly used soft solder is an alloy of equal parts of tin and lead. It is called 50-50 or "half and half." Its melting point is lower than either tin or lead, and it is satisfactory for most soldering jobs. There are other commonly used solders. While 50-50 melts at between 360° and 420° F., other solders melt at different temperatures and are used for different purposes. Combinations of lead, tin, and cadmium are used on pewter and other readily fused materials. On electrical parts, an alloy of 95 percent tin and 5 percent antimony is used. If soldering parts will touch food and beverages, 100 percent tin, which melts between 450° and 575° F., is used.

All metal which is to be soldered must be cleaned with materials like a wire brush, steel wool, or emery cloth. These remove all grease and other impurities which would prevent the solder from fusing. After cleaning, the metal must have a flux applied. Flux is a combination of chemicals which, when applied to metal, prevents oxides from forming on the surface during heating. Flux expedites the flow and fusion of the solder to the metals. Acid fluxes can be harmful to the body or clothes and should be cautiously handled. When not in use, acid flux should be stored in capped containers and bottles.

Soldering paste, available in any hardware store, is not as corrosive as acid flux and is easier to apply. The solder is also available at hardware stores in solid bars, solid wires, hol-

### SOFT-SOLDERING MATERIALS

For soft-soldering with an iron, you will need steel wool and emery cloth for cleaning the metal; soldering paste, which is a fluxing agent; soft lead solder, solder with a resin core, or soft-solder flux liquid and a soldering iron.

For soldering with a flame you need an oxy-acetylene torch as well as the abrasive materials for cleaning, solder, and flux. A small propane tank would also be sufficient.

Experiment with thin-gauge metal shapes such as these when you first begin to solder. These shapes of steel were joined by using lead solder and a soldering iron.

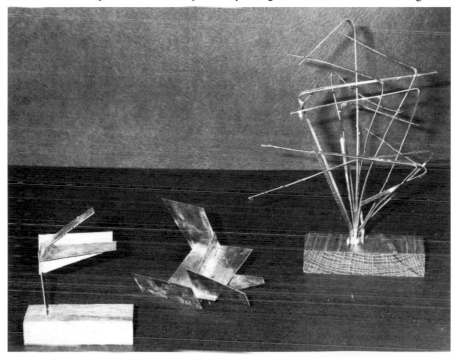

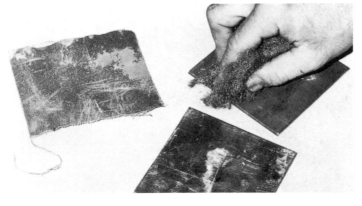

Clean the metal thoroughly, using an abrasive material such as steel wool or emery cloth. Metal should be lightweight steel, copper, brass, tin, etc. Heavy metals are not adaptable to this soldering method.

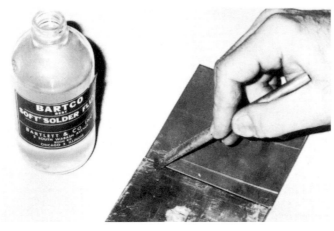

Apply flux to the joint with a brush. Either paste or liquid may be used.

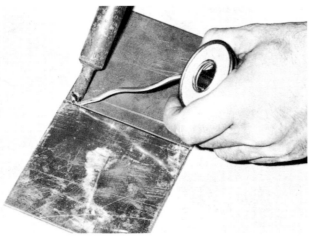

Dip the hot iron point into the flux if only a small portion of the joint is to be covered. Apply some solder to the fluxed point until it begins to flow. Then move the solder and hot iron along the joint slowly until the solder flows easily off the iron onto the joint. To remove flux after brazing, wash off in a solution of vinegar and water.

A small section may be attached to a larger shape by applying solder in the same way as you do to join two pieces of metal together. More heat should be applied to the heavier portions of the metal and less heat to the thinner portions.

low wires filled with flux, or in ribbon form. The shape chosen depends on the ease of handling in the individual job. Zinc chloride is a good general flux for soldering tinplate, copper, brass, lead, stainless steel, Monel, and nickel. Muriatic acid is used for galvanized iron and zinc. It is highly corrosive, so should be used sparingly. Sal ammoniac is a good flux for plain steel, cast iron, copper, and brass and can be bought at drug and hardware stores. Resin is a mild and non-corrosive flux which is used for tin, brass, copper, and lead.

The materials and techniques for soft soldering are illustrated on pages 53 and 54. Basically this is the procedure: allow the iron to heat up until a small bead of solder melts when it touches the tip. If solder doesn't flow, there may not be enough heat or flux on the iron. Too much heat will make the solder ball up and bounce around, thus preventing its flow. The amount of heat needed depends on the thickness of the parent metal and the size of the iron. Use plenty of flux when soldering; it helps to create a good joint. Always check to be sure you have the correct solder and flux for the type of metal to be soldered. The flux may be put on the tip of the iron and/or the materials to be soldered.

The procedure for flame soldering (soft) is similar to that described in soldering with an iron. As soon as the metal is cleaned with the abrasive material, apply plenty of flux to the area to be soldered. Next, play the flame over the area for a few seconds. Then reapply the flux and heat again. Apply solder to the area and let it melt into the joint from the heat of the metal—not the flame. If you use plain solder without a flux core, then dip the solder bar into flux before touching it to the hot metal.

To learn the soft-solder technique, the beginner would do well to cut out shapes of thin-gauge sheet metal (between 18- and 32-gauge) of copper, brass, or steel. Wire made of the

same metals in a variety of thicknesses may also be soft-soldered. Certain common metals cannot be soldered without special rods. Aluminum, for example, requires an aluminum rod and special flux for soldering. Experimentation with each technique by soldering small pieces of material together will give the beginner an idea of how more extensive and challenging forms can be created in sculpture. For further information, see Chapter 2, chart on rod and brazing data.

## HARD SOLDERING OR SILVER SOLDERING

Hard soldering requires about twice as much heat as soft soldering. A coil of silver solder is used as the joining agent. It flows into small parts easily, which makes this operation a favorite among silversmiths and in some industrial procedures where close-tolerance soldering is required. Any air-gas unit is satisfactory unless the metal is rather thick; then the oxyacetylene torch may be more efficient. The novice sculptor will find inexpensive portable torches available at most hardware stores.

The procedure for silver soldering is similar to soft soldering:

1. Clean the parts of the metals and flux carefully.
2. Heat the joint, using a soft flame which moves evenly around the area to be joined. Spread the heat over the entire joint.
3. Flux the wire, and apply it to the metal when the metal has turned a dull red. The wire will melt quickly and flow to all the cleaned and fluxed parts. The less solder used, the stronger the joint will be.

It is important to heat the parts just enough so that the heat of the metal, not the flame, will cause the silver solder to melt and

to flow evenly and deeply into the joint. The solder will ball up if there is not enough heat and will burn up if the torch is applied directly to it. The solders used are various compositions composed of silver, copper, and zinc in various percentages. The most commonly used are silver 45–50 percent, copper 30–35 percent, and zinc 15–25 percent. When silver is used in greater quantities than these alloys, the solder becomes yellow in color and is often used for brass or copper. When the silver in the alloy ranges from 45–65 percent, the color is white and is preferred by most silversmiths for this reason. The lower-content silver alloy also has a lower melting point which is between 1280° and 1325° F. as opposed to the yellow solder which flows at about 1500° F.

Cleanliness and good fluxing are important. Although there are a number of good fluxes on the market, you can make your own by dissolving common borax in hot water until it makes a pasty solution.

The success of Konstantin Milonadis rests partially on the ease, patience, and confidence he exhibits in his work. He uses stainless steel wire in many gauges. The shapes are silver-soldered with flame. Milonadis uses a propane gas and oxygen unit which is capable of soldering, brazing, and welding. Most of his work is done with very fine tips to offer better control in soldering work. Owing to the difficulty of handling the fine, delicate music wire and stainless wire, he has devised many ingenious clamps made out of surgical instruments.

Examples of hard-soldered forms by students of the Institute of Design, I.I.T. These shapes are based on a repetitive module form. Each section is soldered or brazed to another to create a total shape which is dissimilar to the original module.

*Ray Pearson, Instructor*

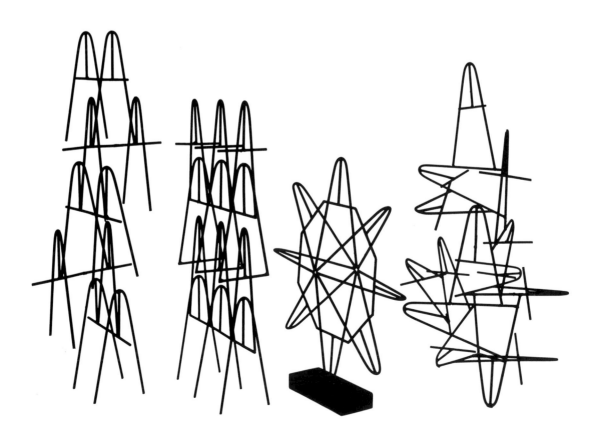

[]

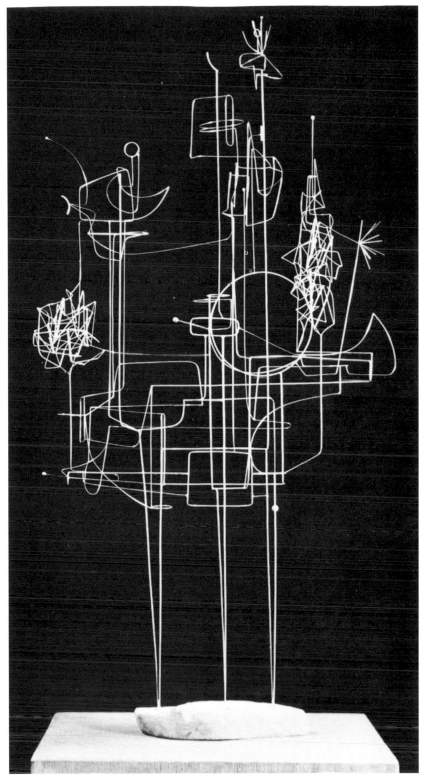

RUNE. Konstantin Milonadis. 1965. Stainless steel. The constantly flowing movement is not marred by obtrusive joints. The fusion becomes an integral part of the flow. The color of the joints matches the color of the metal. The technique is flawless, and the hard work and patience required belie the spontaneous appearance.

*Collection, Mr. and Mrs. B. Kowalsky, Chicago*

Stainless steel wire is hung from hooks on a rack in Milonadis' small studio. His "workbench" is simply an old wooden table. His work is testimony to the fact that it is not the materials or the studio that makes the sculpture—it is the material in the hands of the sculptor that brings out the potential forces.

Each form is as durable as it is delicate-looking. Milonadis bounced these forms on the floor to prove their strength. These finished sections will later be soldered together to create the final sculpture.

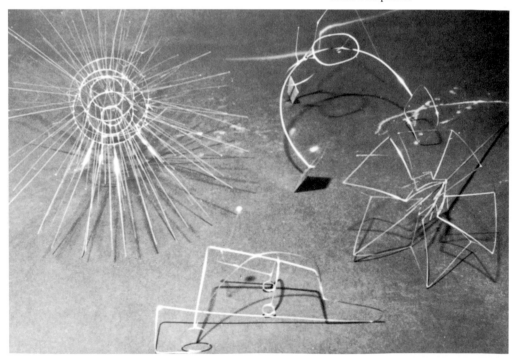

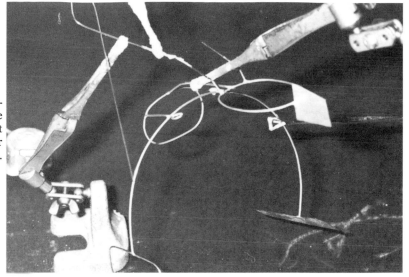

Milonadis uses this method to create his sculpture. Parts which are to be soldered together are first clamped into place using either jeweler's clamps or surgical clamps.

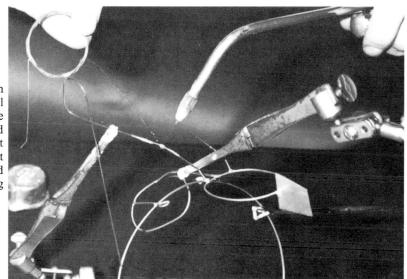

After the pieces are fluxed with either all-purpose or stainless steel flux, joining takes place with the application of the silver solder and the heat of the torch. Notice that the torch heats the joint and not the solder. Pieces are then cleaned in a solution of water and baking soda.

Finishing includes filing joints until they are smooth and unnoticeable.

*Photo Series, Dona Meilach*

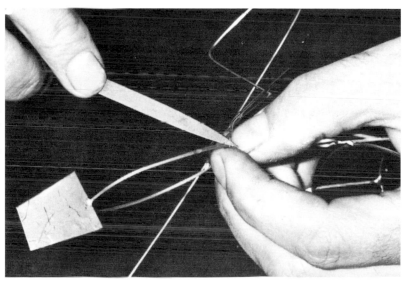

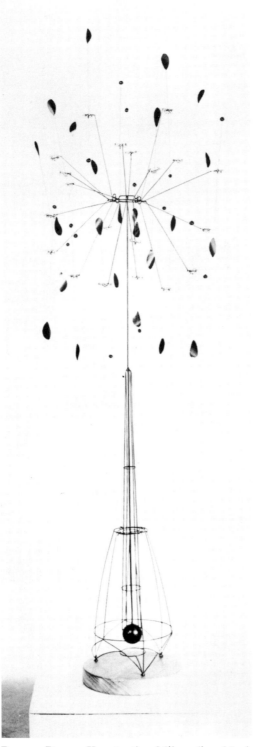

BERRY BUSH. Konstantin Milonadis. Music wire and glass.

*Collection, Mr. and Mrs. Howard G. Haas, Glencoe, Ill.*

QUEEN OF CHESS. Konstantin Milonadis. Music wire.

*Courtesy of the artist*

JEWELRY. Robert Pierron. Pins and pendants are frankly decorative and beautifully crafted. They have been formed from sterling silver sheet, sawed and hammered.

BROOCH. Nita Lustig Platosh. Shapes are stamped from sheets of sterling, then designed into the brooch by adding and building up more shapes. The edges of the silver are textured by melting them down slightly.

Many artists who work with silver solder make jewelry as well as sculpture. It is simply a matter of moving one's materials and knowledge to a different statement that can be as original and pleasing as a free-standing piece of art. Robert Pierron demonstrates his technique for making jewelry. The heat source used is a Prestolite acetylene and air-mix tank and torch with a variety of tip sizes; small for fine work but generally Nos. 1, 3, 4, and 5.

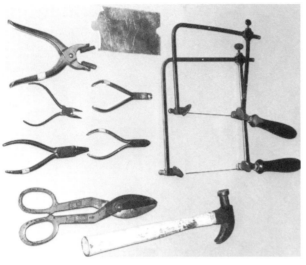

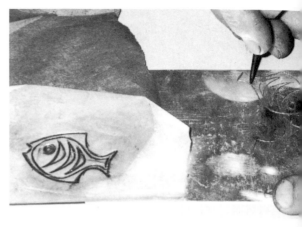

Scribe and trace the design onto the metal, using a sharp instrument.

Other tools are: small jeweler's saw with a 2-0 blade. Large saw, #4 blade. Sheet of sterling silver, riveting pliers for findings, wire snips, tin shears, hammer, round-nose and flat-nose pliers.

Secure metal on a bench pin or in a vise, and saw the design with a jeweler's saw; in this case a #1 blade on 18-gauge metal.

The piece to be shaped is placed into a depressed block of wood. It is gently shaped with a tapper to produce a curve in the metal which corresponds to the depression in the wood. This is called "dapping."

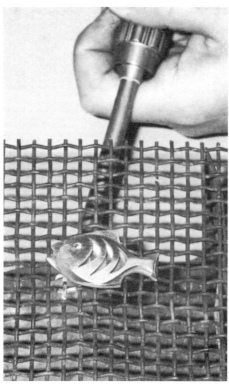

Two separate shapes are soldered together. Small pieces of solder called "pillets" are placed on the fluxed surface and then melted down from the heat of the torch placed under the screen.

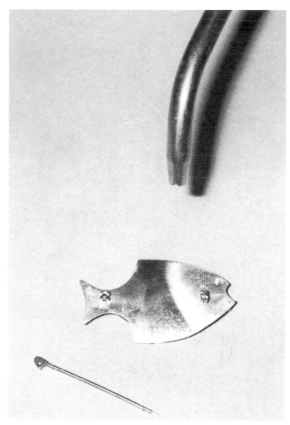

The findings (in this case a pin) are then soldered into place. The finest tip of the torch is used.

The pin is cleaned and buffed for polished appearance.

The finished piece of jewelry.
*Photo series, Dona Meilach*

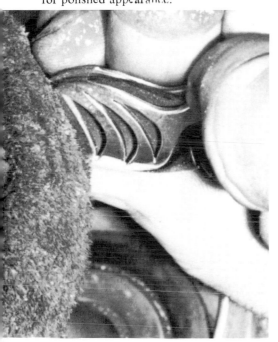

64                                    SOLDERING AND BRAZING

EARRINGS. Nita Lustig Platosh.
Silver-soldered, brazed with gold.

When jeweler Nita Lustig Platosh stamps
shapes from a sheet of silver, she has many
scraps left over that have interesting possibili-
ties for the creative mind. She utilizes these
scraps to build up a sculpture that has all the
appearance of the skeleton of a large sky-
scraper.

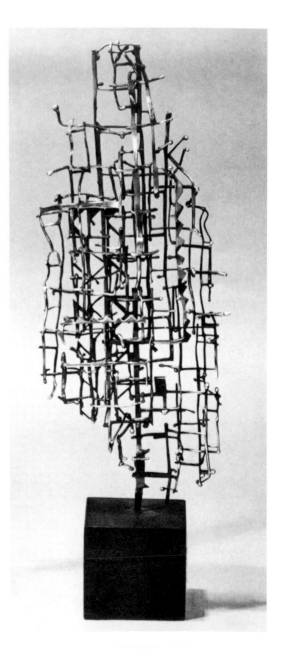

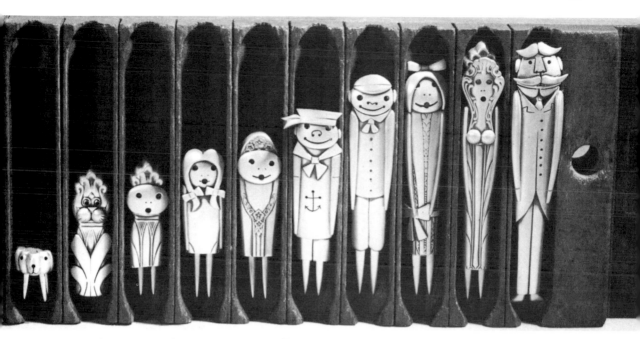

THE CIGAR MAKER'S FAMILY. Robert Pierron. 1965. An old wooden cigar mold contains the "cigar maker's family" made from pieces of sterling silverware such as knives, forks, and spoons. Each figure is ingeniously crafted, and the humor and wit are evident.

FIVE KNIGHTS. Robert Pierron. 1965. Silver that was poured into lost-wax molds and then designed, soldered, mounted, and polished. Old fork tines were used for the knights' legs.

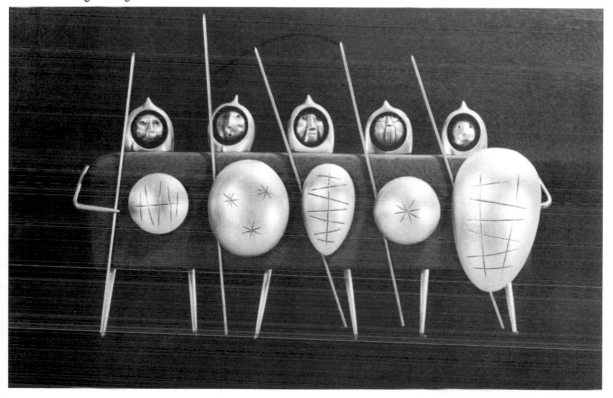

ADOLESCENT SHISHKABOB. Robert Pierron. 1965. A humorous comment on the conformity of this group, which combines characteristic expressions on each face—individuals attached on a skewer.

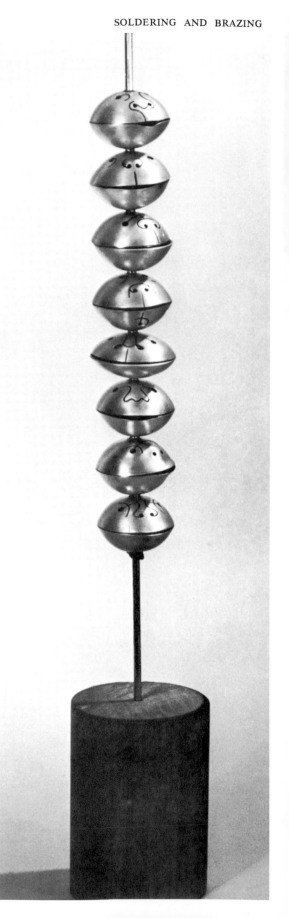

THREE SOUNDS. Tom Kapsalis. 1964. Stainless steel industrial findings assembled into a sculptural arrangement.

*Courtesy of the artist*

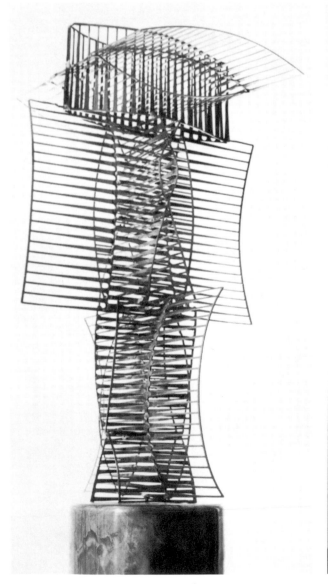

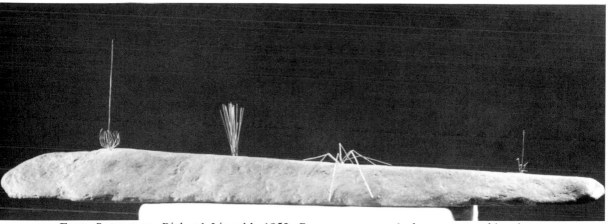

Four Seedlings. Richard Lippold. 1952. Brass, copper, and chrome are soldered to create a sculpture that contrasts the metal forms with the stone base.

*Courtesy, Willard Gallery, New York*

Early Bird. Robert Pierron. 1965. An upside-down sterling silver loving cup and fork tines create the simple imagery. The finely finished work attests to the capability of the artist in terms of his material.

Three Who Watch. Ruth Pennington. The silversmith often works with utilitarian forms as shown by this well-designed candlestick of silver with enameled shapes.

*Courtesy, Cooper Union Museum, New York*

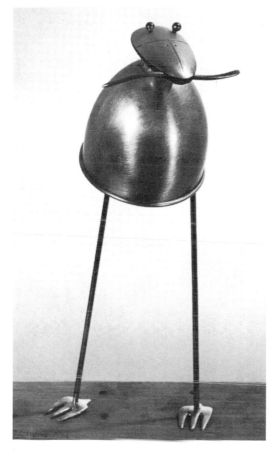

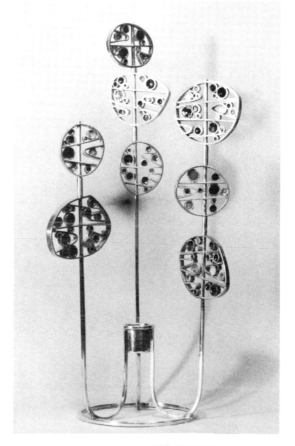

## BRAZING

Brazing is another type of hard-soldering operation. It is used for fusing joints and for coating surfaces. However, in brazing, the fusing metal is not silver solder. Bronze, copper, aluminum, or other alloys are used, depending on the metals to be joined. The amount of heat necessary for any job is one of the determining factors in selecting the proper rod for the work. All the hard solders melt at temperatures below 2500° F. Silver melts between 1280° and 1500° F. Bronze rod melts at about 1600° F.; copper at about 1400° F.; and all other rods used for brazing purposes will melt below 2500° F. Other factors that determine the type of rod to use are color, strength, and flow.

Sculptor Harry Bertoia works on a screen which is a major feature of the Manufacturers Hanover Trust Company's office in New York City. Bertoia is coating and joining rods using the brazing technique.

Bertoia also joins sheet metal by brazing. The molten metal is pulled along by the heat of the torch and thus tins or coats the base metal. Welding rods are seen in the foreground.
*Courtesy, Manufacturers Hanover Trust Company*

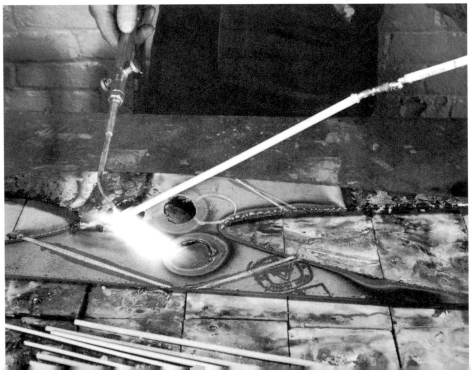

Heat the end of the rod, and dip it into the flux.

For brazing, you must clean the areas to be joined thoroughly with emery cloth or some other abrasive. The flux, torch, and bronze rod are necessary for brazing steel.

The air-acetylene torch is ideal for any work ranging up to 2500° of heat. The additional heat produced by an oxyacetylene torch may be necessary only when the metals to be brazed are quite thick.

Brazing rods for each metal come in various lengths and thicknesses. The size of the rod used is determined by the thickness of the metal to be joined. The heavier the parent metal, the larger the rod. Some rods can be purchased with a flux coating, and the others are plain and must be dipped in flux before brazing. All brazing rods may be ordered from any welder's supply house.

The bronze rod is most commonly used for joining, since it is probably the most versatile and creates a very strong joint. The bronze rod can be used on steel, copper, brass, and cast iron but not with aluminum.

Brazing, sometimes referred to as bronze welding because of the use of the bronze rod, is similar to soldering techniques. Prepare the metal for brazing by cleaning the area to be joined with a wire brush, emery cloth, steel wool, or other abrasive. Cleaning is essential, since the braze will not flow over surfaces that are greasy or coated with impurities. The met-

Heat the area to be joined until it is a dark cherry-red color. Place the heated, flux-coated tip of the rod onto the parent steel, and move it slowly along the joint. The flame should be directed on the parent metal—not on the bronze rod. The rod melts as a result of the action of the heat from the metal.

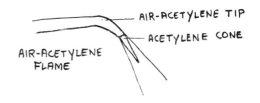

This is the flame used for brazing. The flame does not contain an inner cone as in oxy-acetylene flame and is not suitable for welding. It is used only for soldering and brazing.

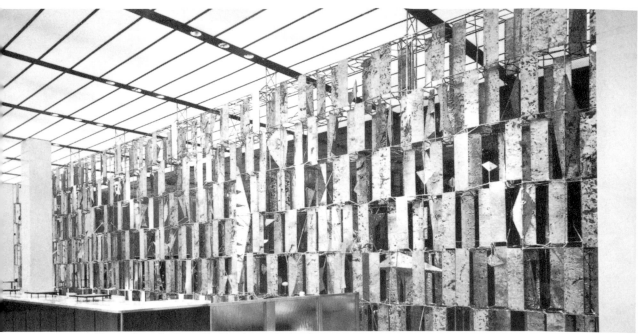

SCREEN. Harry Bertoia. Installed in the main banking room of the Manufacturers Hanover Trust Company, New York.

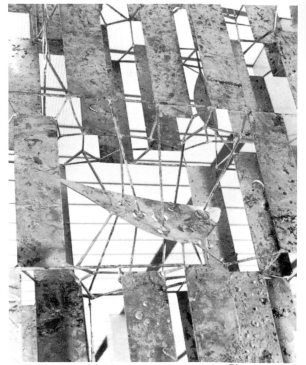

Close-up.

als to be joined should be placed in a clamp device or propped to keep them from coming apart.

The proper flame for brazing is automatically produced in the air-acetylene torch because the mixer in the torch stem determines the correct amount of air and gas. If the oxy-acetylene torch is used the flame must be adjusted so there is an excess of acetylene (see page 48). The blue flame that comes off the tip should be about two to three inches long. Now heat the end of a brazing rod and dip it into the flux until about two inches of the end is coated (unless it's a precoated rod). The heated rod will cause the flux to stick to it. Be sure to use the proper flux for the rod you are using: aluminum flux for aluminum rods, bronze flux for bronze rods, etc.

Now the metal is ready to be heated. Direct the flame onto the joint, and when the area to be fused turns a cherry red all around the joint, you are ready to braze. Place the flux-coated rod on the metal at the joint, and allow the heat of the metal to melt the rod. Keep the flame *near* but *not on* the rod. The molten bronze will follow the heat of the flame and can thus be pulled along a seam or directed into a joint.

Chicago sculptor Eldon Danhausen demonstrates the complete construction of a nine-foot sculpture crafted from copper and brazed.

Materials used are:
Anvil. Used for shaping and hammering copper pieces.
Ball peen hammer.
Shapers—used to hammer over and create concave shapes. These shapes are placed under or over the metal.
Metal snips.
Various types of pliers.
Sheet copper.

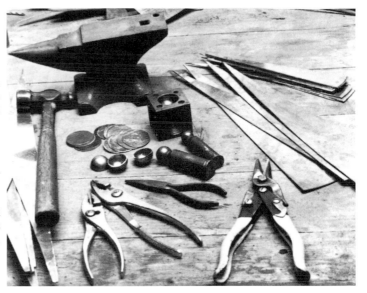

The copper is cut with snips after first being scored with any sharp instrument. If the metal tends to curl, it must be hammered flat so you can work on it.

The metal is shaped over the anvil using a ball peen hammer. Copper is extremely malleable. After it is hammered it becomes brittle and must be annealed. Annealing is done by heating the metal frequently to keep it soft. You use a soft flame on the torch or any other heat supply.

Half balls of copper are shaped from the circles. A circle is placed in the concave area of the shaper. The ball end instrument is placed over the circle, then tapped with the hammer, resulting in the half rounds. They will be fused to form the heads of the figures.

A phos-copper rod is used to fuse the pieces of copper. This is a brazing technique. Phos-copper has copper in it, thereby making the whole unit one color except for the many areas purposely allowed to discolor from the heat.

Male and female figures will later be assembled into the large composition.

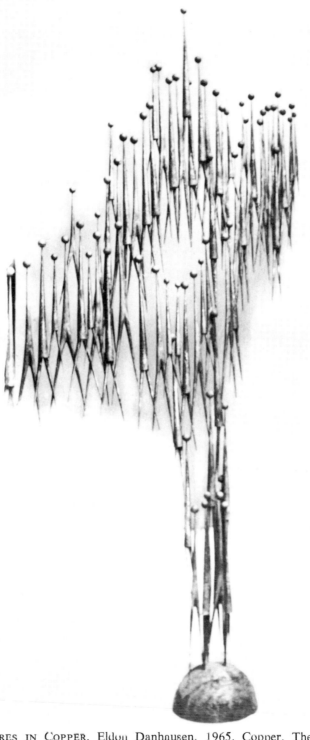

FIGURES IN COPPER. Eldon Danhausen. 1965. Copper. The figures
unite to form a nine-foot sculpture which uses a repetitive and sym-
bolic form—male and female. The observer is aware of the general
silhouette from all views. The awareness that each form is a figure
becomes secondary to the effect created by the entire sculpture. Beauti-
ful nuances of blues and greens are mixed with the copper color and
result in a warm, expressive creation.

*Photo series, Dona Meilach*

Brazing requires a little more technical skill than soldering. The proper amount of heat on the metal is important to good brazing. If the metal is too hot, the braze will bubble and roll around like water on a hot griddle. If the flame is too cool and the metal not hot enough, then the braze may ball up and not melt at all. Balling may also occur if the metal is not clean or if the torch flame is placed directly on the rod rather than on the metal. After brazing, the flux may be cleaned off with a wire brush or file.

Remember these points for good brazing:

1. Clean the metal thoroughly.
2. Don't melt the parent metal.
3. Keep the molten bronze moving around the joint.
4. See that the metal is not too hot or too cool.
5. For seam brazing or to coat the metal, dip the rod into the flux frequently.

Aluminum is a difficult metal to braze, since it doesn't show a change in color when

EVOLVING FORM. Italo Scanga. 1962. Copper has been cut, hammered, and joined with oxyacetylene heat and a phosphorous alloy for brazing. The brazing is simply used for joining and does not form an esthetic part of the sculpture.
*Courtesy, Devorah Sherman Gallery, Chicago*

heated and often will suddenly collapse if it is overheated. It must generally be backed up or supported when brazing to prevent it from collapsing. The flux used with aluminum is corrosive and must be washed from the joint after brazing. The method for joining is much like brazing with bronze rods. Make a light paste of aluminum flux and water. Paint this on the joint and on the rod. Take care to avoid contact with the skin and eyes, since this flux can be irritating. The flame of the torch should have excess oxygen. To determine how hot the metal is before applying the rod, use a piece of blue carpenter's chalk on the joint. When the chalk turns white, then the aluminum is hot enough to braze.

When brazing copper, the recommended rod is a phos-copper alloy. The 90 percent copper content makes it ideal for use on copper, brass, and bronze without the use of a flux. Phos-copper rods are less expensive than silver solders and melt at relatively low temperatures between 1350° and 1400° F. The method for joining is the same as the brazing technique described above except that no flux is necessary with this rod.

However, when fluxes are necessary in brazing operations, they are of the utmost importance. The characteristics of the metals involved as well as the materials in the flux are highly specialized areas. Fluxes are used: (1) to prevent oxidation; (2) to remove oxides

DENSITY IN RED. Ibram Lassaw. 1964. Copper can be treated in a variety of ways and given many surface textures. Copper sheet has been partly melted to give the form a purposeful crudity and openness.

*Courtesy, Kootz Gallery, New York*

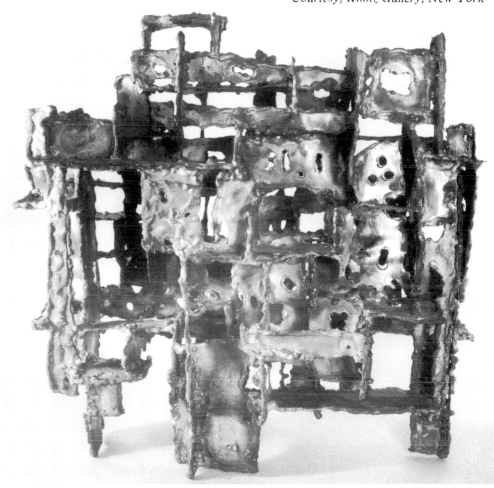

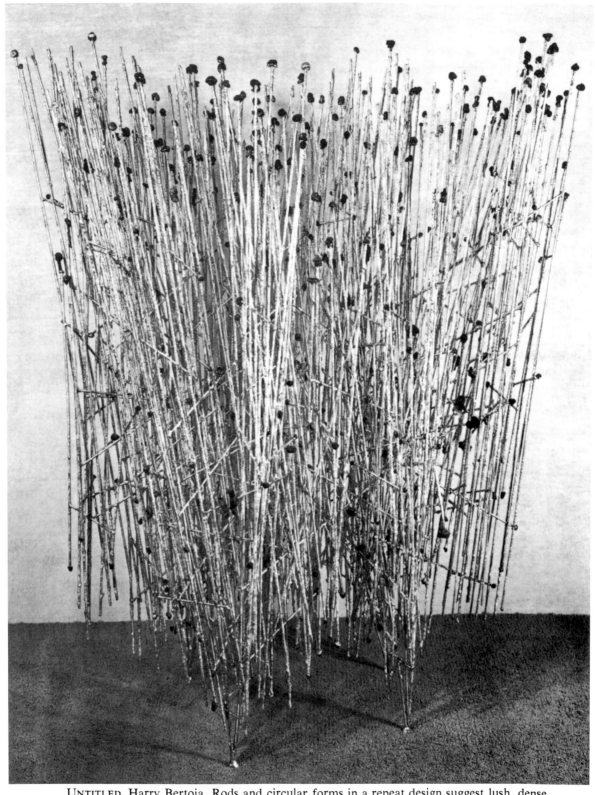

UNTITLED. Harry Bertoia. Rods and circular forms in a repeat design suggest lush, dense texture. The visual effect is like peering through tall grass.

*Courtesy, Staempfli Gallery, New York, Collection, Peter Gimpel, London*

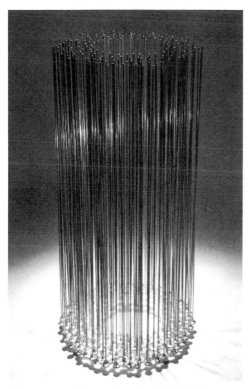

UNTITLED. Harry Bertoia. 1960. Copper, nickel, and brass.
*Courtesy, Chase Manhattan Bank, New York*

GOLDEN PRINCESS #1. Richard Lippold. 1953. Gold.
*Courtesy, Willard Gallery, New York, Collection, Tiana Lippold*

formed during the brazing; and (3) to remove other impurities. Not all fluxes are required to do all these things, but the proper flux for the proper job will ensure good results.

Be sure to consult the chart in Chapter 2 for the proper rods and fluxes to use when brazing.

Rods and wires can be joined by brazing to create an infinite variety of visual effects. The engineering method becomes an integral part of the form, and not noticed for its own sake.

METEOR. Richard Lippold. 1955. Gold and stainless-steel wire.
*Courtesy, Willard Gallery, New York, Collection, Lawrence Fleischman*

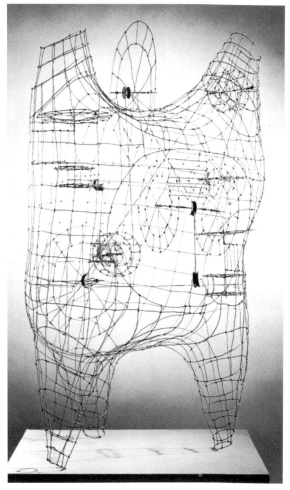

TORSO. Harry Kramer. 1964. Wire construction. Through expert manipulation of open shapes, an illusion of solidity and volume is achieved. The negative shapes become almost positive and suggest a weight and stability beyond what the material and techniques would normally imply.

*Courtesy, Tate Gallery, London*

SMALL SCREW MOBILE. Kenneth Martin. Brass and steel. When this mobile is revolved, the viewer becomes visually involved. The bars are placed so carefully that they form a cohesive, almost solid appearance when the sculpture turns about.

*Courtesy, Tate Gallery, London*

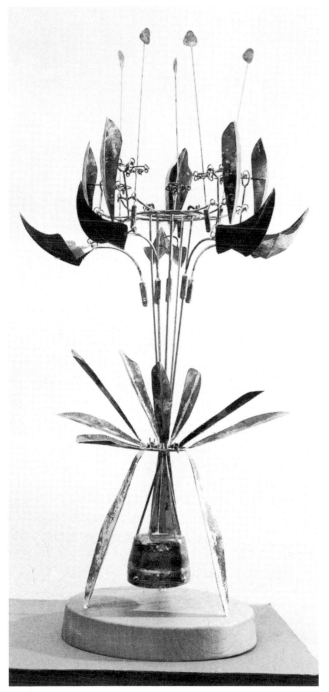

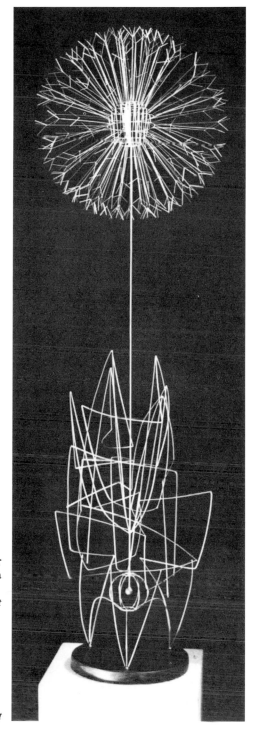

MAGNOLIA. Konstantin Milonadis. Brass. This moving flower form is compatible with nature. It might be considered a romanticized, idealized symbol of a natural form.

*Courtesy of the artist*

DANDELION. Konstantin Milonadis. Stainless steel.

*Courtesy of the artist*

# Welded Iron and Steel Sculptures (Ferrous Metals)

### WELDING IRON AND STEEL

Steel is most often used for welded sculptures. It is low in cost, available, and easy to handle. It reacts almost humbly to the heat of the torch, so the artist can impose his will on the material. Iron is also a favorite but not quite as easily available as steel.

A quick glance at the technical information in Chapter 2 will familiarize you with the important properties of the three kinds of iron: pig iron, cast iron, and wrought iron, and the many ways they may be treated with the oxyacetylene torch. It's a good idea to experiment with small sculptures while you become familiar with metals and their reactions to heat. When you have the technical aspects mastered, then you can begin to engineer your constructions.

There are three basic types of steel: carbon, alloy, and tool steels, which are sometimes difficult to differentiate in a finished sculpture. As you delve more deeply into the technical aspects, you will want to work with the many steel alloys to learn their potentials.

Actually, the grade of steel or iron is not as important to the artist as to the manufacturer. The manufacturer must be concerned with performance and durability if he is making a machined part or tool that is subjected to wear and tear. The sculptor usually selects his material with these considerations in mind:

1. Does the material have good esthetic possibilities such as inherent shape, texture, and color?
2. Is it workable and practical to handle? Can it be hammered, shaped, and welded easily?
3. Where will the sculpture be placed? If outdoors, the material must tolerate various weather conditions. Can the material be maintained and still retain its original appearance several years after it was created?
4. Does the cost make the project feasible?
5. Is the material easily accessible?

The artist is free to experiment with any materials that suit these considerations. He may buy new metal from various suppliers. He may scan junkyards for suitable scrap metal. He

may use heavy shapes of iron or steel, sheets or rods, or any combinations. Restrictions are imposed only by the workability of the material, the function of the torch, and the imagination of the artist.

As the artist approaches his materials, he knows that his experiences with them are physical, visual, and intellectual. The creation of a sculpture begins simply by selecting a piece of material that has no function—that simply exists. By bending that material and shaping it to a form that pleases him for some reason, it becomes an object of meaning. The moment he picks up that material he begins to plan, to choose, to direct the course of action he will take. The actual physical work of creating a sculpture involves constant decision-making. The artist selects what is essential and eliminates what is non-essential. His sculpture grows as he constantly selects that which is important

and arrives at and discovers the meaning of simplicity and good form.

Remember that working with a torch is safe, providing all the safety precautions are rigidly enforced. Be sure to review the use of the oxyacetylene torch in Chapter 2 before proceeding.

Fusion of iron and steel may be accomplished by welding with the oxyacetylene torch mainly. In some instances, the air-acetylene torch may be used along with soldering and brazing methods. However, oxyacetylene has the advantages of producing stronger joints and obtaining colors at the joints that are consistent with the metal. There is less propping and clamping necessary. Heavier metals can be joined because more heat can be produced in welding. More versatile forms can be created along with greater texture possibilities. Cutting and modeling are also possible.

Students at the School of the Art Institute of Chicago use the cutting tip of a torch for this thick piece of steel. Cutting metal this size with a torch takes only a few seconds.

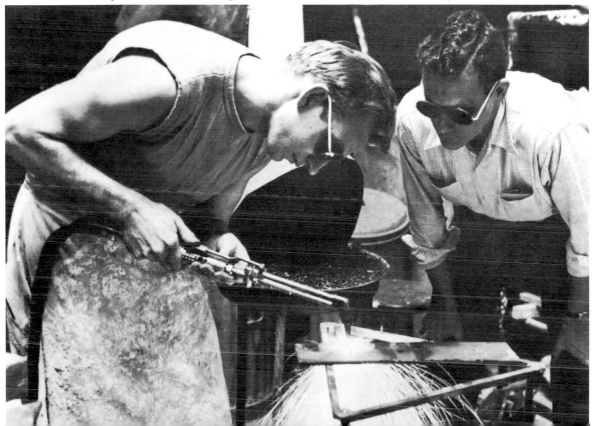

TWIN. Carel Visser. 1963. Iron.
*Courtesy, Bertha Schaefer Gallery, New York*

BIRD. Andre Volten. 1955. Iron.
*Courtesy, Toledo Museum of Art*

GROWTH WITH OVAL.
Joseph Goto. Steel.

WOMAN DISROBING.
Joe Clark. Steel.

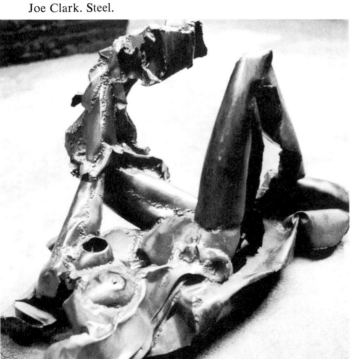

Iron can be forged, welded, and textured in a range of shapes. Compare Visser's rigid weighty sculpture with Volten's light-looking rhythmic forms that suggest the *Bird*.

These sculptures illustrate two different treatments and types of steel. Clark's figure of crushed, hammered, and welded sheet steel has large areas of exciting, rugged forms in smooth and rough textures. Goto's forms are tensely controlled and imply restrained violence.

Both these sculptures utilize rods, pipes, and heavy metal shapes that one would normally not associate with a wall hanging or a tree. Yet the parts are well integrated into a formal coherence so the original parts take on a new meaning.

THE IRON TREE. Oliver Andrews. Steel and iron.
*Courtesy, Alan Gallery, New York*

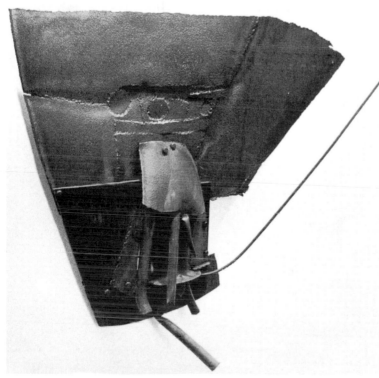

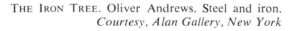

WALL RELIEF. John Heric. Steel and iron.
*Courtesy, Devorah Sherman Gallery, Chicago*

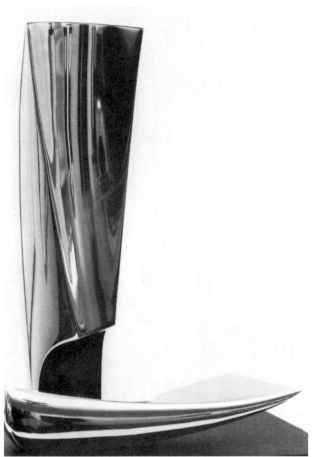

TWO FORMS. Roy Gussow. 1965. Stainless steel forged and welded. Full advantage has been taken of the esthetic qualities of highly polished stainless steel. The reflected images add to the general warmth of the sculpture.

*Courtesy, Grace Borgenicht Gallery, New York*

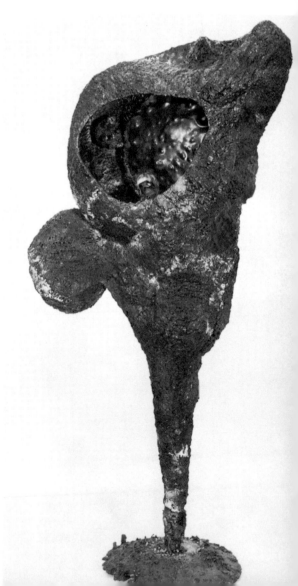

EARTH CRADLE I. Don Seiden. 1964. The crude texture was achieved by modeling steel while it was still in a molten state. The steel, following the heat of the torch, can be moved and deposited much like a soft material such as clay. The surfaces adopt a unique pebbly appearance meant to simulate the look and feel of "earth."

## USE OF SPACE IN COMPOSING SCULPTURES

As we search for form, we must learn to analyze how it is used as well as what it represents. Sculpture, because of its three-dimensional existence, has a different relationship to space than a two-dimensional art such as painting. Sculpture can be seen from all sides, and it exists in space. Therefore, the sculpture must utilize that space as part of its composition. It may thrust in and out of space and result in a flowing, easy, visual experience. Or it may enclose space entirely.

The sculptor, either consciously or subconsciously, works space into and around his construction. When a sculpture exists with open areas that allow space to come in and out, between and among the metal portions, the spaces themselves become shapes which the artist must consider as part of his composition. (These are called negative spaces.) Such "open" sculptures depend more on line than on large, unbroken surface areas.

A closed sculpture emphasizes volume and mass. It encloses space much as a box encloses its contents. Its surfaces are solid. The viewer often wishes to touch the surface as well as see it. And the surface texture, whether smooth or rough, contributes considerably to the esthetic effect.

Frequently the sculptor combines open and closed space in one composition. Surface area and line work together as contrasting elements. The following three sculptures illustrate these concepts. Keep them in mind as you analyze other sculptures for their compositional characteristics.

BRUSSELS CONSTRUCTION. Jose de Rivera. 1958. Stainless steel. This "open" sculpture almost seems alive and flowing in its ability to use light, motion, and space. Notice how the negative spaces (the shapes within the sculptures outline) become important to the composition.
*Courtesy, Art Institute of Chicago, gift of Mr. and Mrs. R. Howard Goldstein*

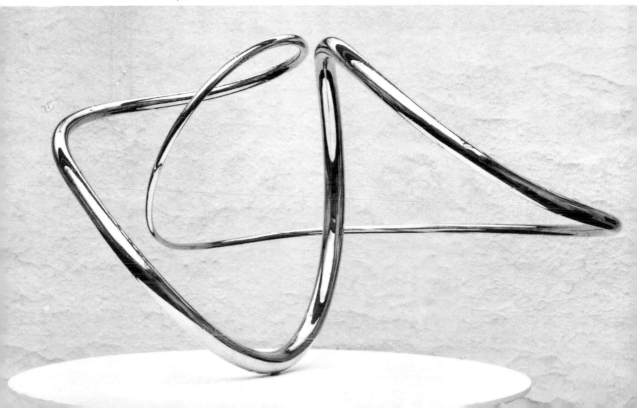

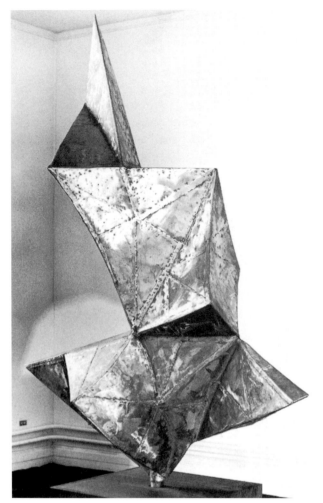

GEOMETRY. Costas Coulentianos. 1962. Stainless steel. The repeated triangular theme of this steel sculpture illustrates the "closed" composition. The forms thrust into space, but space does not penetrate through the sculpture at any point. The surface of a closed sculpture is often rich and varied.
*Courtesy, Bertha Schaefer Gallery, New York*

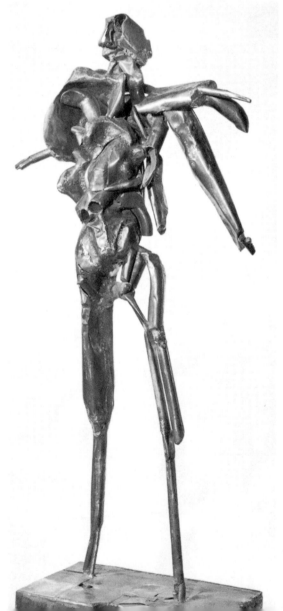

HERO CONSTRUCTION. Richard Hunt. 1958. Steel. Basically large surface areas of a closed sculpture are contrasted with some open areas in one composition. The open shapes change from every viewing angle and must be extremely well designed and cirsply defined.
*Courtesy, Art Institute of Chicago, gift of Mr. and Mrs. Arnold H. Maremont*

These works illustrate the artists' use of different symbols. In Hatchett's sculpture, you immediately get the feeling of machinery, of man-made shapes. In Müller's work, the expression is based on organic growth, on a plant form. Hatchett's piece is direct, simple, with a vertical stress. Müller's suggests a circular movement as the convolutions of shape and deep pockets catch, hold, and reflect light.

The tense, knotted, "open" forms imply that part of the excitement and beauty inherent in metal sculpture comes from the actual working of the metal by the artist. Texture marks left by the hammer and torch become an integral part of the form. Motion and tension are created by the metal itself and also by the enclosed negative spaces which are fragmented and split into many separate units.

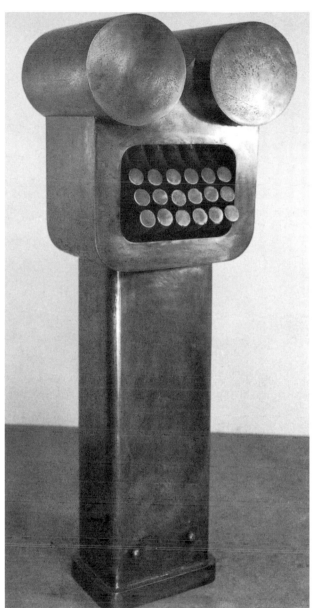

TOTEM STEEL. Duane Hatchett. 1965.
*Courtesy, Royal Marks Gallery, New York*

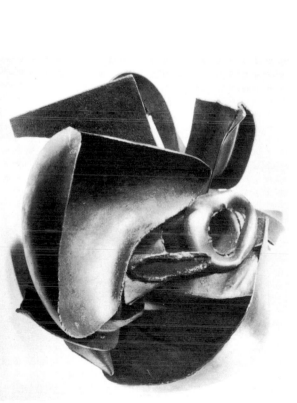

L'AVALEUR. Robert Müller. 1959. Iron.
*Courtesy, Contemporary Collection,*
*Cleveland Museum of Art*

LANDSCAPE. Joseph Goto. 1957. Welded steel and iron.

MORNING. Joseph Goto. Welded steel and iron.

TANKTOTEM #1. David Smith. 1952. Steel.
*Courtesy, Art Institute of Chicago, gift of Mr. and Mrs. J. Z. Steinberg*

HISTORY OF LEROY BORTON. David Smith. 1956. Steel.
*Collection, Museum of Modern Art, New York, Mrs. Simon Guggenheim Fund*

David Smith was one of the American sculptors who consistently worked with metal and probably is most responsible for the new language combining art with industrial metals and tools. In his earlier works, Smith repudiated the traditional conception of sculpture as an art of volume and monolithic mass. He favored a more dynamic, esthetic, open, linear form with some part of the sculpture held in a subtle spatial tension. His early works show a humor in the way the forms almost struggle to keep their balance and freedom. The same note is apparent in his later work, which moved into the use of more solid geometric masses of steel with interestingly textured ground surfaces. They still retain the feeling of gravity defying forms thrusting into space as in his *Cubi V*.

CUBI V. David Smith. 1964. Stainless steel. About this sculpture Smith said,
"I like outdoor sculpture, and the most practical thing for outdoor pieces is
stainless steel, and I made it and polished it in such a way that on a dull
day, it takes on the dull blue, or the color of the sky in the late afternoon
sun, the glow, golden like the rays . . . the colors of nature."

*Courtesy, International Nickel Company, Inc. New York*

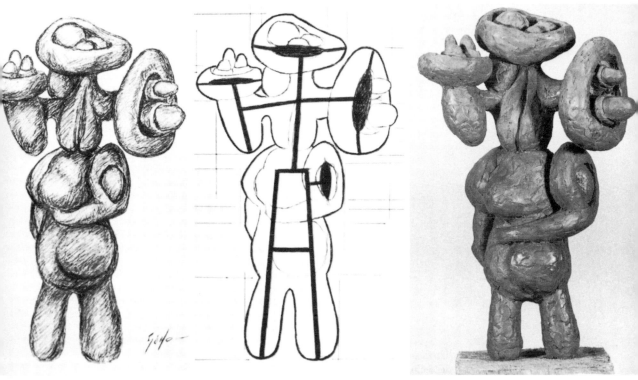

The first step is a drawing showing the concept in mass form. A second drawing illustrates the inner structure and support of the proposed sculpture. The lines are used to determine the scale of the drawing to the size of the larger finished sculpture. A clay model is made on a small scale to test the concept in dimension.

The working methods devised by each sculptor are uniquely related to what he wishes to create. As we have indicated throughout the book, many sculptures seem to grow and evolve as the artist shapes and welds his materials. Other artists sketch their work first and build and construct their composition in a definite logical step-by-step process. Sometimes both processes occur in the same sculpture.

Chicago sculptor Rudy Seno works in a controlled manner, using a variety of techniques and materials to create his tightly contained, yet explosive sculpture. As *The Waitress* (page 93) evolved, we followed its growth by photographing the steps over a period of time. This dynamic working series into the heart of a sculpture from beginning to end will give the reader a valuable insight into the creative process.

The sculptural form is begun by welding a steel armature to create the skeletal form. Rods range from $\frac{3}{16}'' - \frac{1}{2}''$. Sheet metal is placed in inner areas for greater support and easier accessibility later on.

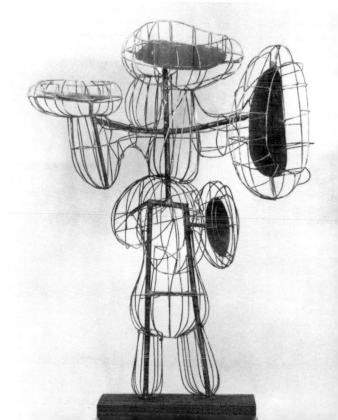

THE WAITRESS. Rudy Seno. 1965. After the rods and sheet metal forms are in place, Seno applies the torch to certain areas and melts the rods into one another further to form a more continuous surface effect. The contrast between smooth and rough surface, the tense, organic forms, all contribute to a strong, contained, sculpture. (opposite)

*Photo series, Dona Meilach*

Lengths of steel rods of various sizes are welded together to form the closed, solid surfaces. Smooth shapes are hammered sheet metal and found object forms welded into pockets built up of rods. The understructure at the bottom shows how the form is being developed over the supporting armature.

Detail shows the thousands of small rods used to build up the scultpure. Yet with welding, this is not a terribly time-consuming endeavor. The work progresses quite rapidly. An estimated total of sixty hours was required for Mr. Seno to create this piece.

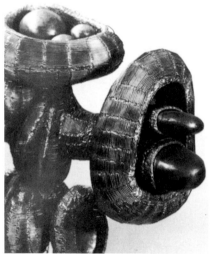

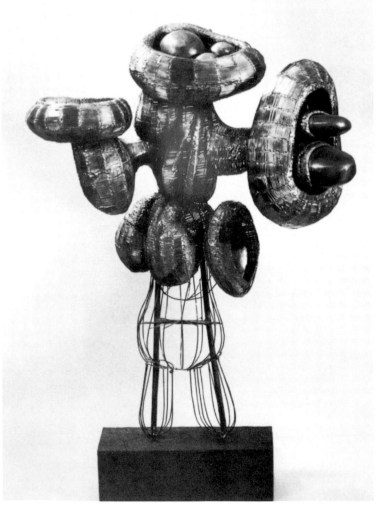

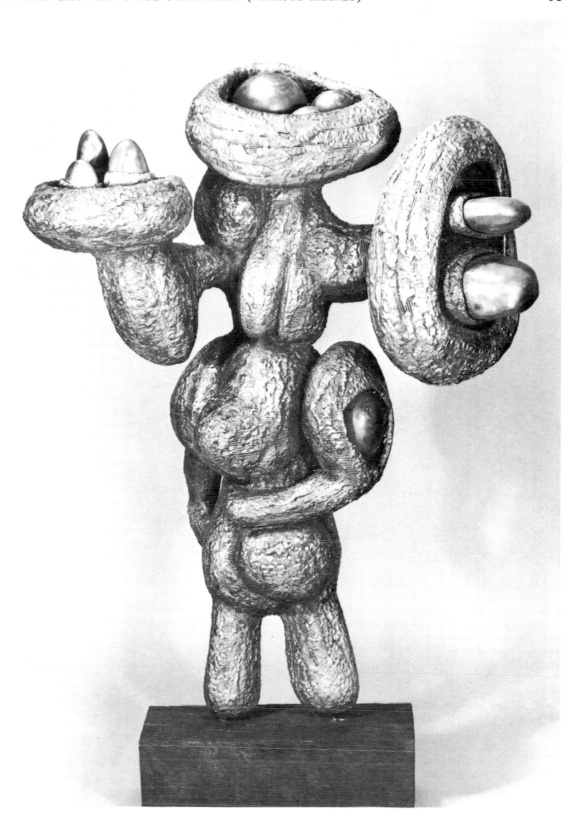

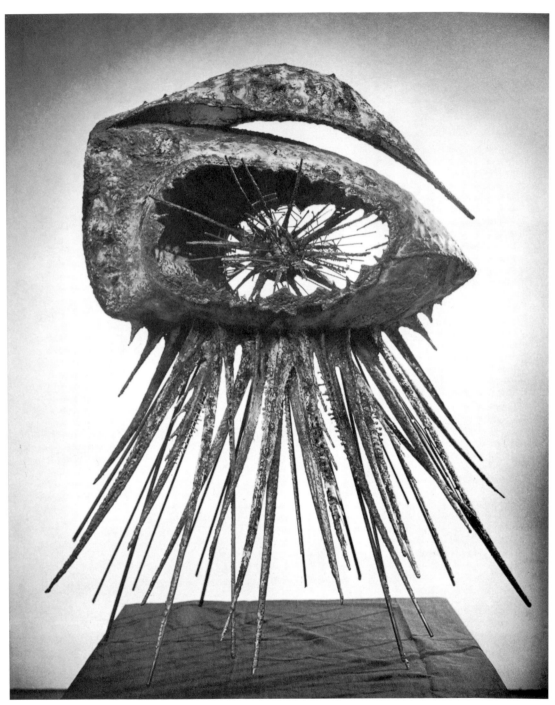

THE EYE. Rudy Seno. Combination of steel rods and sheet metal.

*Courtesy of the artist*

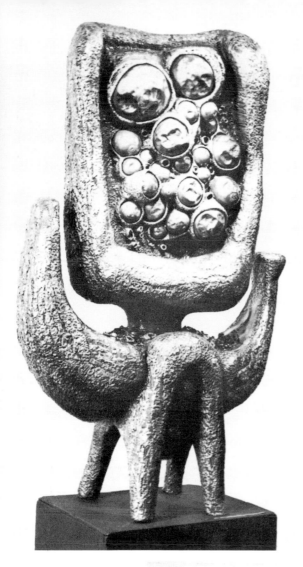

LADY IN GREY FLANNEL SUIT. Rudy Seno. Hammered sheet metal is formed, dented, and welded into an inner structure of steel rods. Drippings of molten metal were added to create the rough texture.
*Photographed at Ontario East Gallery, Chicago*

AMPHIBIAN. James Kwiatowski. Steel rods and sheet metal. Although the results look professional and complex, the artist is an eighteen-year-old Carl Sandburg High School student. Orland Park, Ill. Teacher, Martin Suchor.
*Courtesy, Illinois State Museum*

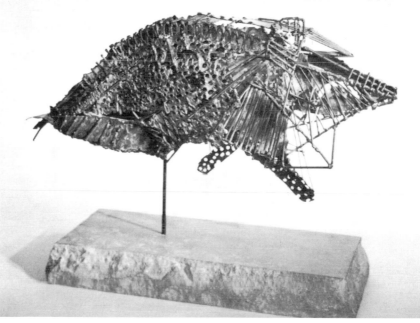

Ralph Bormacher's technique is in direct contrast to Rudy Seno's use of rods over an armature. Bormacher's sculptures emerge by the simple, but patience-requiring process of building up the form directly by fusing one bead of molten metal to another until the desired shapes are produced. No armature is used.

The end of a steel rod is melted with the oxyacetylene torch until it is molten enough to drop off the rod and adhere to a heated drop before it which has been allowed to cool slightly. The heat must be applied to both pieces of metal, however, and fusion occurs when the metal reaches a glowing red condition. The resulting texture is an interesting modeled effect which cannot be obtained by any other welding method. This technique of adding drips and drops from the molten rod to enrich another surface is frequently used.

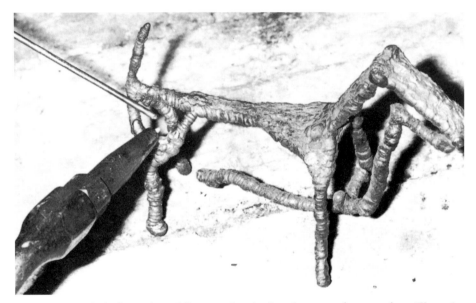

A basic form is built up by adding one bead of molten metal to another. Then the areas are filled in and rounded out. The artist has some control over the size of the beads. He may make them larger or smaller, flatter or rounder, by working them with the heat of the torch.

After the area at the rear of the animal was filled in, it has this almost scaly appearance.

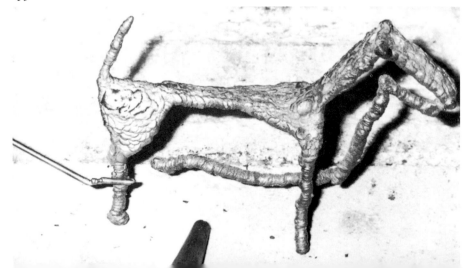

# Color Section for Revised Edition

# Iron and Steel

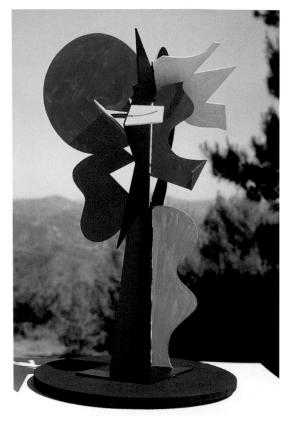

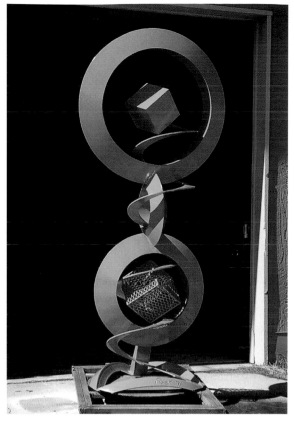

*Top left:* EQUINOX. Rafe Ropek. Forged and fabricated steel, orange automotive paint. This piece was designed to be the sight (as in a rifle sight) for the moon's rise. 8' high, 4' wide, 4' deep.         *Photo, artist*

*Top right:* SPIRIT TALKER. Jan Pearson. Eagle is blued steel. The bird's body is made by sandwiching the metal, then blowing air into the cavity to inflate it, then sealing it. Turquoise bust by Leone Connie. 6' high, 4' diam. at base.         *Courtesy, artist*

*Bottom right:* ILLUSION. Karel Meloun. Steel with textured surface. Model for a sculpture and photographed in a potential location for the finished piece. 21.6" high.         *Courtesy, artist*

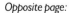

*Opposite page:*
*Top left:* TERRA FERRA. Lee Sauder. Steel with ochre finish and a concrete base. Forged from a 42" sphere. The large fissures that enhance the surface are the result of experimenting with a large hollow form heated from the inside, thus forming its own furnace. This was forged with a single blow from a home-rigged thousand pound drop hammer. Sphere 42" diam.         *Photo, Ellen M. Marten*

*Bottom left:* TERRA FERRA (detail). Shows the texture and resulting fissures in the cylinder.

*Top right:* CRIMP MARKER. Fred Borcherdt. Forged steel and stone. Although this sculpture is small, it has monumentality and could be enlarged to become a public sculpture. 14" high, 10" wide, 8" deep.         *Courtesy, artist*

*Bottom right:* HEAD #1. Ron Tatro. Polychrome steel. 32" high, 21" wide, 20" deep.         *Courtesy, artist*

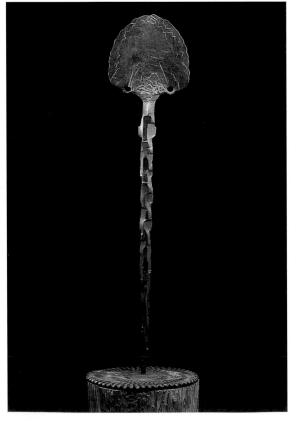

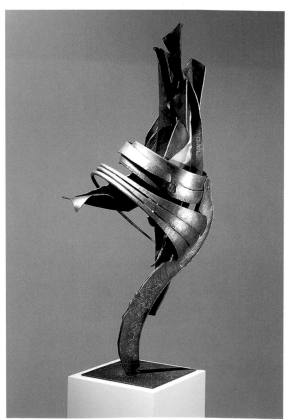

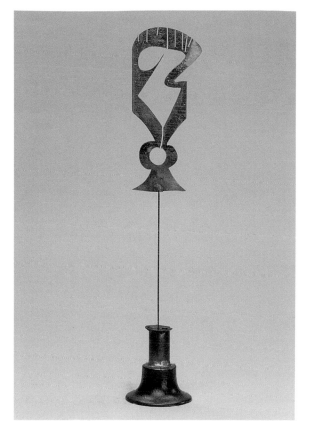

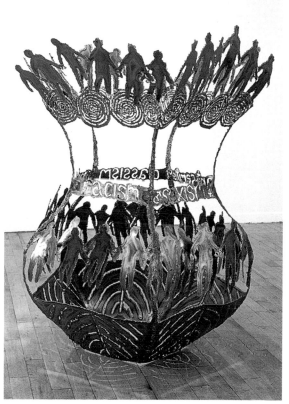

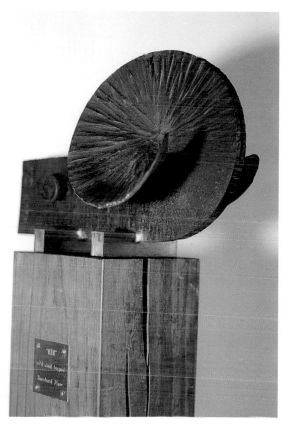

*Top left:* UNTITLED. Nick Such. Brass, steel, and cast iron with silver solder joinery. 21" high.

*Photo, Paul Moshay*

*Top right:* -ISMS. Janet Goldner. Steel. Text and images cut into constructed steel with a welding torch as a drawing instrument to examine contemporary social issues. 39" high, 24" diam.

*Photo, artist*

*Bottom right:* RAM. Bernhard Heer. Forged mild steel on a wood base. 7.5" high, 11.5" wide.

*Photo, artist*

*Opposite page:*
*Top left:* FAN DANCER. Christopher T. Ray. Welded iron. 36" high, 24' wide, 10" deep.

*Photo, artist*

*Bottom left:* "IT" SPIRIT STICK. Russell Jaqua. Mild steel. Forged from a single length of steel rod. 60" high, base 12" diam.

*Photo, artist*

*Top right:* GRUS GRUS. Bengt Gustafsson. Forged iron. 19" high, 7.5" wide.

*Photo, Anders Nilsson*

*Bottom right:* I HATE IT WHEN THIS HAPPENS. David A. Ponsler. Forged and fabricated steel plate and bar. Extensive use of fold forming. Wax finish. 5.25" high.

*Photo, Daryl Bunn*

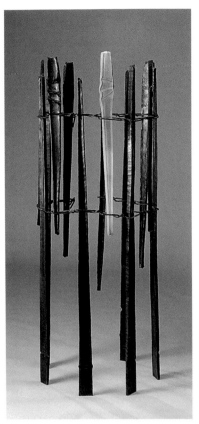

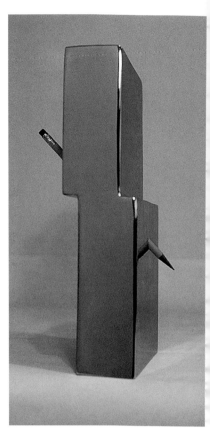

*Left:* THE WILL TO LIVE. Brian F. Russell. Forged steel and cast glass. The sculpture arose out of feelings of helplessness and hope on hearing of the grave illness of a friend. A mold was made from a forged piece and the glass made from that mold so it mirrors the shape and texture of the iron element. 72" high, 30" diam.

*Courtesy artist*

*Center:* REFRACTION. Rod Baer. Chromed steel and pencil. Part one of a set. 12" high, 6" wide, 5.5" deep.

*Photo, artist*

*Right:* REFRACTION CORRECTED. Rod Baer. Chromed steel and pencil. Part two of a set. 12" high, 6" wide, 5.5" deep.

*Photo, artist*

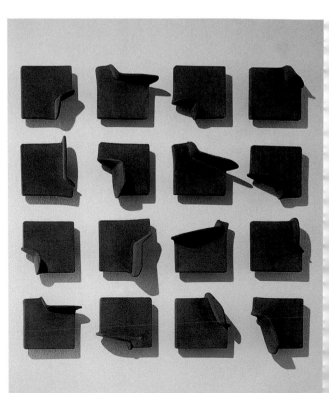

SET, DRAW, FOLD. Tom Joyce. Forged iron. Sixteen identical 4" X 4"X 1/2" plates were each cut half way through with a straight line and an angled line to isolate a corner which was forged out as fast as possible in one heat Each "ear" was then folded back into the corner rising out of the original flat plates. 21" high, 21" wide, 3.25" deep.

*Photo, Nick Merrick*

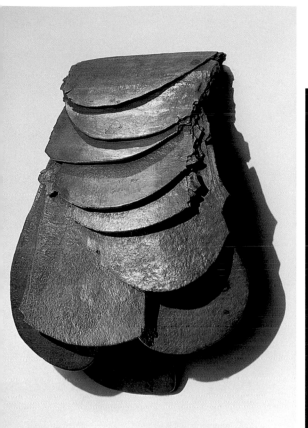

TEN FOLD. Tom Joyce. Forged iron. A 72" piece of 19th Century wagon tire was folded, fire welded and drawn out over and over as if kneading bread until it could no longer be folded again. 14" high, 11" wide, 5" deep.

*Photo, Nick Merrick*

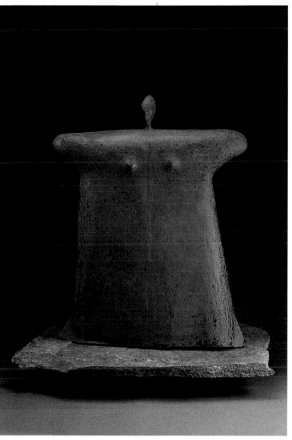

GARDEN FIGURE. Paige Hamilton Davis. Forged iron with rust patina and stone. 30" high.

*Photo, Tom Mills*

CUPLE. Rod Baer. Fabricated and welded steel cups and chain. 4" high, 15" wide, 3" deep.

*Photo, artist*

SNAKE PIT. Kenneth Capps. Painted steel. 30" high, 68" diam.

*Courtesy, artist*

EQUATOR 35° S14. Kenneth Capps. Treated steel and paint. One of a series of Equator sculptures showing the division of the earth at different degrees. 30" high, 30" diameter.

*Courtesy, artist*

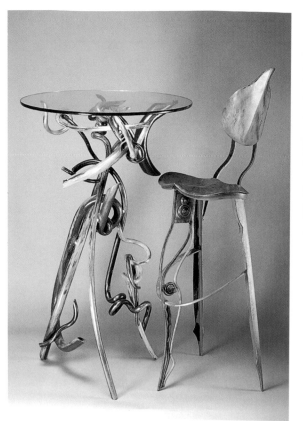

PIPE TABLE and "LEG" STOOL. Jack Brubaker. Hot formed steel pipe and steel bar with copper accent and paint. An example of functional sculpture. Table 45" high. Stool 48" high.

*Photo, Bob Barrett*

*Left:* SPHERE. Tom Joyce. Iron and books. Books are tightly compressed between the metal, then grooved, seared, and burned. 11.5" diam.

*Photo, Nick Merrick*

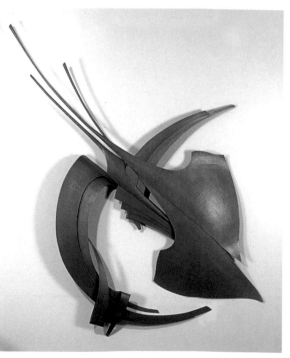

*Right:* SOME SORT OF COSMIC COMBUSTION. John Medwedeff. Forged and fabricated steel wall sculpture commissioned by the Illinois Capital Development Board Art-In-Architecture program for the Communication Building, Southern Illinois University at Carbondale. The piece is mounted at the center of an entry hall atop the grand staircase. 8' high, 7' wide, 8" deep.

*Photo Jeff M. Bruce*

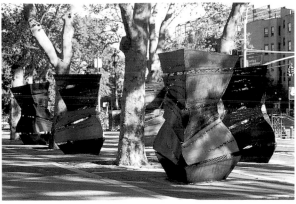

MOST OF US ARE IMMIGRANTS. Janet Goldner. Steel. The sculpture celebrates immigration as an integral and continuing part of the American experience. Originally installed in the Sara D. Roosevelt Park, New York, New York. Now in the permanent collection of the Islip Museum, Long Island, New York. 8' high, 50' wide, 18" deep.      *Photo, artist*

## Non-Ferrous, Mixed Metals and Found Objects

ANIMAL AND MACHINE SERIES (sculptures in progress). HAWK, painting. Italo Scanga. Many artists are versatile and multi-talented moving easily from painting to sculpture and other media. Scanga's studio is outfitted with the tools and equipment of the metal sculptor. The painting is acrylic and collage on paper. Each sculpture is approx. 62" high, 36" wide and 24" deep. Painting, 59" high, 40" wide.

*Photo, Jim Durant.*

MOTHER NATURE. R. Mike Sohikian. 36-plate steel edged with a welded band of stainless steel. Necklace and earrings are 15 pounds of 18-gauge wire. All materials are recycled from industrial cast-off. Finished with nitric acid and used crankcase oils. 6' high, 18" wide, 10" deep. Collection: Mr. and Mrs. J. Simon. *Photo, artist*

SEWING MACHINE AND OPEN WRENCH. Italo Scanga. Metal, found objects, and glasses. Scanga is well known for his ability to combine found objects in meaningful, poetic relationships. His pieces are often humorous, yet intensely introspective. 53" high, 18" wide, 9" deep.

*Photo, Roy Portello*

S0. Daniel Radven. Steel. Found metals with surfaces that suggest remnants of a prior use are formed into a sculpture that depicts farm plow implements but ma indeed, once again be turne into another sculptural for 48" high, 24" wide, 30" dee
*Photo, art*

FIGHTER II. Karel Meloun. Steel, scrap iron, and sandstone. 31" high.
*Courtesy, artist*

ARCHIMAGE (MASTER MAGICIAN). Jeffery Laudenslager. Constructed kinetic sculpture of stainless steel and titanium. The top elements move in the wind to result in a constantly changing relationship of positive-negative space against the sky. 34' high; width varies because of its kinetic nature.
*Collection, American Assets, Inc., Torrey Reserve, San Diego. California. Photo, Claire Slattery*

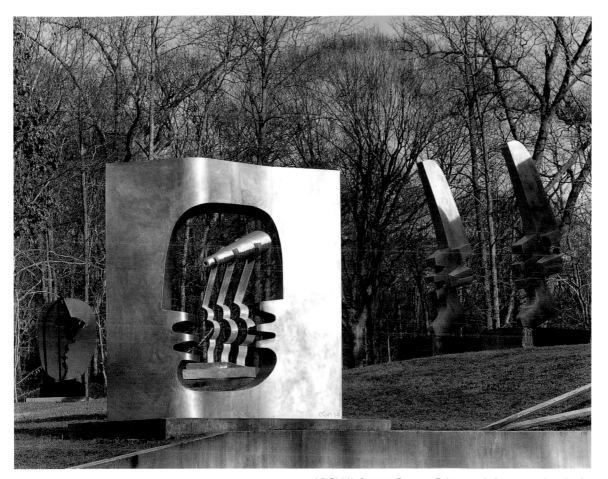

ARCH II. Strong-Cuevas. Fabricated aluminum, brushed. 12' high, 11' wide, 5' deep.

*Photo, Renate Pfliederer*

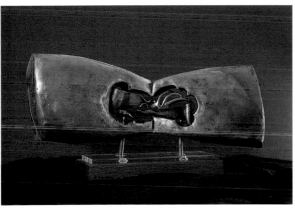

UNTITLED. James Hubbell. Forged bronze sheet. 8" high, 22" wide.

*Photo, artist*

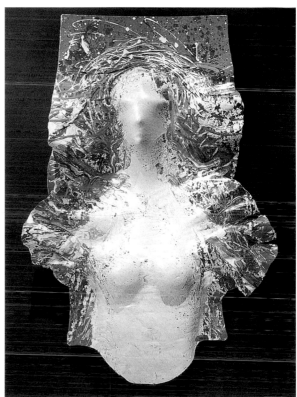

WALL RELIEF. Jack Brubaker. Hot forged aluminum, formed with a power hammer and hydraulic press. One of a group. 25" high, 24" wide.

*Photo, Sidney Sander*

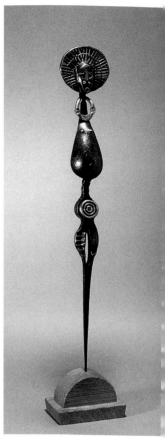

CRITICAL MYTH. Rod Baer. Hand crafted welded steel and plaster figurines. All items are hand built including the pencils and erasers in the cup. The calipers are painted white to suggest that the artist had tried to obscure their "real" tool originals. They are a non-functioning, non-adjustable hand built sculpture of calipers; fakes parading as real pretending to be fakes. 36" high, 40" wide, 8" deep. *Photo, artist*

FERTILITY GODDESS. Brad Silberberg. Forged steel and brass with wood base. Sanded black oxide finish. 24" high, 6" wide, 4" deep. *Photo, artist*

ESTABLISHING A CLAIM. Rod Baer. Welded steel, wood, and paint. Paintings on the wall flank the central axis of a mining hopper laden with paintings. The ore cart is chained to a turntable that can be manually pivoted into alignment and the tracks take larger and larger leaps, culminating in a twenty foot vertical stretch that leads through the roof into an overhead skylight. Fallen paintings and slides litter the ground. Gallery installation. *Photo, artist*

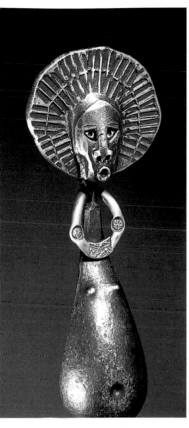

FERTILITY GOODESS (detail). Brad Silberberg. Silberberg creates incredibly original forms from hot iron using power hammers and custom made stamps and punches.
*Photo, artist*

EVE FLYING OVER THE GARDEN. Jack Brubaker. Brass and iron panel using repoussé. Hand sanded and lacquered. 24" high, 14" wide.
*Photo, artist*

THE FAMILY. Don Seiden. Steel, bronze, copper, and mixed media. Two from a grouping of six large antelope are gathered around a male leader who is on the ground fallen. Each of the seven antelopes is approximately 7' high, 7' long, 2" wide.

*Photo, Gary Henderson*

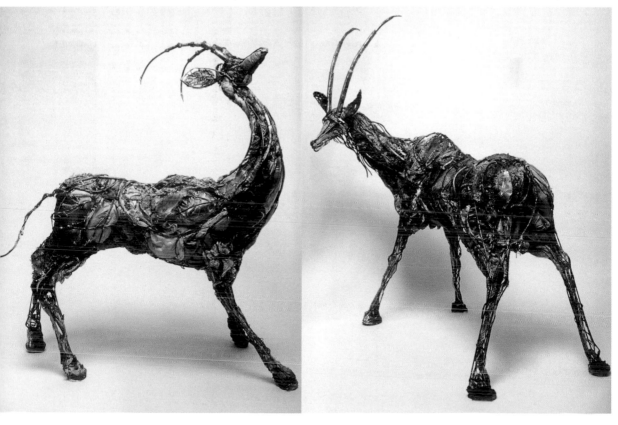

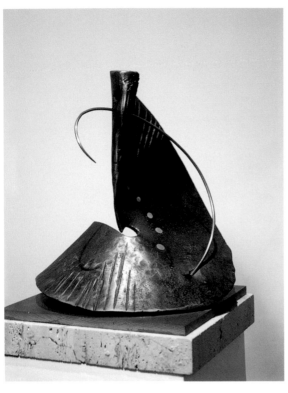

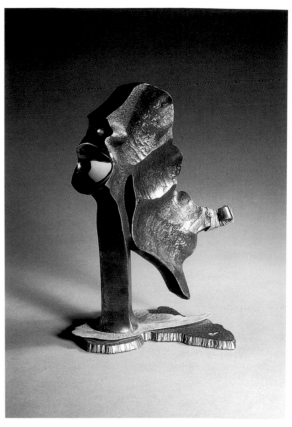

UNTITLED. James Hubbell. Forged iron and brass. 20"
high.

*Photo, artist*

THIRD WORLD. David Thompson. Forged steel and
copper. 14" high, 10" wide, 8" deep.

*Photo, Rebecca Ellis*

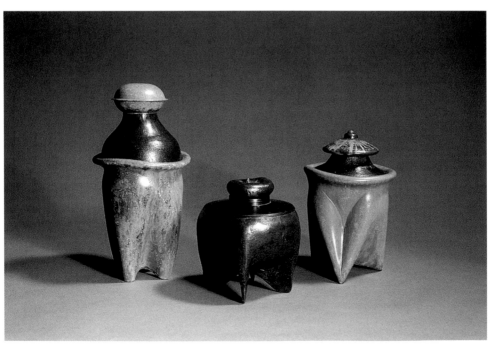

FORGED VESSELS
WITH LIDS. David
Thompson. Left:
forged copper and
steel. 10" high, 4.5"
wide. Middle: forged
steel and bronze.
5.5" high, 10" wide,
8" deep. Right:
Forged copper and
steel. 7.5" high, 4.5"
wide.

*Photo, Rebecca Ellis*

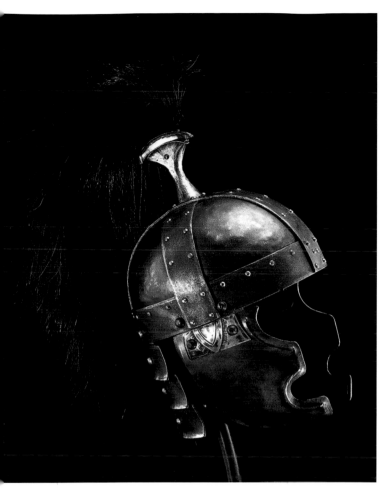

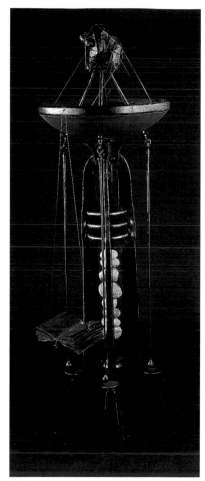

SPANGELHELM HYBRID. David Tuthill. Steel, copper, bronze, leather, horsehair. Raising and repoussé techniques with welding. 16" high, 8" front to back.

*Photo, Jay Dotson*

INSIGHT. Bengt Gustafsson. Iron, wood, and stone. 53" high, 12.5" wide.

*Photo, Anders Nilsson*

AN ASSOCIATION - A LIFE. Bengt Gustafsson. Objects in the panel's spaces are made of iron, wood, and paper. One of two panels located in a senior people's home in Langhem, Sweden. 4.9" high, 4.9" wide.

*Photo, Anders Nilsson*

LAID TABLE. Bengt Gustafsson. Iron, quartz, and iron sinter. 15.4" high, 22.8" wide.

*Photo, Anders Nilsson*

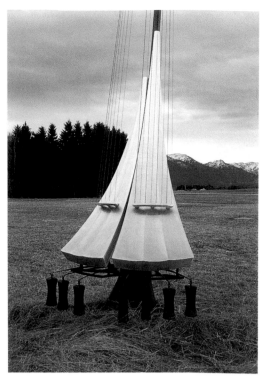

JIMMY'S SONG. Jeffrey Funk. Wind actuated sculptural aeolian harp. A musical instrument of stainless steel, aluminum, copper, and iron that incorporates the disciplines of art, physics, and musical theory. Approximately 30' high.

*Photo, artist*

*Left:* CROSS-ING THE AGES; PISCES TO AQUARIUS. Alber De Matteis. Steel, granite, and sandstone. 75" high, 25" wide, 28" deep.

*Photo, artist*

*Right:* DAWN. Phil Alan Simpson. Steel sculptures with a drawing of graphite on masonite. 144" high, 240" wide, 120" deep

*Photo, artist*

GIRAFFE. Ralph Bormacher. 1965. Steel rods, melted. The realism which is apparent in this work is affected greatly by the ability of the artist to control the placement of each separate bead of molten steel in a careful manner. None of the movement or sensitivity of this sculpture is lost in the technique which is more controlled and less spontaneous than that of working directly by building up with larger pieces of metal.

*Photo series, Dona Meilach*

IMPRISONED FIGURE. Seymour Lipton. Wood and lead. Lipton's work illustrates a consistency and versatility that have made him one of the great contemporary metal sculptors. His forms and textures illustrate the tremendous versatiiity of metal. He uses geometric shapes that imply speed and mechanization as well as organic and sensual images.

*Courtesy of the artist*

GALACTIC INSECT. César. Welded iron. César, another well-known sculptor, illustrates how shapes can be retained in a form that is simple and direct, yet express movement and force. The form is basically closed, yet the open spaces seem to lend emphasis to the closed, weighty forms which are supported on thin structures.

*Collection, Museum of Modern Art, New York, gift of G. David Thompson*

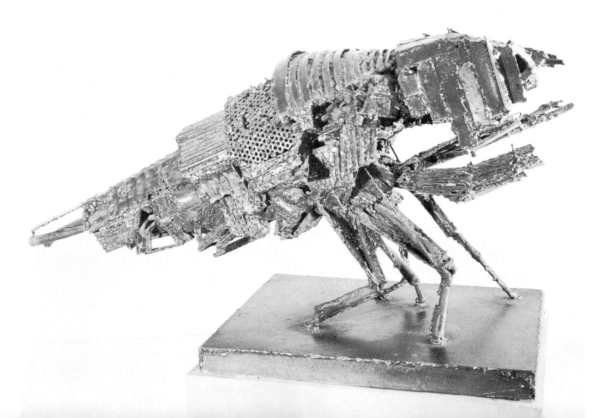

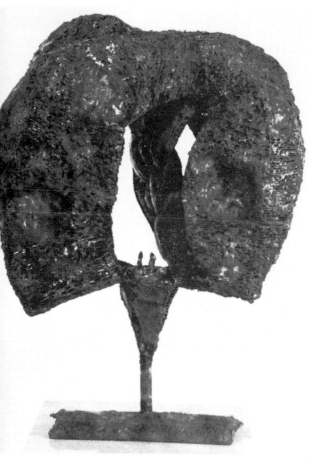

EARTH CRADLE II. Don Seiden. 1964. Steel rods with molten steel dripped on for texture. In delivering the message of a cavernous dwelling in earth's environment, the artist is conveying the idea that while man builds and conquers, he still seeks warmth, comfort, and security. The negative spaces have been purposely created between the rods to give the sculpture an open feeling.

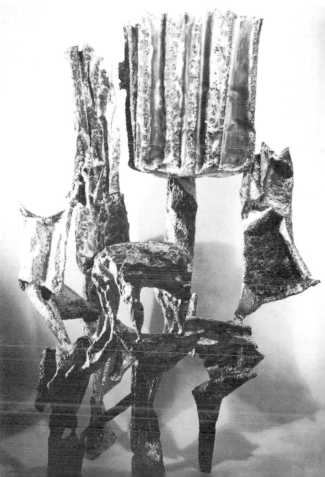

CYTHEREA. Ibram Lassaw. 1964. Sheet metals with overlays of various metals. This frank statement of an organic, growing form has a soft, moving quality, despite its hard materials. The almost formless individual shapes become one because of their relationship to one another.
*Collection, Albright Knox Art Gallery, Buffalo, New York*

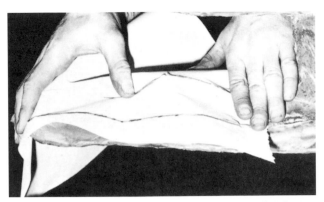

To create each individual shape for the finished sculpture on page 101, Urry first folds a paper over the area to be filled in with metal. He then traces a line around the edge of that shape with a grease pencil and cuts the shape out of the paper.

He traces the pattern onto a piece of sheet metal with chalk.

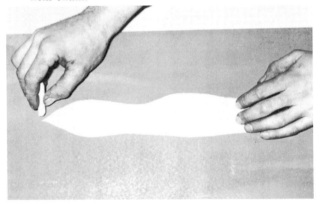

The metal piece is then curved and shaped into the area by hammering.

With the oxyacetylene cutting torch, he cuts the shape out of the sheet metal.

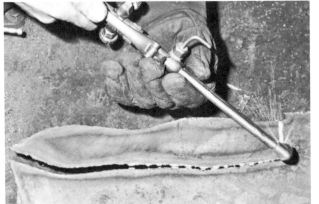

It is always easy to conjecture about why an artist created a sculpture. Regardless of what the sculptor had in mind, the viewer can decide, on the basis of his own experiences, what the sculpture means to him. But it is often difficult to reconstruct the manner in which the artist worked. In this series, Steve Urry demonstrates the methods he uses to build up a sculpture which states an exciting, personal, intelligent relationship between organic and geometric forms.

Urry uses an oxyacetylene torch for cutting and an arc-welding unit for fusing the sheet metal.

He fills in the seam, using an electrode with the arc welder. He may add a filler rod of ordinary steel for additional metal, which is necessary if the seams do not fit perfectly.

The welded seam. The solid form results when all sides of the form have been assembled by welding.

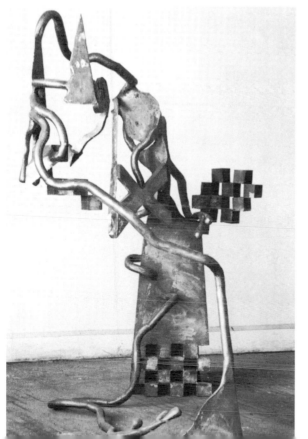

CHECK THE PYRAMID "X"ING. Steve Urry. 1965. Steel.
*Courtesy of the artist*

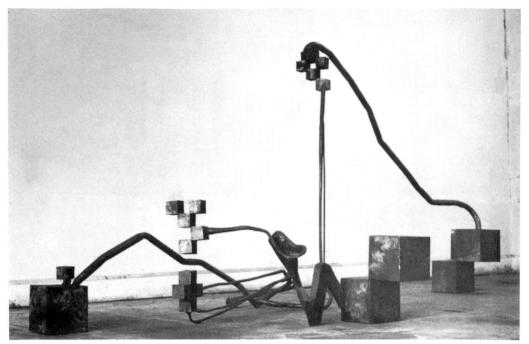

1, 2, 3, CHECK. Steve Urry. 1965.  Steel.            *Courtesy of the artist*

THE CHASE. Richard Hunt. 1965.  Steel.            *Courtesy of the artist*

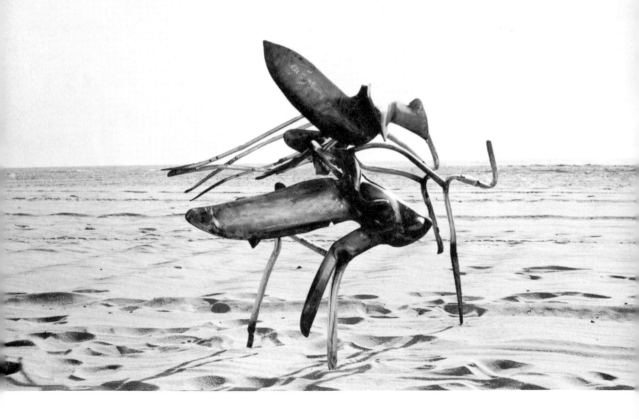

**METAL SCULPTURE CAN EXPRESS A TENSE, ENERGETIC MOVEMENT...**

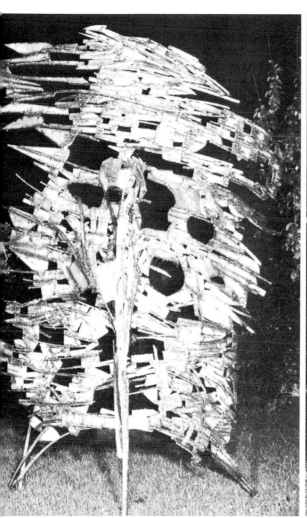
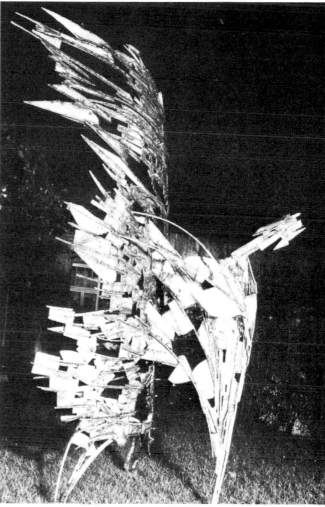

DER GEFLUGELTE. Friedrich Werth-
mann. Welded steel.
*Courtesy of the artist*

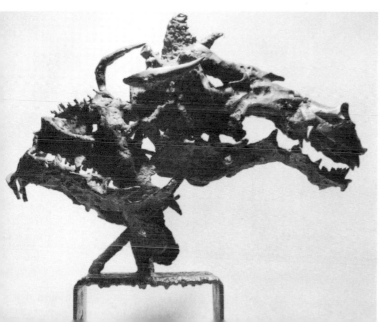

SPECTRE. Juan Nickford. Welded
and forged iron.
*Courtesy, Devorah Sherman
Gallery, Chicago*

**. . . AND A FLOWING, UNBROKEN MOVEMENT.**

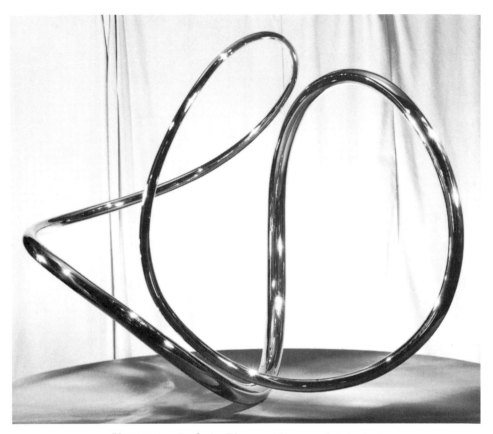

UNTITLED. José de Rivera. Chrome nickel steel.
*Courtesy, United States Steel Corporation*

MONOANGULATED SURFACE IN SPACE. Max Bill.
*Courtesy, Detroit Institute of Arts*

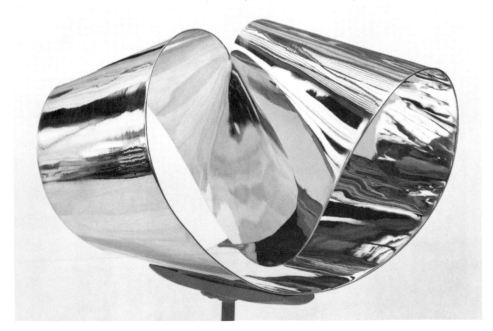

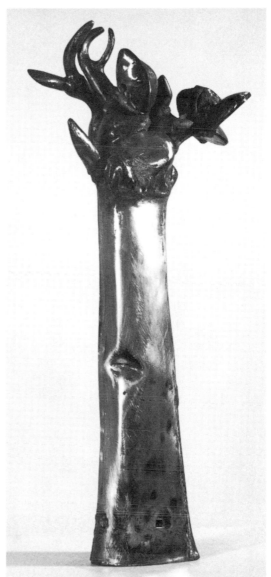

HYBRID FORM #4. Richard Hunt. 1964.
Welded steel.
*Courtesy, B. C. Holland Gallery, Chicago*

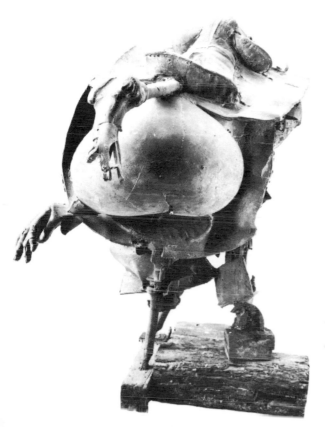

LA NUIT DE LA SAINT JEAN. D'Haesc.
1961.
*Courtesy, Galerie Claude Bernard, Paris*

**. . . AND A RHYTHMIC, LINEAR QUALITY.**

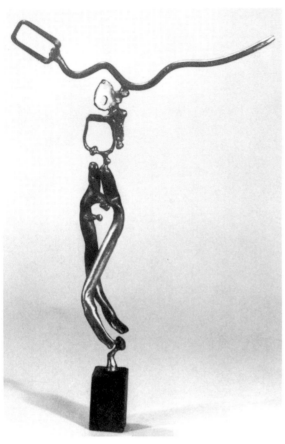

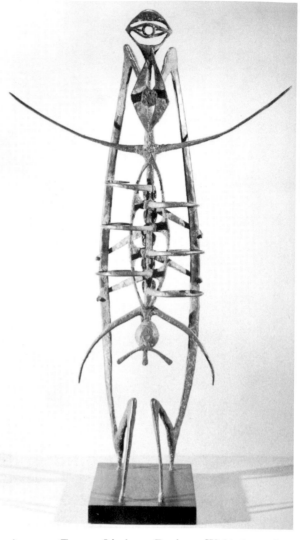

EVE AND THE SERPENT. Richard Hunt. 1963.
Steel.

*Collection, Dr. and Mrs. Eugene Solow*

AUTO-DA-FE II. Lindsay Decker. Welded steel.
*Courtesy, Detroit Institute of Arts*

**METAL CAN BE REALISTIC. . .**

BEAST No. 1. Lynn Chadwick. Iron and composition.
*Courtesy, Art Institute of Chicago*

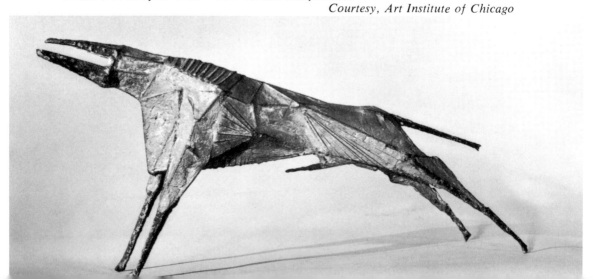

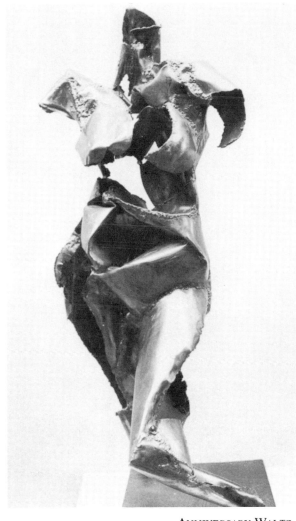

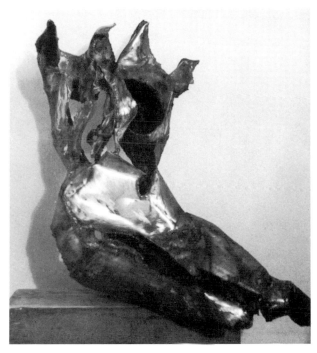

M.G. Joe Clark. Sheet steel
*Courtesy of the artist*

ANNIVERSARY WALTZ.
Joe Clark. Sheet steel.

. . . AND ABSTRACT.

POSSESSED. Ezio Martinelli. Steel.
*Courtesy, Willard Gallery,*
*New York*

TRIAD. Katherine Levisetti.

108

. . . UNRELATED SHAPES CAN BE RELATED.

ARCHANGEL. Robert Müller. 1963. Iron.
*Courtesy, Galerie de France, Paris*

METAL CAN BE MOODY, CAPRICIOUS. . .

LINEAR FORMS. Richard Hunt.
1963. Welded steel.
*Courtesy, B. D. Holland Gallery, Chicago*

METAL CAN SHOW STRENGTH AND POWER. . .

SQUARE FLAT. John Hoskin. 1963. Mild steel.
*Courtesy of the artist*

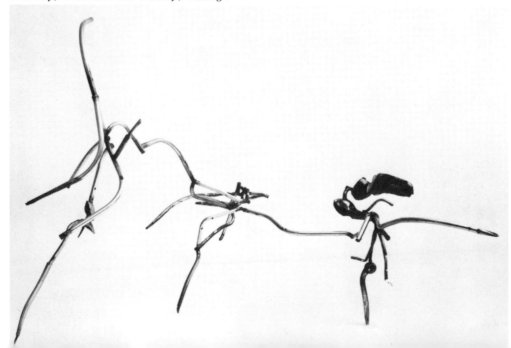

# . . . OR WITTY.

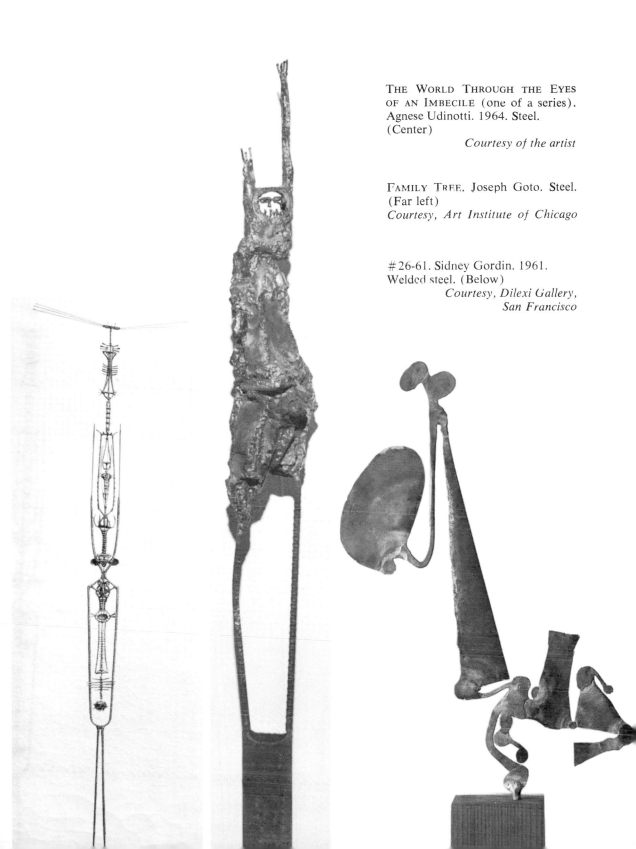

THE WORLD THROUGH THE EYES
OF AN IMBECILE (one of a series).
Agnese Udinotti. 1964. Steel.
(Center)
*Courtesy of the artist*

FAMILY TREE. Joseph Goto. Steel.
(Far left)
*Courtesy, Art Institute of Chicago*

#26-61. Sidney Gordin. 1961.
Welded steel. (Below)
*Courtesy, Dilexi Gallery,*
*San Francisco*

METAL CAN BE GEOMETRICAL. . .

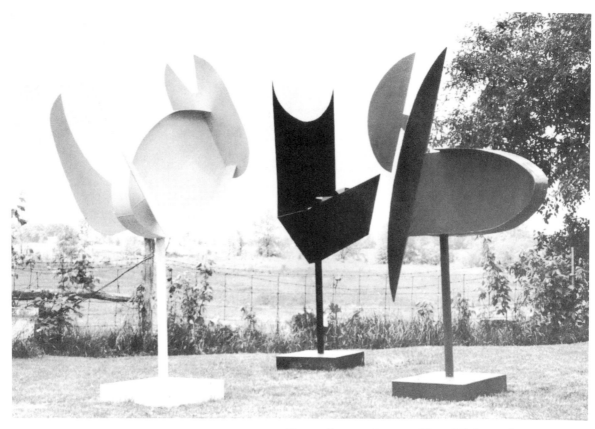

TRIAD. PEACE, DEATH, WAR. Michael Bigger. 1965.
Steel painted white, black and red.
*Courtesy of the artist*

RISING MOVEMENT. Robert Adams. 1962. Bronzed steel.
*Collection, Gimpel Fils, London*

**. . . AND MECHANICAL.**

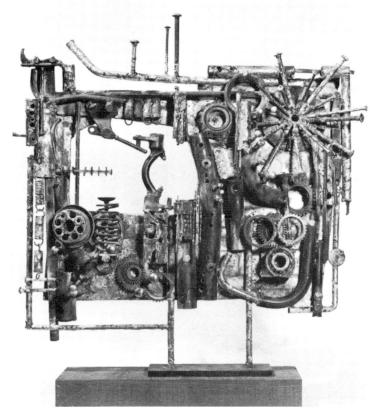

INDUSTRIALS. Kenneth J. Beer, Jr. Iron and steel.
*Courtesy, Detroit Institute of Arts*

IRON SCULPTURE. Julius Schmidt. 1959. Cast iron.
*Courtesy, Art Institute of Chicago*

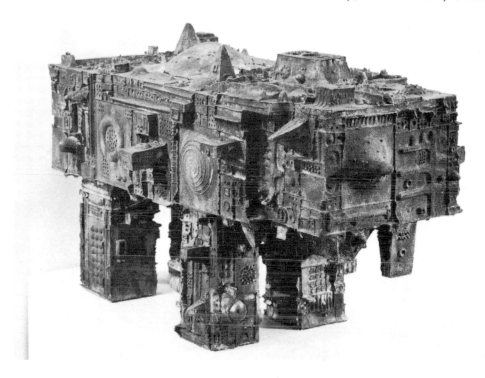

METAL CAN BE SET IN MOTION. . .

CLOUDS OVER MOUNTAINS. Alexander Calder. 1962. Steel plate.
*Courtesy, Art Institute of Chicago*

. . . OR IT CAN BE STABLE.

YOUNG ANIMAL. David V. Hayes. 1964. Forged steel.

*Courtesy, Willard Gallery, New York*

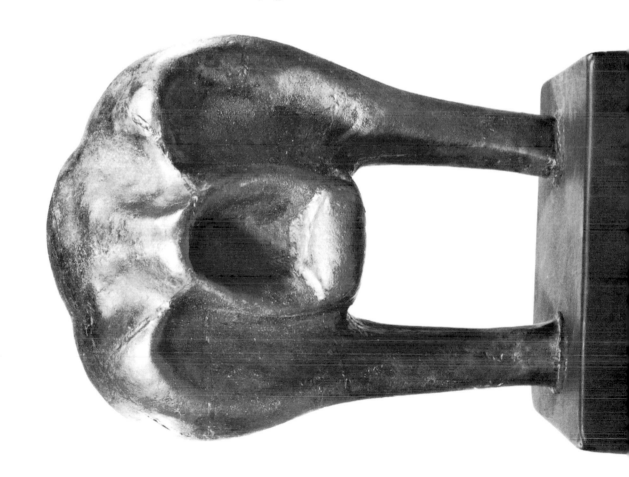

114

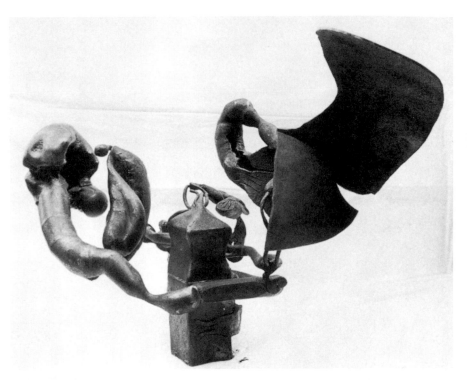

UNTITLED. Rodger Jacobsen. 1964. Welded iron and steel.
*Courtesy, Dilexi Gallery, San Francisco*

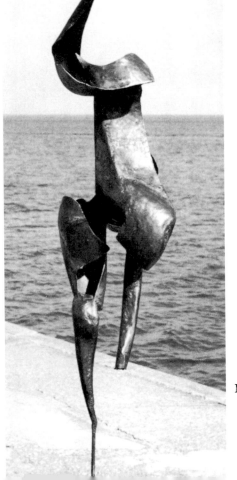

**THE MOODS OF METAL ARE VARIEGATED. . .**

MUSE. Katherine Levisetti. 1965. Steel.
*Courtesy of the artist*

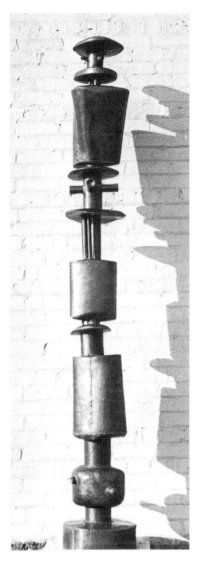

**. . . AND INFINITE.**

TOTEM. Richard Kowal. 1965. Sheet
steel.
*School of the Art Institute of Chicago,
Don Seiden, Instructor*

UNTITLED. Arnold Cherullo. 1964. Sheet
metal.
*School of the Art Institute of Chicago,
Don Seiden, Instructor*

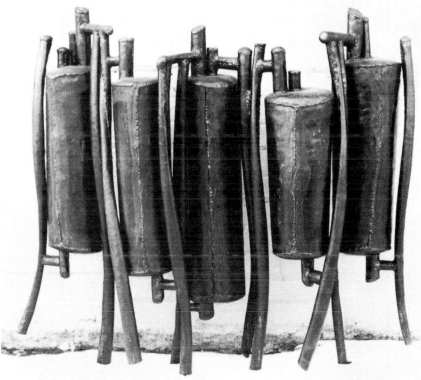

## FORGING

Forging is a method of working metals by heating, hammering, and shaping them while they are in a red-hot state. The method dates back to prehistoric times, and the first metals worked in this way were probably copper, gold, silver, and bronze. The handcraft method of forging is usually associated with the blacksmith, who placed his metals over a forge containing charcoal or coke. These fuels produce an intense, easily regulated heat and are free from impurities that might injure the metal.

In medieval times, forging methods were used to make decorative hinges and ornaments, helmets and weapons. For some types of work, a few artists still prefer the traditional forge, but the torch is a good, convenient substitute. The torch tends to give a concentrated heat in a smaller area rather than a uniform heat over a large area.

Often forged shapes are welded together to create a sculpture, or they may be fused by hammering two pieces of metal together while both are red-hot. In this case, a molecular fusion takes place. Forging tends to increase the toughness of iron and steel.

The decorative ironwork shown below was done by the forging process. Forging requires a good sense of timing as well as a strong arm.

FORGED SHAPES. Ralph Bormacher.

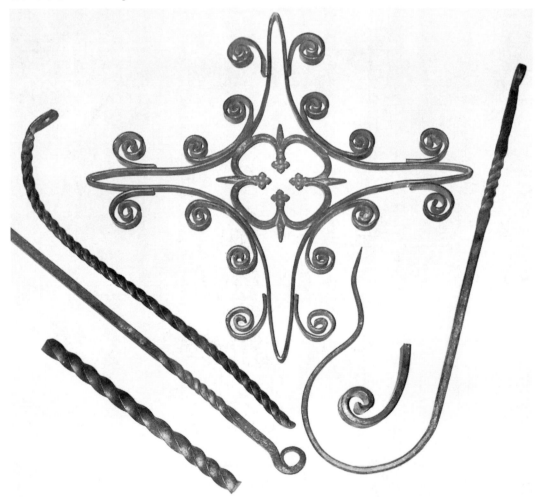

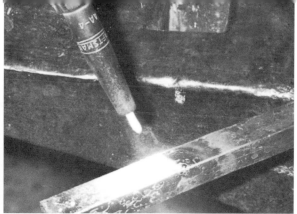

Forging requires a heavy hammer, an anvil, and heat. The oxyacetylene torch or a blowtorch may be used. Here a solid iron bar is heated until it is red-hot.

Bending or twisting a piece of heavy iron or steel may be done more easily by forging. The metal is heated where the bend is to be made, then placed over an anvil and hammered until the metal angles as desired.

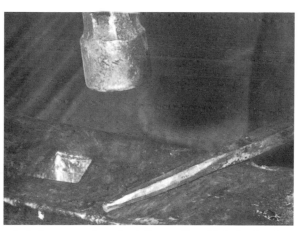

It is hammered against the anvil until it begins to shape and stretch. As soon as it cools, it must be reheated before additional shaping can be done.

The iron bar can be hammered to a point.

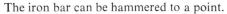
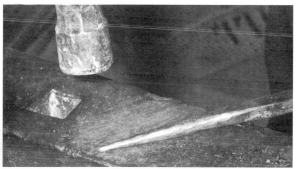

A ring or any other circular or oval shape may be formed by working the hot iron over the end of the anvil.

The finishing touches. The ring is flattened and evened on the anvil's surface.

It can be flattened.

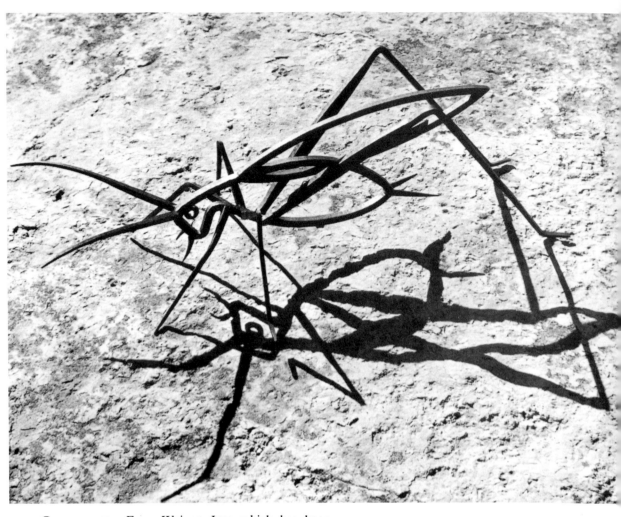

GRASSHOPPER. Egon Weiner. Iron which has been forged to shapes and fused by welding. There is an interesting contrast between the insect's form, arrived at in the rather violent forging method, and the humor of the subject and the pose.

A bar of iron can be twisted by placing it in a vise and using a wrench to create the twist.

*All photos, Dona Meilach*

CHIEN MOQUER. David Hayes. 1964. Forged steel.

*Courtesy, Willard Gallery, New York*

FROM WITHIN. Eduardo Chillida. 1953. Forged iron.
*Courtesy, Solomon R. Guggenheim Museum, New York*

SEATED FIGURE. David Hayes. 1963. Forged steel.
*Courtesy, Willard Gallery, New York*

# Sculptures from Found Objects

A junkyard has fragments, bits and pieces of a civilization which, in its technological advances, has left behind objects that have outlived their usefulness. To many people, junk is an eyesore which should be hidden from view. To the industrialist, this scrap is potential material that can be melted down to form new metal from which new objects can be made. The junk dealer sees his yard full of unrelated objects as a source of revenue. To the artist, junk may be a source of inspiration and potential beauty. A junkyard may be a place where new relationships in terms of art may be discovered.

Railroad spikes lose their identity as they are almost magically transformed into flowers by the artist's imagination and skill. Wrinkled, smashed auto fenders have an inherent beauty in the way their folds and bends catch light, have motion, and can be symbolic of man's inner struggle. Old gas and water pipes assembled in a new order can become a microscope encased in glass.

It is this skillful transformation from nothingness to something meaningful that constitutes the artist's continuing experience with the materials of direct metal sculpture. The techniques for assembling sculpture from these found objects are the same as those used for welding, soldering, and brazing. They depend on the materials to be fused. And in all cases, the tools must be technically combined with the sweat of creation.

Rather than define movement by implication only, these artists have engineered moving sculptures. The *Rooster,* when "turned on," becomes a prancing, dancing, noisy barnyard animal. The springs of the *Crawling Insect* enable it to jerk along in a tormented, yet humorous movement.

121

SMALL PRINCE. William Accorsi. Found objects: letter opener, chain, nails, tin, wood, and stained glass.

*Courtesy, Dene Ulin, Agent*

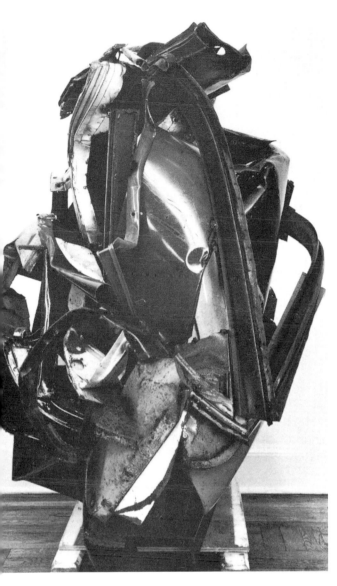

NUTCRACKER. John Chamberlain. 1959. Welded auto metal. Fragments of bumpers and fenders have been juxtaposed into new relationships by forming and welding. The sculpture attains a feeling of movement and spontaneity, although it is almost completely closed.
*Courtesy, Leo Castelli Gallery, New York*

SWINGING OUT. Jason Seley. 1963. Seley limits his sculpture to the repetition of the same basic shape, in this case, automobile bumpers. A completely different sense of movement exists than in Chamberlain's use of auto parts.
*Courtesy, Chase Manhattan Bank, New York*

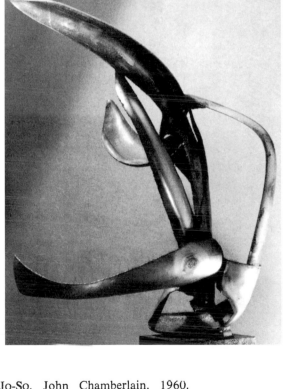

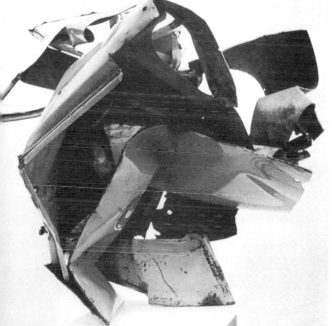

Jo-So. John Chamberlain. 1960. The crushed, bent, yet still painted and chrome parts of autos take on a more open relationship to space than his *Nutcracker*.
*Courtesy, Martha Jackson Gallery, New York*

TEMPEST. Fred Borcherdt. Parts from a plow become winglike forms that balance precariously in space.
*Courtesy of the artist*

COASTAL TERRAIN. Harry Bouras. 1964. Metal welded and embedded in cement. The use of auto parts and scrap steel is hardly evident in this sculpture where the parts lose their identity by becoming submerged in the tense, shifting shapes.

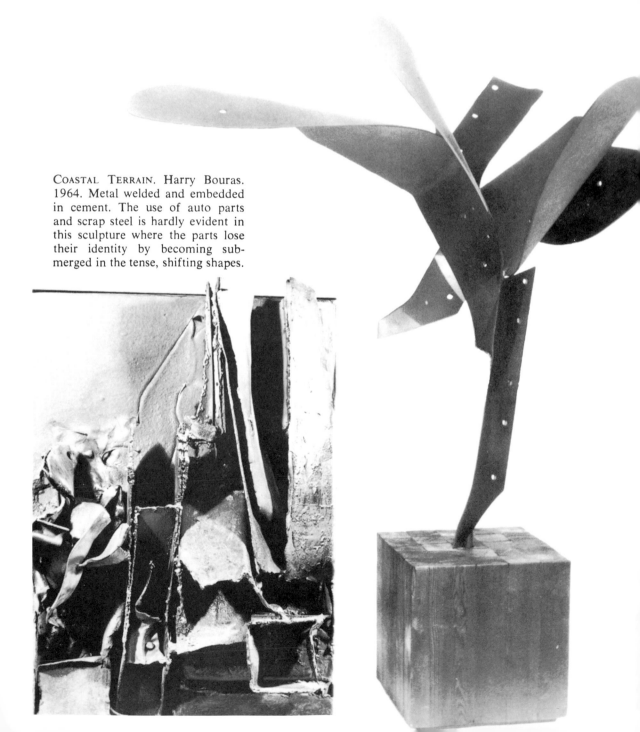

TRIUMPHANT MECHANISM. Jerry Dodd. Bicycle parts placed in a new context resemble a small fortress. The machinelike parts are a continuing testimony to the artist's preoccupation with the influence of our machine age.

*Courtesy of the artist*

Howard keeps his found objects intact and relates the parts through shape or color or both. Painting the scrap pieces of steel gives them a bold, clean contrast to other work left in its rugged state. They stand out, not as the objects they once were, but as basic abstract elements of shape, color, texture, and interesting interrelationships.

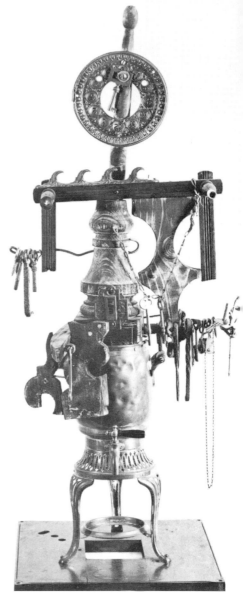

CLOCK GARGOYLE. William Accorsi. Found objects: samovar, keys, metal clock face, chains, wood. Accorsi's work has been referred to as "toys for grown-ups," and Accorsi himself states, "I presume what I have done is to extend in adulthood an overwhelming love of the romantic and whimsical I enjoyed as a child."

*Collection, Dene Ulin Nathan, New York*

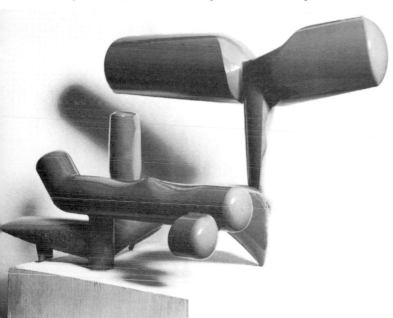

LANDSCAPE XVII. Robert Howard. 1964. Steel and plastic painted red. *Courtesy, Royal S. Marks Gallery, New York*

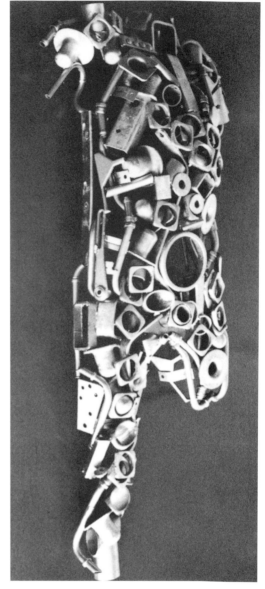

GOLDFADEM. Ken Fadem. Found objects painted gold. This sculpture was created by an interesting variation of welding found objects. Ken Fadem made a plaster mold of the back of his own body. The metal objects were placed into the mold and welded from behind or "through" the mold. The control exerted on the form is contrasted with the spontaneity of the welded parts.

The plaster mold into which the objects were placed, then welded, to create *Goldfadem*.
*Photos, courtesy of the artist*

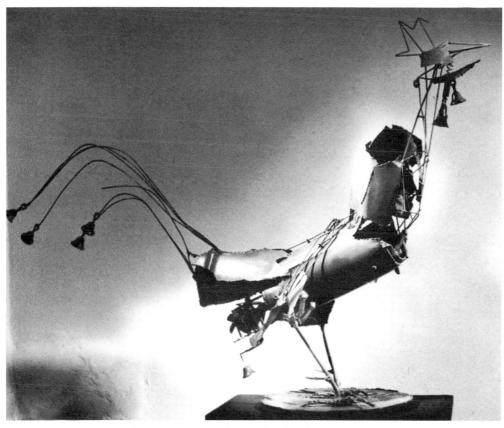

THE ROOSTER. John Kearney. Welded steel painted red.
*Photographed at Ontario East Gallery, Chicago    Collection, Chrysler Museum*

CRAWLING INSECT. Student. Institute of Design, I.I.T., Chicago.
*Instructor, Ray Pearson*

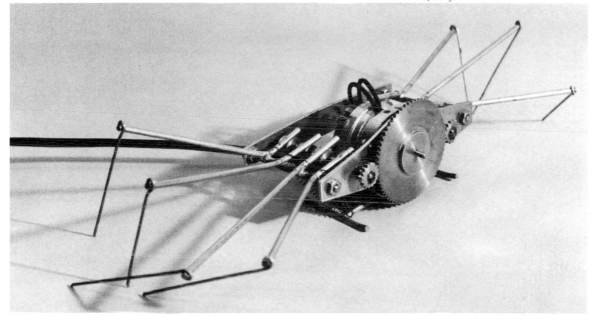

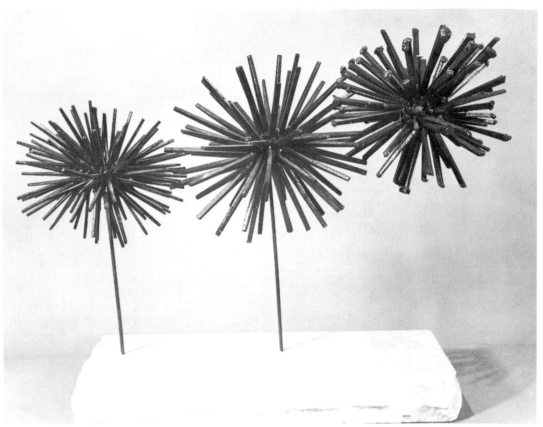

SPIKED FLOWERS. Student, Carl Sandburg High School, Orland Park, Ill. Welded railroad spikes.

*Instructor, Martin Suchor*

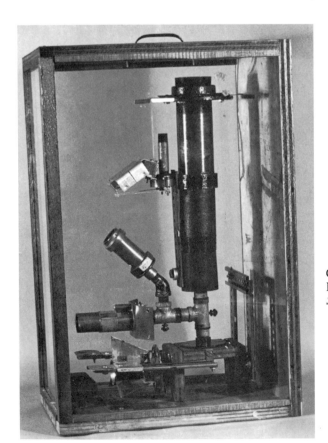

CAGED INSTRUMENT. Dan Wrobliewski. Found objects. Student.
*School of the Art Institute of Chicago.*
*Instructor, Don Seiden*

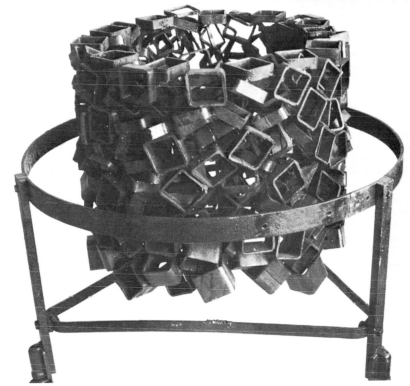

Untitled. Ken Fadem. Found objects arranged and welded through a plaster mold.

*Courtesy of the artist*

Instruction. Richard Stankiewicz. 1957. Welded iron and steel and found objects. The robotlike forms almost take on human characteristics and attitudes.

*Courtesy, Museum of Modern Art, New York, Philip C. Johnson Fund*

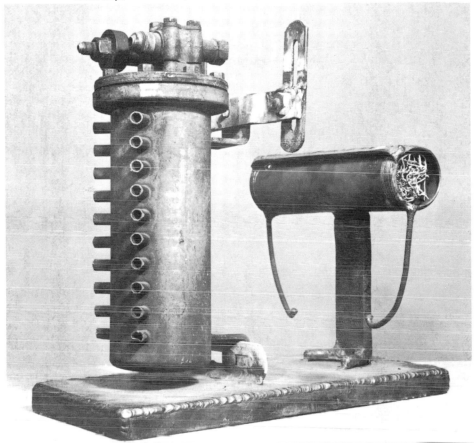

Small pieces of metal are formed by working them on various types of shapers. A circle which has been cut from a sheet of copper with a duckbill shears is worked into a half dome by hammering it into a depression in a wooden block. This procedure is called "sinking." Depending upon the depth, two half domes may be combined to form a sphere, an oval shape, or other shapes. Use a ballpeen hammer for making original forms and a planishing hammer for evening up and smoothing the shapes.

REMEMBER: The shapes must be annealed frequently while working to keep the metal soft. If you wish to clean the copper, bathe the finished form in a solution consisting of 1 part sulfuric acid to 15 parts water. (For brass, substitute nitric acid for sulfuric acid.) The color of copper may be darkened by dipping the metal into a solution of ¼ ounce of liver of sulfur and 1 quart water. If green is desired, expose the metal to the fumes of spirits of ammonia. (See Chapter 2 for other methods of creating patinas and color changes of metals.)

Or a piece of copper is placed *over* a shaper (here a tongue shaper is used) and pounded until the desired form is achieved. This procedure is called "raising."

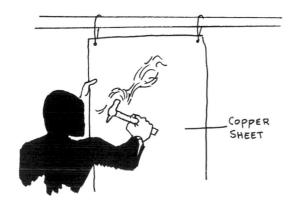

Working from a large piece of metal can be cumbersome unless an efficient method of handling the material is devised. A large sheet of copper can be suspended from a ceiling beam. Then the artist can work from front or back to develop the relief forms. The artist works one portion at a time, annealing each portion as he hammers and stretches the metal. Shapers may be placed behind the sheet as the artist raises or sinks a shape.

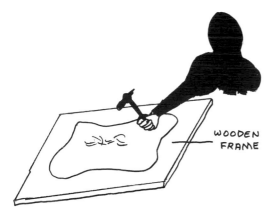

A wooden frame containing the copper sheet is placed on two wooden supports. The artist can work the top first, then flip it over and work the other side. Again, annealing must be done; shapers can be used.

LARGE LANDSCAPE. Robert Cronbach. Bronze. *Courtesy, Bertha Schaeffer*

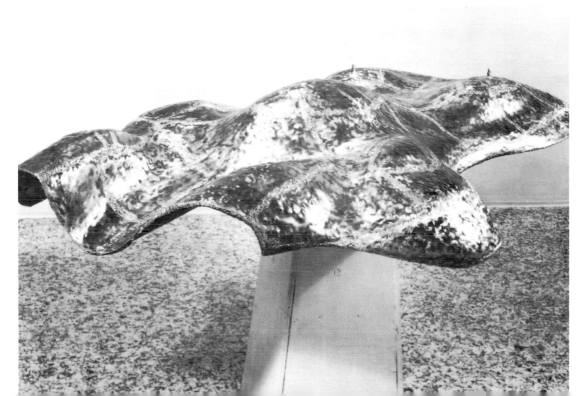

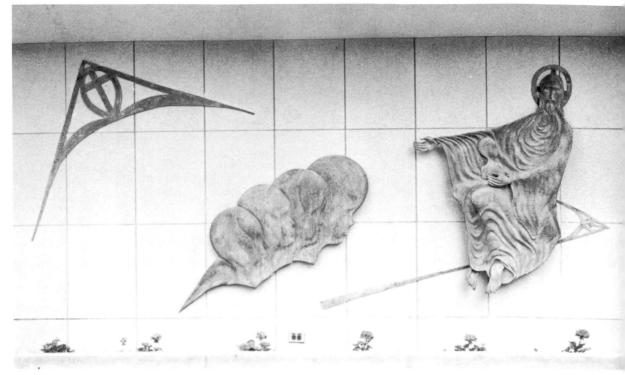

DESIGN FOR A CHURCH. Sam Gendusa. Copper repoussé relief. The shapes were created in separate units and brazed together using phos-copper rods and the oxyacetylene torch.

Gendusa devised this system to create each of the individual shapes needed. Negative shapes of the feet, hands, and head were cut out of plywood. The copper was bolted to one side of the wood (left picture), then hammered into the negative areas. Details of toes, fingers, and bone structure were worked from both front and back. Right picture illustrates the way the copper was hammered into the negative area, designed, and given a relief surface.

*Courtesy of the artist*

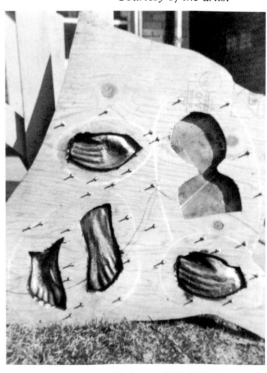

CHURCH DOORS. Albert Vrana. Copper repoussé. The relief or embossed design was accomplished by covering the wooden doors with two layers of heavy tar paper and the copper sheet. Wedge-shaped wooden tools were used to indent the copper and emboss the design from one side only.

*Courtesy of the artist*

VAISOVIE. Wostan. 1965. Hammered copper.
*Courtesy, Galerie Lara Vincy, Paris*

FIELD OF FORCES. Etienne Hajdu. 1956. Copper relief. A rhythmic expression of related shapes that suggest an inner vitality which bubbles to the surface of the sculpture.

*Courtesy, Solomon R. Guggenheim Museum, New York*

SATURNIA. José de Creeft. 1939. Hammered lead relief.

*Courtesy, Museum of Modern Art, New York, gift of Mrs. George E. Barstow*

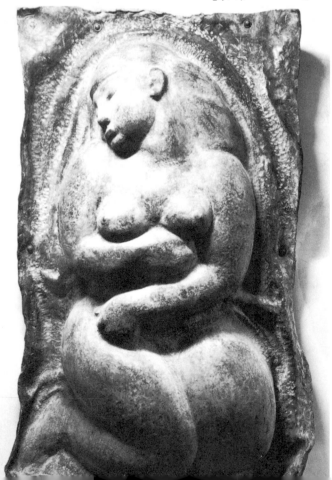

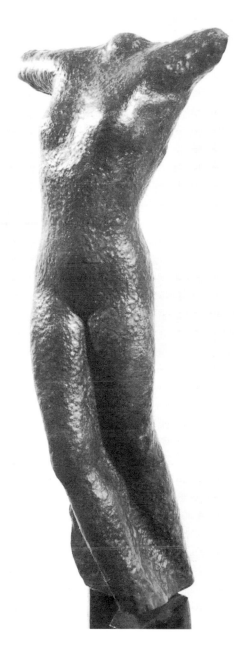

FIREBIRD. Saul Baizerman. 1950–57. Hammered copper.
*Courtesy, World House Galleries, New York*

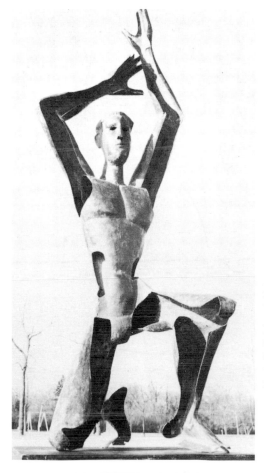

KNEELING YOUTH. Walter Midener. 1964. Hammered Muntz metal. This metal contains 60 percent copper and 40 percent zinc and is harder than brass. Sixteen-gauge sheets are sunk first and then raised over various shapes of metal forms. The different parts are brazed together and a patina applied with acid. This material is extremely adaptable to outdoor use.
*Courtesy of the artist*

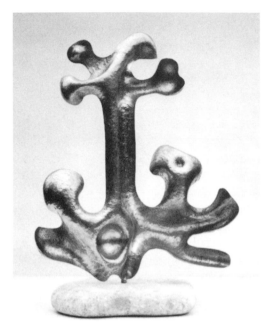

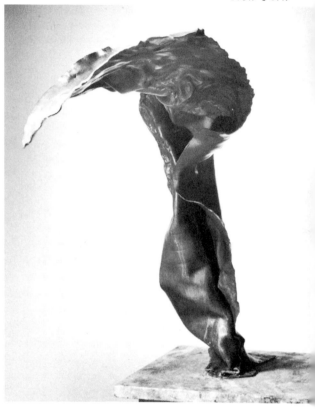

MYTHICAL MONSTER. Richard Kowal.
1965. Hammered copper.
*Courtesy of the artist*

PETIT SOIR LE MATIN. Zoltan Kemeny.
1959. Aluminum and brass. The two
metals have been beautifully combined
to take full advantage of their work-
ability, color, and contrasts. The gray of
the aluminum sheet metal is contrasted
with the rich yellow of the brass nails.
*Courtesy, Art Institute of Chicago*

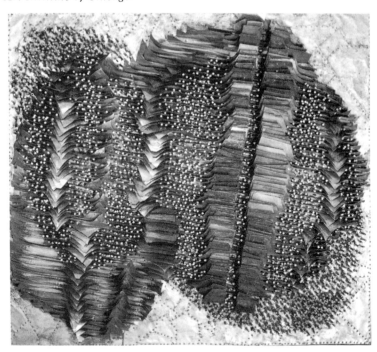

# Combining Ferrous
# and Non-Ferrous Metals

We have demonstrated welding ferrous metals, one to another. We have dealt with combining the various non-ferrous metals. But for many reasons the artist may wish to fuse a ferrous with a non-ferrous metal, which creates certain technical problems.

Why should the artist wish to combine such dissimilar metals that are difficult to join? Sometimes he seeks contrasting qualities in a sculpture: the lightness of bronze with the heaviness of iron; the warm color of brass with the cool color of gray steel; the weightiness of cast iron with the lightness of aluminum.

These combinations pose technical problems which have to do with the molecular structures of the metals and how they will combine physically. For instance, when you weld iron and steel (both ferrous), you break down the molecules of each, and they flow one into the other because they are compatible in their molecular makeup. However, the non-ferrous metals have a molecular structure completely different from the ferrous metals. Their molecules will not flow together. Therefore, to fuse these dissimilar metals successfully requires an agent—the brazing rod. The brazing rod must be compatible with the materials being welded. (See chart, Chapter 2, for the suggested rods and fluxes for combining the various metals.)

The combinations of metals are limited only by the technical problems that must be overcome. Sometimes an arc weld may be more suitable than an oxyacetylene weld. Much depends upon the weight of the materials being joined as well as upon the materials themselves. Again, experimentation is the best teacher.

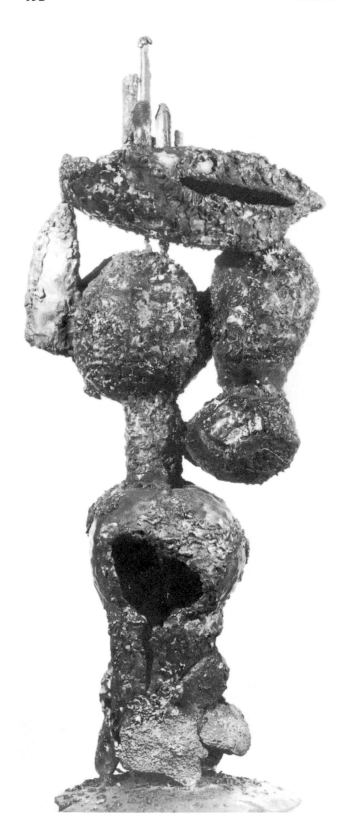

PRISON AND PALACE. Don Seiden. 1965. Steel, copper, bronze, and cast iron. The basic round forms are hammered from sheets of copper and steel. The base of the sculpture is cast iron. Some of the smaller forms, such as the projections at the top of the sculpture, are small bronze castings which were welded to the steel. To achieve a continuity and consistency with varying metals, the artist attempts to relate these materials by color, by rhythmic gradations, and in texture by creating a rugged, mottled surface feeling. The basic structural shape is a round organic form suggestive of caves.

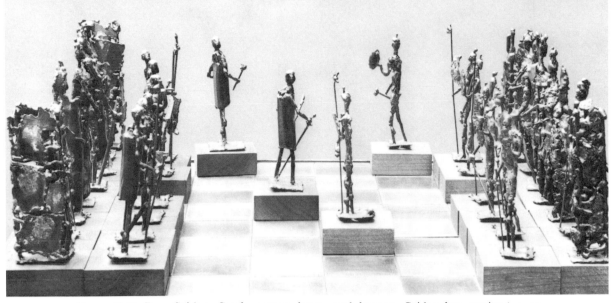

CHESS SET. Don Seiden. Steel, copper, brass, and bronze. Seiden has attained a contrasting visual concept between bronze and steel, although each chessman is made from only one basic metal. One team is made up of players constructed of steel. The opposing team is made of bronze. The board itself is inlaid with copper and brass sheet and measures 24″ square. The figures range in size from 5″–7″. The following demonstrations show how the chessmen were created.

To create the steel figures on the left side of the chessboard, Seiden shapes sheet steel. He works on an anvil placed on a bed of firebricks so he can shape and weld in the same area.

Shaping the body with a hammer. (*Below, left*)

Arms and legs and base are welded, and a bronze rod is used to coat the steel figure's body in places where the artist wishes the suggestion of clothes or other decorations to appear. (*Below, right*)

The finished figure is cleaned and polished to a velvety finish with a rotary wire brush.

The bronze shape is cooled.

To create the bronze figures of the team on the right side of the chessboard, the four sides of a soft firebrick are carved out to be used as the mold. Each side contains the form for a different part of the figure. One side has a broad cavity for the body, another has narrow cavities for the legs, another for the arms, and the fourth side for the head.

Two half sections are welded together to form the body of the chess pawn.

An Everdur bronze rod, which requires no flux, is heated and melted into the firebrick cavity. Here, a front side of the body is being formed.

The powerful moving forms are shaped in sheet steel which is cut, hammered, then welded into the form. The surfaces are coated with bronze or copper rod. Some steel will show through to give the surface a weathered, worn appearance. Additional coating will be added on the finished sculptures.

*Photo series, Dona Meilach*

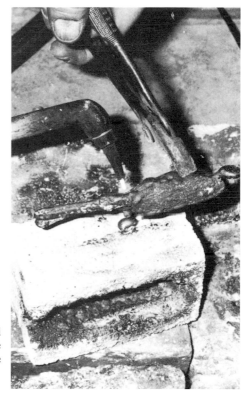

The body, head, and legs are welded, and the figure begins to take shape. Notice how the figure is held with pliers while the torch is worked.

A steel base is welded to the bronze figure.

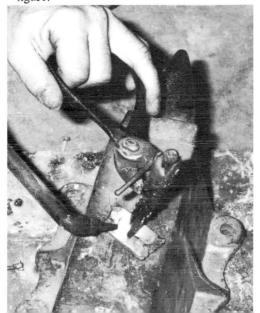

A grinding stone on a flexible shaft is used to give the surface a polished finish in certain areas. Details necessary to identify an individual chessman are added.

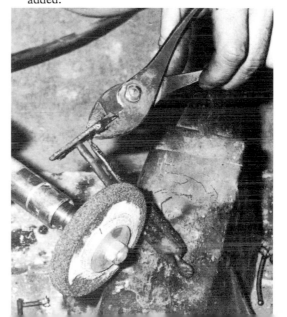

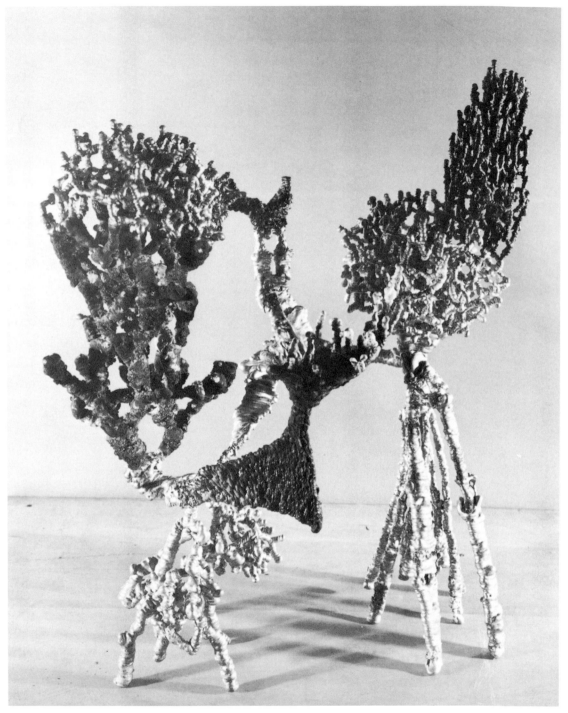

ANTIPODES. Ibram Lassaw. 1960. Bronze, nickel silver, steel, and other alloys. The sculpture, built up drop by drop by melting the various alloys, assumes a quality similar to coral or stalactites and stalagmites.

*Collection, Mrs. Ibram Lassaw*

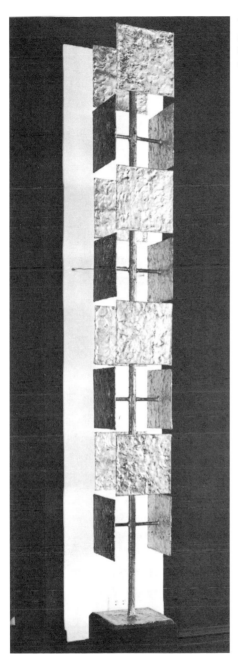

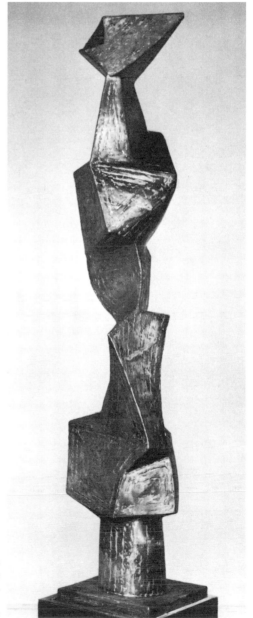

UNTITLED. Harry Bertoia. Bronze, brass, and steel. The metals are handled consistently, but their colors and textures become the aspect of the sculpture.
*Courtesy, Fairweather Hardin Gallery, Chicago*

LA COLONNE. Costas Coulentianos. 1960. Iron and bronze. The dark of the iron contrasted with the light of the bronze gives the sculpture a moving, ever-changing texture.
*Courtesy, Galerie de France, Paris*

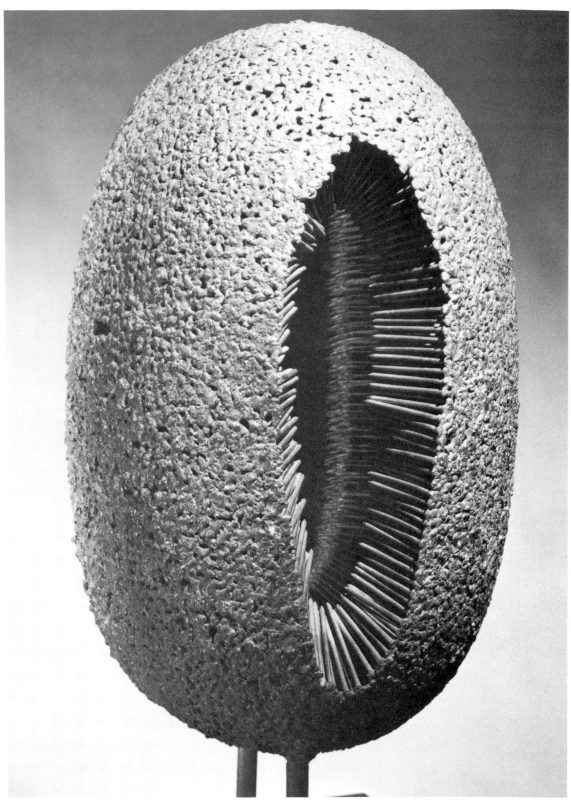

METAL SCULPTURE 14. Dusan Dzamonja. Steel rods, brass, and bronze.
*Courtesy, Tate Gallery, London*

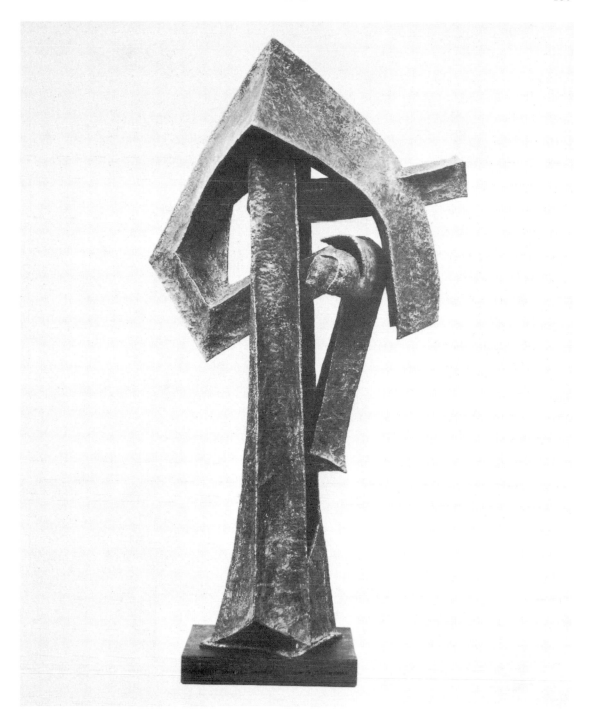

SENTINEL. Seymour Lipton. 1959. Nickel silver on Monel Metal.
*Collection, Yale Art Gallery*

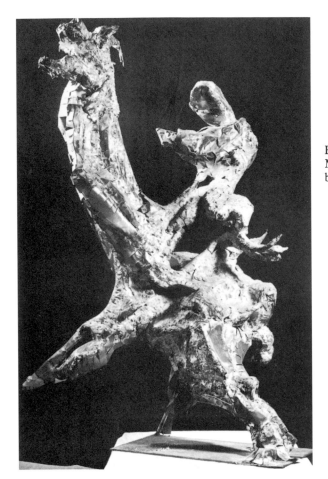

BLACK KNIGHT ON A UNICORN. Geraldine McCullough. 1965. (Unfinished.) Steel, brass, and copper.

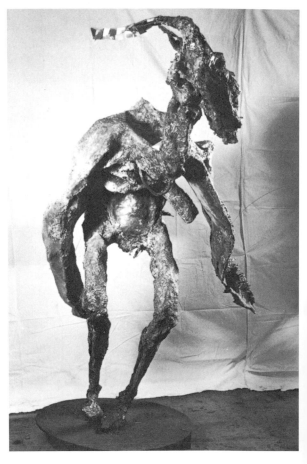

WAR DANCE. Geraldine McCullough. 1965. (Unfinished.) Steel, brass, and copper.

*Courtesy of the artist*

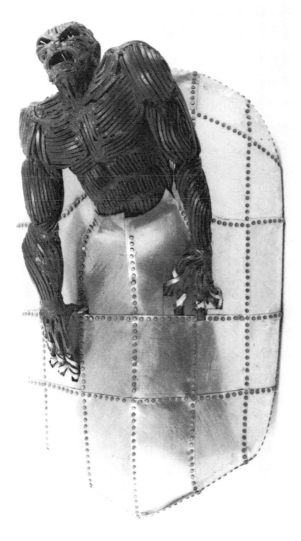

SAM #1. Stephen Auslender. Steel bars, stainless steel sheet, brass-plated nuts and bolts. The agonized struggle of the figure attempting to escape from his container is analogous to the use of different materials which might be trying to break away from one another.

*Photo, Ron Nameth*

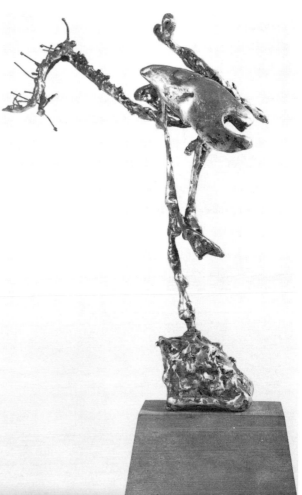

THE MARTYR. Ezio Martinelli, 1954. Bronze, nickel silver, and steel. The materials are contrasted in color and texture. The steel, which is purposely allowed to show through, has a dark, pitted feeling as opposed to the polished areas around it.

*Courtesy, Willard Gallery, New York*

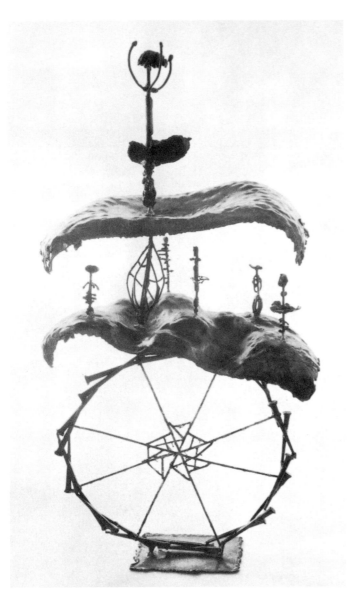

THE BUS. Don Seiden. 1965. Steel and
copper. The two metals are used to com-
pliment each other. The warmth of red
copper sheet acts as protection for the
black steel forms which express the rigid
symbolic figures.

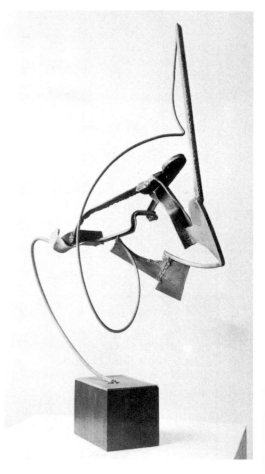

SECOND ALLEGORY. Charles Ross. 1962.
Steel with metallized zinc. Zinc is used
mainly to prevent corrosion and give
color and texture to the welded forms.
*Courtesy, Dilexi Gallery, New York*

UNTITLED. Alfred Brunettin. 1964. Sheet steel shaped and formed, then coated with brass and bronze for the texture.

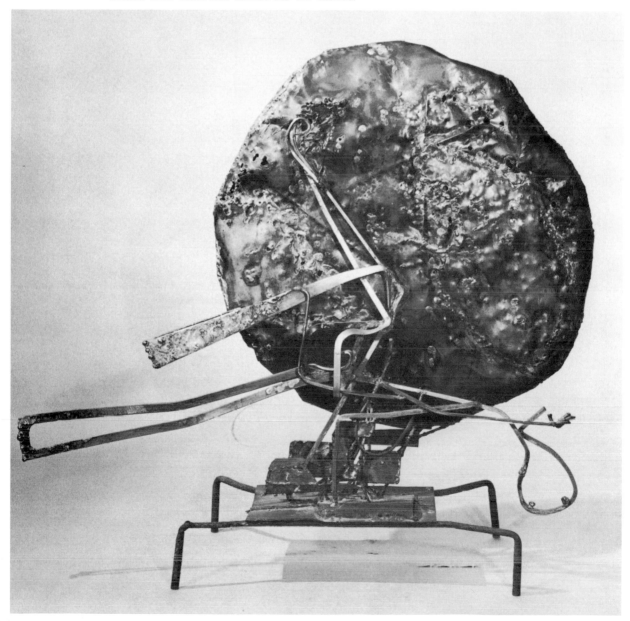

# Combinations of Metals with Other Materials

A metal sculpture does not necessarily have to be composed completely of metal. There are no rules or regulations governing the way the artist must work. He is free to experiment, to invent, to delve into any combinations of materials he likes. And the materials one can combine with metal are almost as unlimited as the forms one can make from metal itself.

An artist will combine materials in an effort to discover relationships that can exist between the materials themselves, between their forms and shapes, between their colors and textures, or whatever happens to fire his imagination.

Often the unique qualities of a material can be more powerfully illustrated when they are contrasted with the qualities of another material. The choice of materials to be combined will depend on what is to be expressed. Yet the materials should always remain subordinate to form and not stand out for their own sake.

Plaster, plastic, cement, string, glass, stone, paint, wood, and canvas are some of the materials that have been successfully combined in the examples that follow. The examples are presented to stimulate your own thinking and perhaps lead you to explore new combinations of one or more materials in the metal sculptures you create.

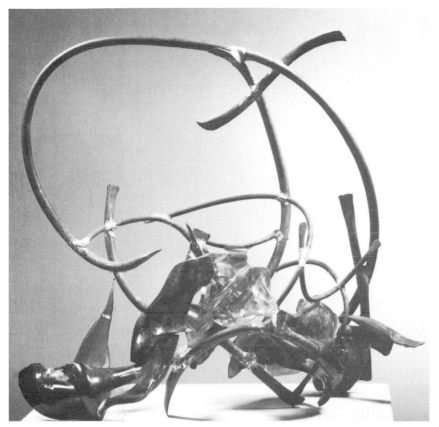

ELEMENT #3. Claire Falkenstein. 1960. Glass
and copper. In this open sculpture composed
of copper tubing, a sense of transparency ex-
ists which is restated by the transparency of
the pieces of glass.
*Courtesy, Martha Jackson Gallery, New York*

CURVED FORMS WITH STRING. Barbara Hep-
worth. The curved sheet aluminum is con-
trasted with the curves and geometry created
by the strings. The shifting patterns and shad-
ows are important to the airy, visual effect.
*Courtesy, Detroit Institute of Arts*

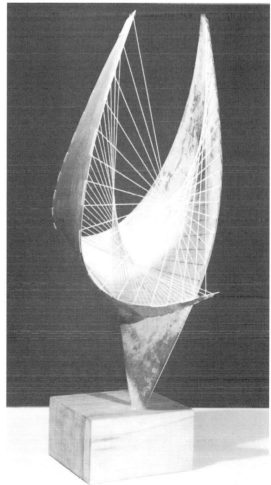

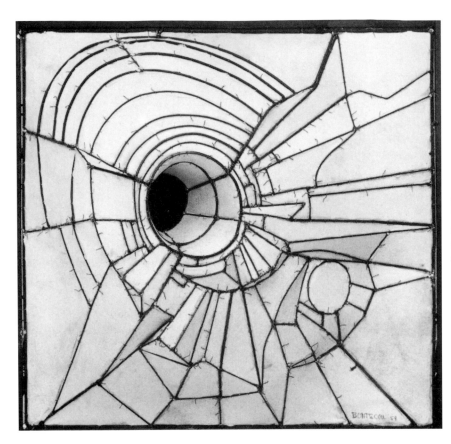

UNTITLED. Lee Bontecou. 1959. Canvas and metal. *Courtesy, Smith College Museum of Art, Northampton, Mass.*

CORONA. Claire Falkenstein. 1961. Metal and glass. *Courtesy, Martha Jackson Gallery, Inc., New York*

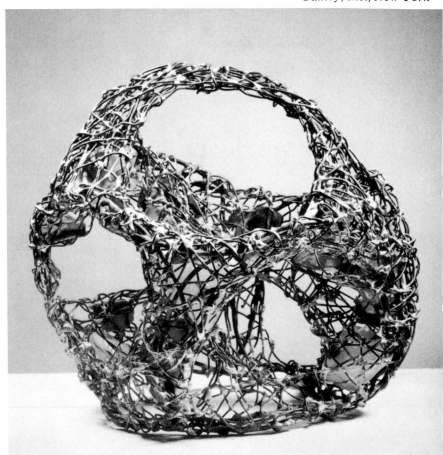

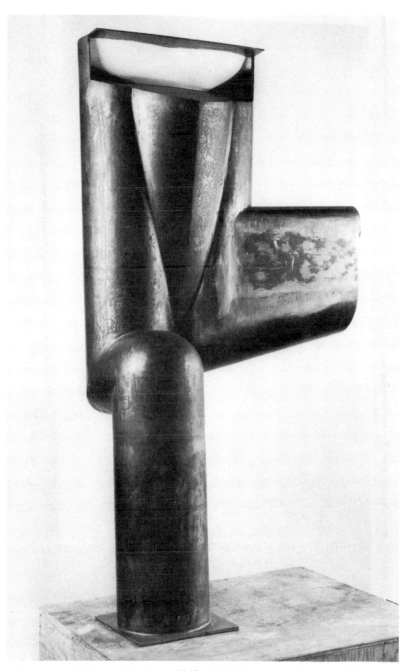

UNTITLED. Edward Higgins. 1962. Welded steel and epoxy. The use of plastics is a comparatively new area for the artist, and Higgins combines them subtly with metal to show industrial and organic forms and their relationships.

*Courtesy, Leo Castelli Gallery, New York*

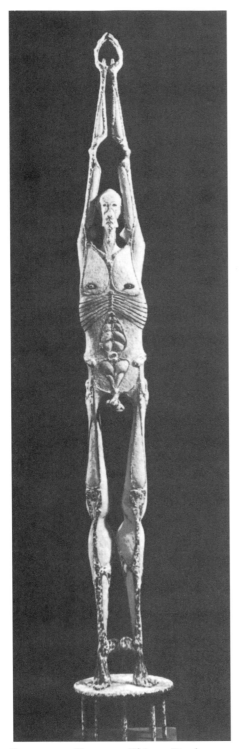

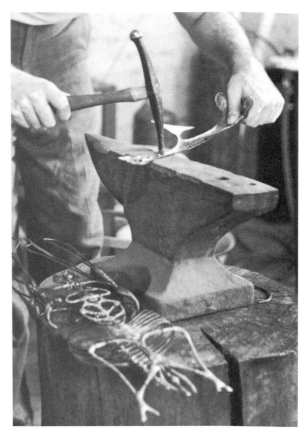

Individual pieces of steel rod are shaped to form the skeleton of the man. A ball peen hammer is used to work the metal against an anvil. The metal must be annealed regularly.

Small "bone structures" are fused together using a brazing rod.

REACHING FIGURE. Eldon Danhausen. Welded metal and concrete. Concrete and plaster are frequently combined with welded and brazed metals. A sculpture composed of concrete and non-corrosive metals will endure weather changes very well out of doors. A demonstration of the creation of this sculpture follows.

*Courtesy of the artist*

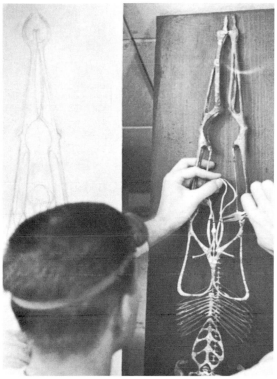

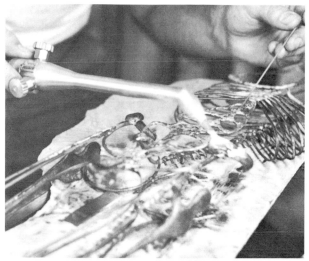

Brazing with a rod.

One complete area of "bone structure" is bent and welded into place. Danhausen places the skeleton against a board to hold its shape as he works to make it conform to his original drawing.

He applies flux to the areas to be brazed with an overlay of bronze, which gives additional color and texture to the skeletal form.

The completed skeleton begins to get "flesh" made of concrete.

The form is further refined by the well-known sculpting and modeling processes. Certainly many of the talents and techniques of the artist are combined here just as the materials themselves are combined.

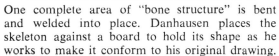

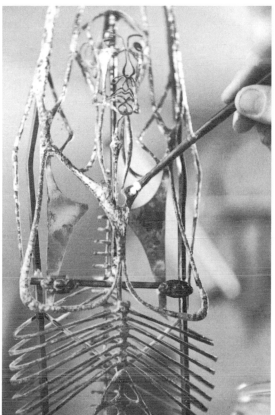

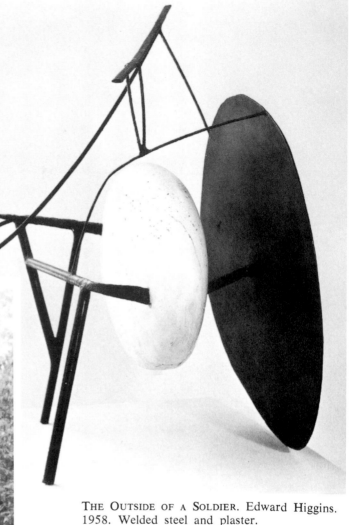

THE OUTSIDE OF A SOLDIER. Edward Higgins. 1958. Welded steel and plaster.
*Courtesy, Museum of Modern Art, New York, Larry Aldrich Foundation Fund*

LION'S MOUTH. Ronald Dahl. Welded metal and concrete on a wood base.
*Courtesy of the artist*

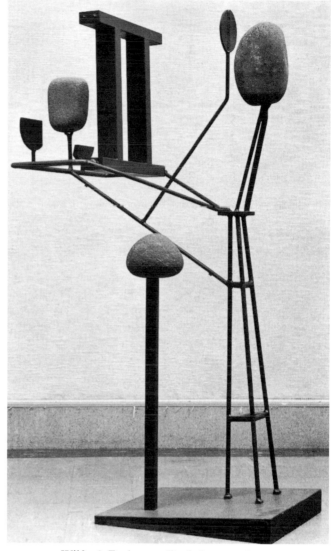

ii. Wilfred Zogbaum. Steel, iron, and cement.
*Courtesy, San Francisco Museum of Art*

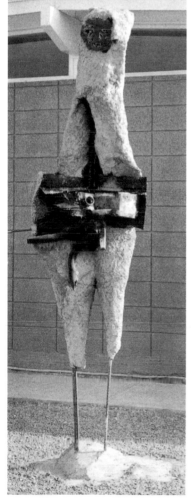

THE WORLD THROUGH THE EYES
OF AN IMBECILE. (One of a series.)
Agnese Udinotti. 1963. Steel and
cement.

*Courtesy of the artist*

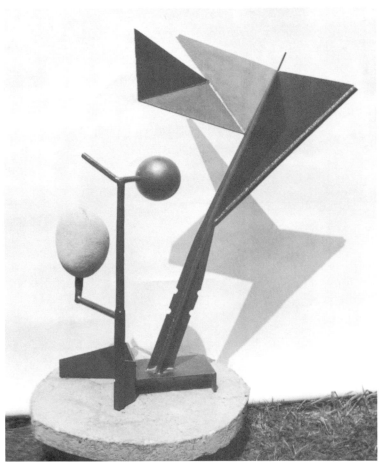

GREAT CAPTAIN ROCKS. Wilfred Zogbaum. 1960. Enameled steel, stone, slate base. Each element of Zogbaum's sculptures retain their identity, yet are independently used. Through a repetition and relationship of form, the materials complement and strengthen one another.

*Courtesy, Staempfli Gallery,*
*New York*

ANOTHER OCTOBER. Harry Bouras. 1962. Forged and welded steel, found objects, and concrete result in a sculpture with an architectural feeling.

*Courtesy of the artist*

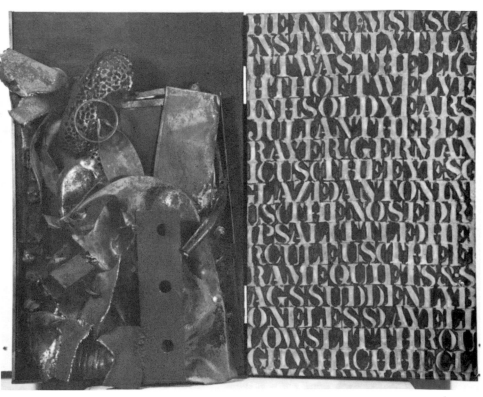

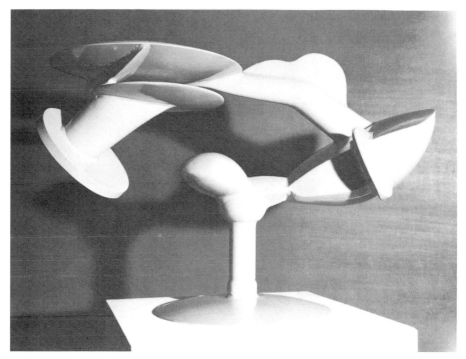

LANDSCAPE XVIII. Robert A. Howard. 1964. Painted steel. The high key colors of yellow and orange tend to unify the flowing moving forms and add a vibrant quality to a peaceful landscape.

*Courtesy, Royal S. Marks Gallery, New York*

MATIERS. Zolton Kemeny. 1958. Aluminum and plastic. Pieces of aluminum square pipe are embedded in plastic in this relief design.

*Courtesy, Hanover Gallery, London*

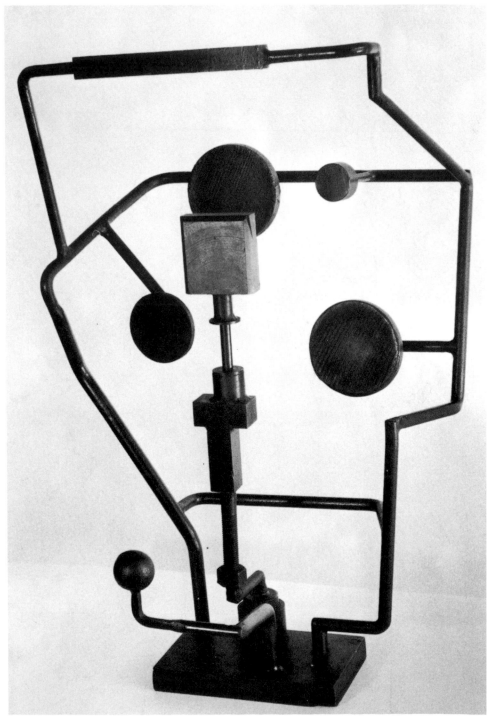

WEDGE SHAFT BRACKET. Wilfred Zogbaum. 1962. Black steel and wood.
*Courtesy, Grace Borgenicht Gallery, New York*

8TH TERRAIN. Harry Bouras. 1964. Welded steel with wood. An old, weathered wooden window frame becomes the containing structure for the conglomeration of found objects and welded steel forms that seem to burst upward from beneath the ground.

UNTITLED. Bruce Fink. Wood with metal. Crude and weathered blocks of wood placed at tense angles mysteriously disclose smooth metal heads partially hidden among them.

*Photographed at Ontario East Gallery, Chicago*

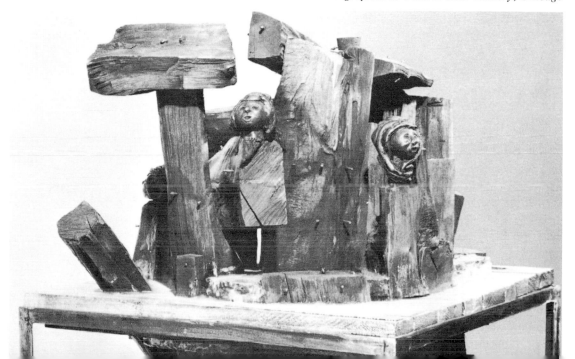

CORE. Harry Bouras. Various materials can be changed from their original shape and texture and suddenly assume a new and vital existence. The large spool becomes a form which shelters a mass of twisted metal shapes. All of the violent activity in the metal is effectively controlled by the containing core.

*Courtesy, Art Institute of Chicago, Mr. and Mrs. Frank G. Logan Prize*

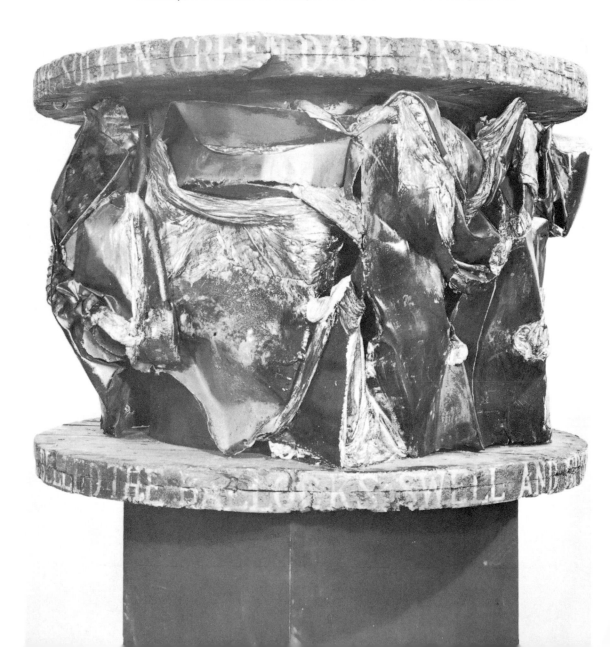

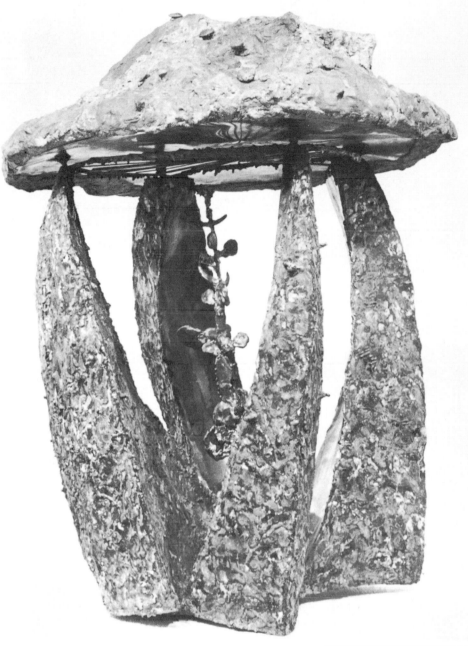

GIANT MUSHROOM. Don Seiden. 1964. The use of many diverse materials, such as steel, copper, bronze, clay, and concrete, is a challenge to the ability of the sculptor. He must attempt to relate all the materials into a simple form which takes advantage of the inherent color and texture of each material. The materials are repeated so that patterns of movement are created. Photo at right shows the understructure in steel and copper sheet of the finished mushroom.

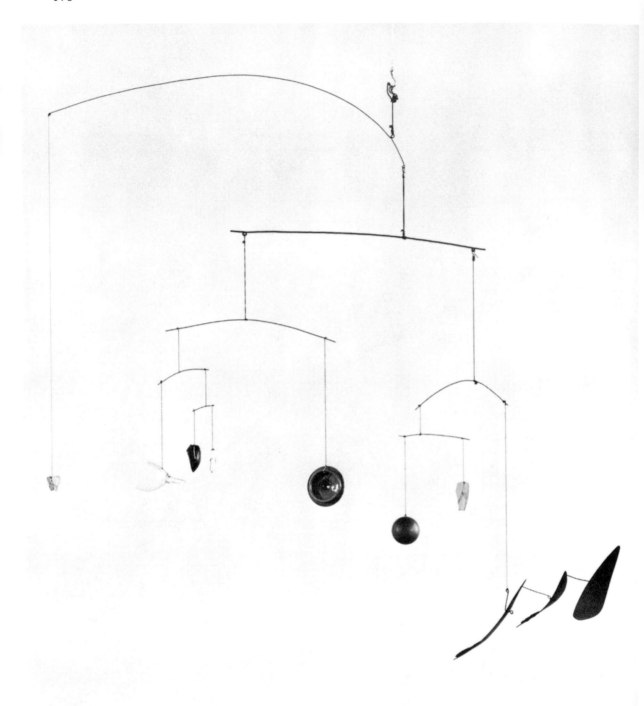

MOBILE. Alexander Calder. 1936. Metal, glass, pottery, wood, and cord.
Calder's mobiles continually move to create ever-changing spatial relations.
*Courtesy, Solomon R. Guggenheim Museum, New York*

# Metal Sculptures
# Made Without Heat

There are innumerable methods for creating a metal sculpture without the necessity of using heat to fuse the joints or add another metal. In Chapter 1, you have already seen how wire sculptures are made without heat. Some sculptors purposely set up a challenge for themselves by creating the problem of joining metals by bending, slotting, screwing, bolting, riveting, or gluing compatible metals. Teachers often present student exercises limiting the lesson to metals that must be joined or designed without heat. The results can be genuinely imaginative and inventive.

The examples shown are further evidence that the techniques are actually subservient to the finished product. The work of art takes form as the artist's creative and physical energy wrestles with the material of his craft. The methods for a complex-appearing work can be deceptively simple, although time, effort, and patience are required.

Besides the joining methods mentioned above, almost all metals can be sawed, filed, hammered, and cut with shears—especially the softer ones such as aluminum, copper, brass, and lead. They can be buffed and polished or left in rough texture.

Both the additive and subtractive processes are employed in the examples that follow. Some are built up by placing one metal onto another. Many are carved out of a core of aluminum or brass in the same way the traditional sculptor carves a form from a piece of marble or wood.

Noguchi works in a variety of methods, and these bronze sculptures, created by slotting and fitting sections together, give the impression of bonelike shapes. The forms as well as the joints become an integral part of the visual experience. See Noguchi's sculptures on page 185.

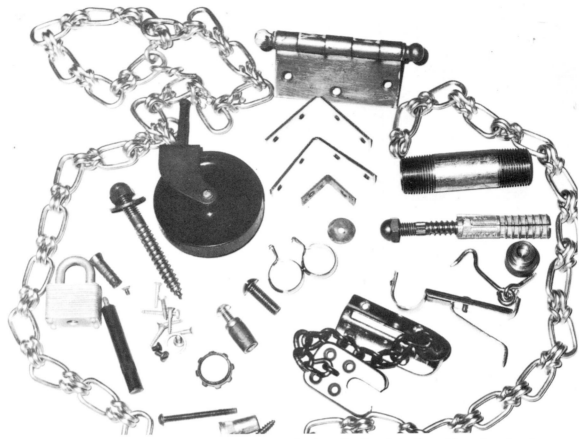

An investigation into the odds and ends of your workbench or a visit to a hardware store will give you endless ideas for joining metals without heat. Every item in this photo illustrates either the method for joining screws, bolts, rivets, bending and slotting, or the metals already joined. The links of the chain are simply bent around one another. The parts of a hinge are folded. The rings for drapes are bent and manipulated to hold them together. Hooks and eyes are bent into one another. The parts of the door lock are attached by bending and slotting. The plaster board sinkers fit into one another and then expand. All these techniques, and the materials themselves, can be adapted to metal sculpture.

Pieces of sheet metal are cut, bent, shaped, and bolted to hold them together.

Sculp-metal, a putty-like metallic material that hardens when allowed to air-dry, is applied over a base of bent galvanized wire. (Chicken wire or any screening may be used also.) Some of the screening holes will be allowed to show through after the sculp-metal is applied. The texture of sculp-metal gives the feeling of painting with a pallette knife. It may be left rough, or it can be smoothed and polished like any other metal after it has hardened. Most hardware stores carry some form of this plastic-like product, which can be used for an entire sculpture or for patching and filling in.

Pieces of scrap metal are easily cut with a tin shears to form a flower.

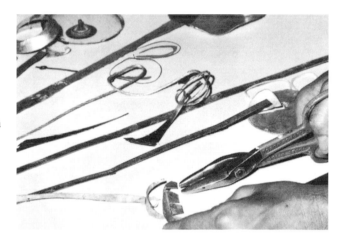

Scrap metal, wire, mesh, and found objects are assembled, then glued to a painted Masonite backing to form a three-dimensional assemblage. Brass, copper, and aluminum scraps are used.

In the basic sculpture workshop at the Institute of Design, I.I.T., Chicago, students develop one design in different materials, then relate the form and methods of construction. The wooden blocks are held together by joints and glue. The parts of the wire sculpture are held together by tension. The heavier metal pieces are simply slotted and bent.

*Ray Pearson, Instructor-Photographer*

From a tube of aluminum, students have sawed, filed, and hand-polished the forms until the design and texture have evolved.

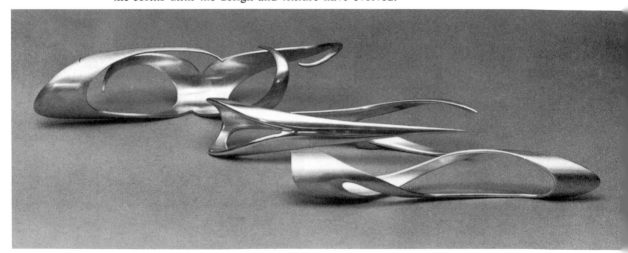

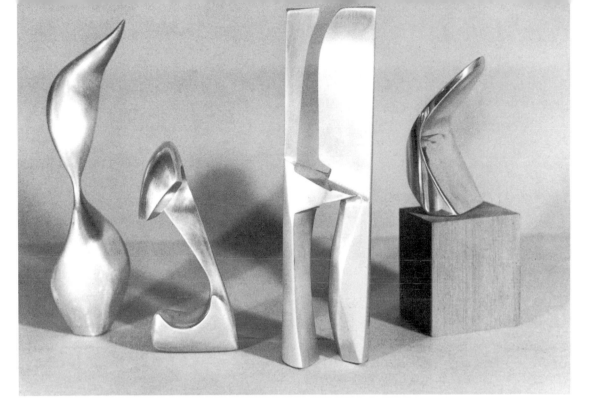

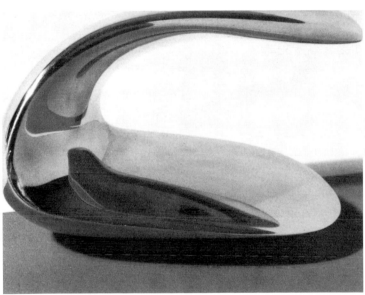

Different shapes that can be "carved" with saws, grinders, and files from a solid piece of metal.

*All examples by students,*
*Institute of Design,*
**I.I.T. Ray Pearson, Instructor**

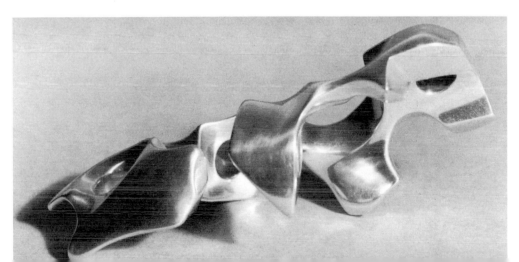

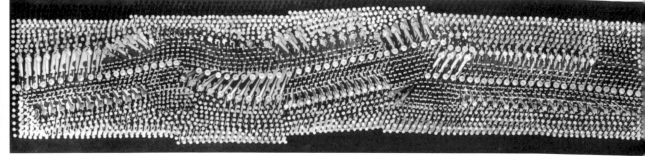

VERTEBRATE CONFIGURATION. David Partridge. 1963. Various-sized colored and shaped nails are combined to give a flowing, supple suggestion to this sculpture with its imaginative use of easily available materials.

*Courtesy, Tate Gallery, London*

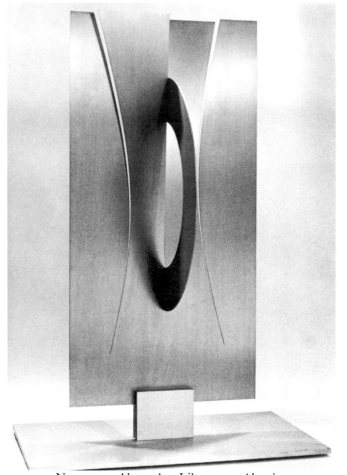

UNTITLED. Conrad Marca-Relli. 1964. Aluminum. Cold, austere plates have been joined without the use of heat. The forms are smooth, stark, and non-moving, yet imply a subtle discovery that motion is present through almost imperceptible changes in plane relationships. The texture that purposely remains from the grinding tool also suggests some movement. (Lower right)

*Courtesy, Kootz Gallery, New York*

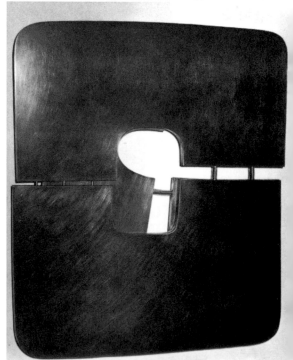

NEPTUNE. Alexander Liberman. Aluminum. Though the forms are joined by slotting, their intersecting, separate shapes retain their individuality. (Lower left)

*Courtesy, Betty Parsons Gallery, New York*

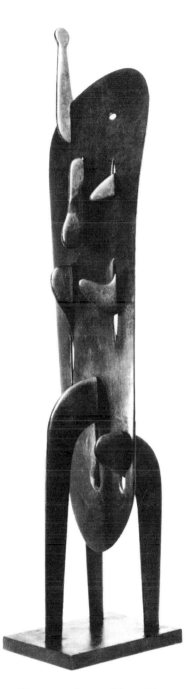

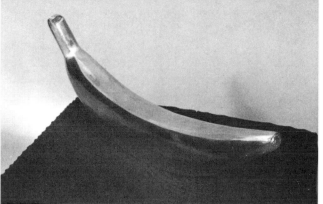

BANANA. Gerald Tomany. Bronze. Student, Art Institute of Chicago. Instructor, Don Seiden.

AVATAR. Isamu Noguchi. 1945. Bronze.

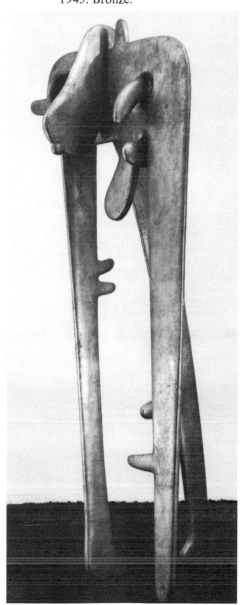

GREGORY. Isamu Noguchi. 1945. Bronze.

*Courtesy Galerie Claude Bernard, Paris*

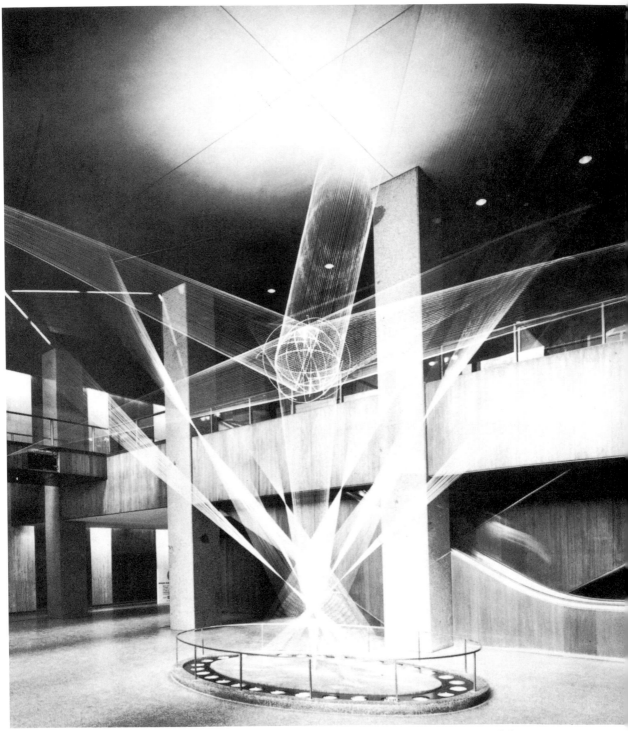

FLIGHT. Richard Lippold. This three-story-tall sculpture stands in the lobby of New York's Pan Am Building. It is made of stainless steel wire and 22-carat rolled gold wire filled with a bronze core. Each strand of the wire is 17/1000 of an inch in diameter.

# Architecture
# and Direct Metal Sculpture

Since the beginning of written history, examples of sculpture used to complement architecture have been evident. The statues of the early Greeks, Romans, and Egyptians were created for many reasons: religious concepts, hero worship, social demands, or pure estheticism. Frequently they were placed where they would become an integral part of the environment of a building. In fact, it was Donatello, in the 1400's, who conceived the idea of "freeing" sculpture from its architectural setting when he designed sculptures which would be set out in the open.

As the popularity of direct metal sculpture grows, its use in architecture is becoming increasingly desirable for several reasons. First, it is a strong contemporary movement in art.

Second, it has many advantages over other materials. Direct metal sculptures are relatively economical as well as versatile. The artist does not have to begin by working in one material

which must then be cast into another permanent material by expensive foundry methods. (With a large sculpture, the cost of foundry work becomes almost prohibitive.) The various metals can be worked directly at less cost. The general freedom which the sculptor has with direct metal work enables him to create on a large scale; the work often goes faster than working in stone or wood.

Third, the type of design which complements and enhances modern architecture is often an open-space construction which emphasizes the spaciousness and simplicity of many contemporary buildings.

Finally, the development and researching of many metals has opened up a variety of possibilities for the sculptor. In fact, many of the steel manufacturers commission sculptors to create constructions using the metals they process.

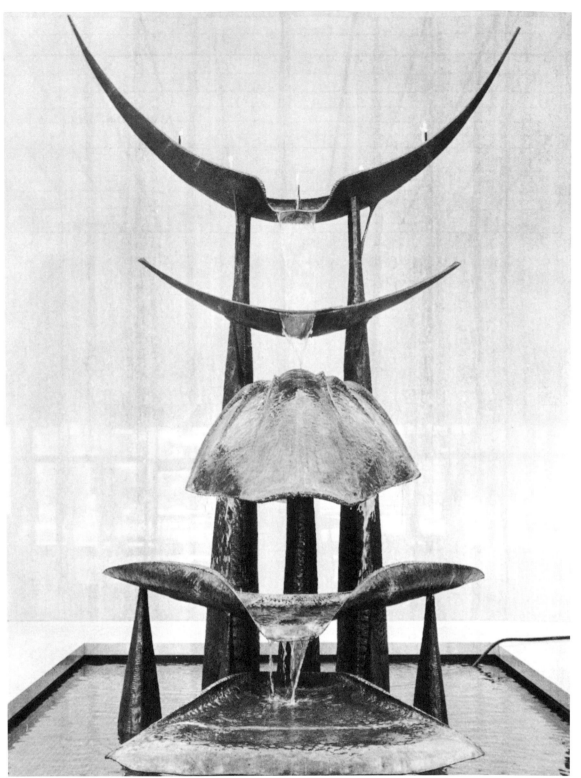

FOUNTAIN SCULPTURE. Robert Cronbach. Federal Building Lobby, St. Louis, Mo. Hammered and welded sheet bronze is used and replaces the traditional bronze casting methods. The forms appear to be floating pieces which utilize the water flowing off each section to create other planes. Water and metal are actually "wedded" to enhance the qualities of each. The result is a visual effect which is strong, functional, and decorative.

*Courtesy of the artist*

HANGING SCULPTURE. Harry Bertoia. Main banking room, Manufacturers Hanover Trust Company, New York. A perfect example of the interest both sculptor and architect share when importance is placed upon airy space and light qualities.
*Courtesy, Manufacturers Hanover Trust Company, New York*

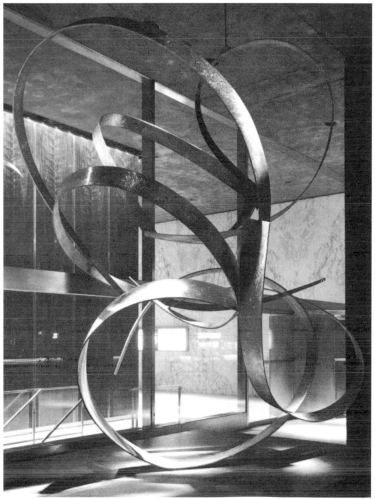

CONTRAPPUNTO. Beverly Pepper. Loggia of the United States Plywood Building, New York. The emphasis on movement gives the 18-foot stainless steel sculpture a living, vital form in an environment which is spatial, geometric, and stable. The top section of the sculpture rotates completely once every five minutes, while the bottom portion remains stable.
*Courtesy, United States Plywood Company, New York*

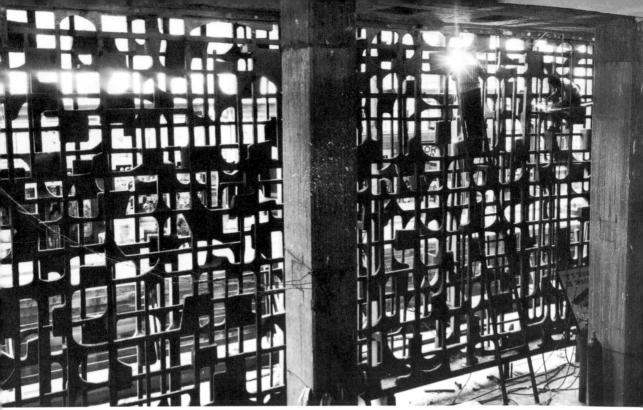

SCREEN. Herbert Hofmann-Ysenbourg. In process of installation in the Nacional Financiera Building, Mexico City, Mexico. Of forged and welded iron, the screen won the artist a gold medal for integration of sculpture with architecture in the 1964 Biennial Exposition. The screen creates an effective and exciting sense of positive and negative interplay.

*Courtesy of the artist*

Among the new metals that artists are trying is a product called Cor-Ten steel. Developed for use in buildings, it is finding its way into the artist's studio. It forms a protective rust coating that prevents the steel from weathering destruction. It can be used outdoors without any protective maintenance. As the weathering continues, the color changes, and an unexpected, unplanned effect will result.

Other metals that are successfully used out of doors are aluminum and stainless steel, both durable and lightweight. Almost any metal can be used for interior architectural sculpture—the only consideration being that they complement the area for which they are designed.

Actually, the metal sculptor's problems are closely allied to those of the architect. The materials with which he deals are those used in the construction of buildings, but the sculptor tends to humanize those materials in the forms he creates. His esthetic considerations deal with the necessity of making the outside and the inside of the building one harmonious unit. The mechanical, technological, and economic considerations are shared by the architect and the sculptor.

When a sculptor is commissioned to design a sculpture for a specific environment, he must plan his work to be compatible with the area as well as to be inherently well designed and constructed. How different become his problems than when he simply creates a free-standing sculpture that may be moved from one place to another. In architectural sculpture, there must be a perfect, ideal marriage between the building and the work of art, yet each must retain its own identity.

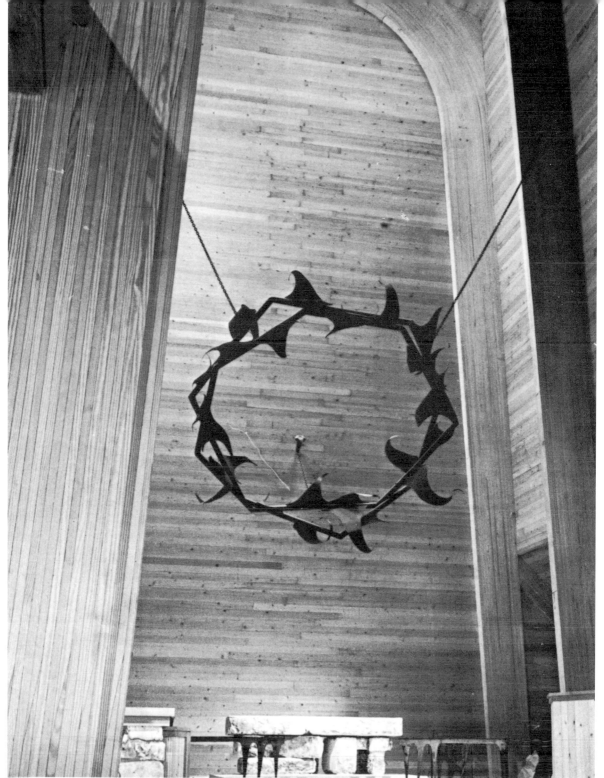

CROWN OF THORNS. Albert Vrana. Hope Lutheran Church, Miami, Fla. Welded iron. Churches and synagogues are commissioning sculptors to create work for their interiors and exteriors. Such buildings are an ideal outlet for the artist who works symbolically or realistically to express these images. Vrana uses three symbolic huge nails and a chain for this hanging sculpture that measures 20 feet in diameter and is suspended 40 feet off the floor. Often, the physical installation of such a sculpture requires a knowledge of engineering.

*Courtesy of the artist*

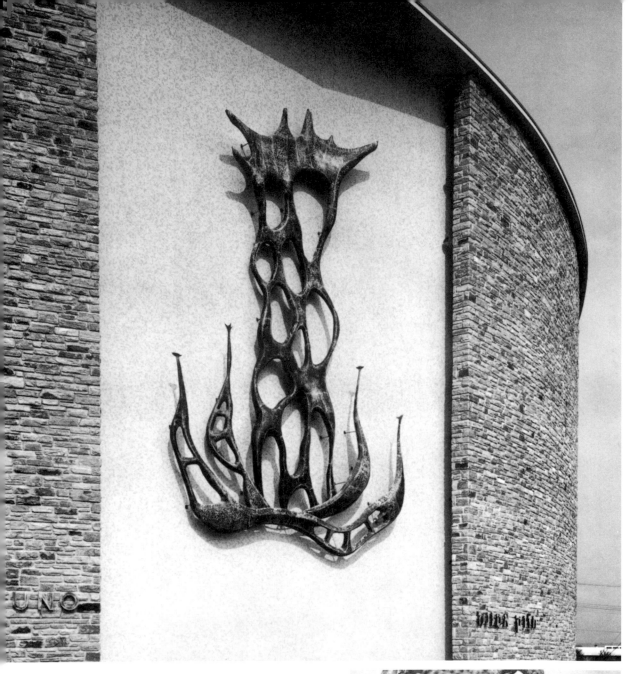

BURNING BUSH. Robert Cronbach. Congregation Chizuk-Amuno, Baltimore, Md. Hammered and welded sheet bronze. The detail of the work in progress illustrates the technique of fitting sections of sheet metal over the skeleton of rod.

*Courtesy of the artist*

LES REMPARTS. Alexander Calder. Stabile created for the grounds of the Foundation Maeght, St. Paul, France. The sculpture becomes an integral part of its surroundings.

*Courtesy, Foundation Maeght, France*

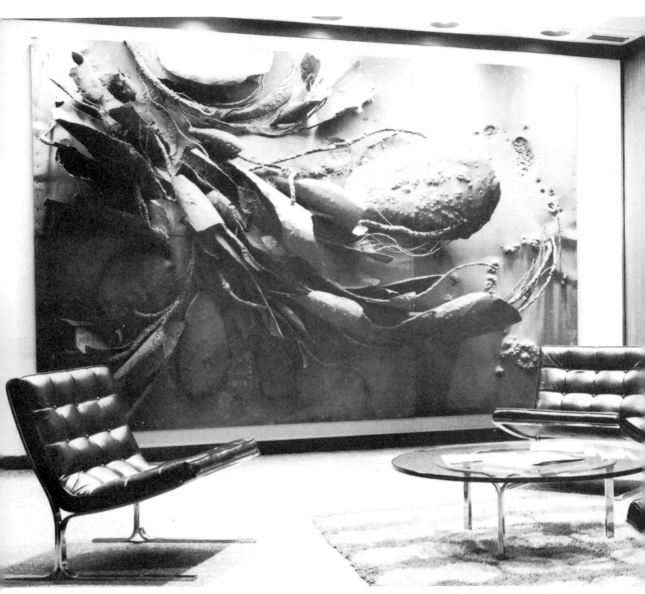

MESSENGER'S FLIGHT. Jack Carlton. Steel. The sculpture is used as a focal point in a simple, effective interior. The violent forms of the metal contrast with the horizontal and vertical of the furnishings to create a complementary situation. By eliminating non-essential furnishings, attention is focused on the once-active area, and the sculpture assumes an importance which would otherwise be dissipated visually.

*Courtesy of the artist*

HOMAGE TO OUR AGE. Richard Lippold. Reception room, J. Walter Thompson Company, New York. Aluminum, bronze, gold, and stainless steel are combined in this elegant display of the use of metals in twentieth-century architecture.

*Courtesy, Willard Gallery, New York*

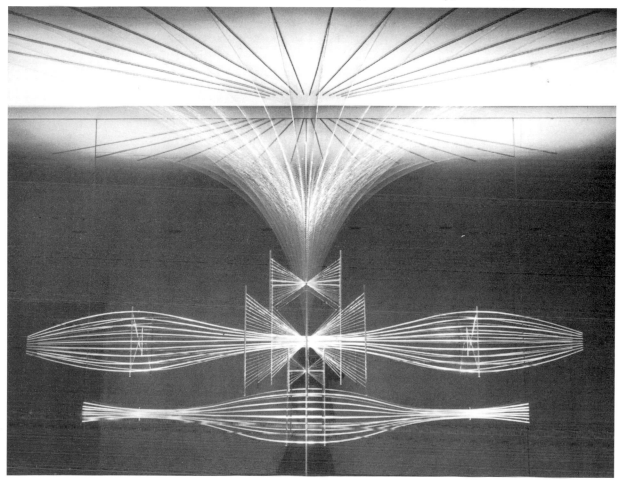

# chapter 11

# Public Art and Sculpture Gardens

Drive into the downtown or business areas of any mid-size or large city today and you will probably observe a variety of contemporary art projects. They may be on main streets, on grassy areas, at road junctures, in front of museums and libraries, in industrial parks, even along major freeways and wherever they can seen by the public. There is exciting activity in the large sculpture market with every indication that it is going to continue.

It is hard to remain oblivious to the current proliferation of art unabashedly designed to permeate the culture of our cities. Much of this activity is the direct result of "The Art in Public Places" program, under the auspices of the National Endowment for the Arts, initiated in 1967. From its rather slow, but auspicious inception, The Art in Public Places program has grown so dramatically that it is now embraced by all 50 states. Its objective is providing communities with grants for commissioning American artists to create works of art for public places.

Art in public places refers to public indoor or outdoor areas that may be owned and/or operated by the public or by a private sector. That extends to buildings and parks, outdoor art museums that are wholly or partially publicly funded, subway and commuter train stations, and college and university campuses. A facet of the program is "Art in Public Buildings," which places commissioned artwork in publicly accessible buildings that are owned and/or operated by the public sector.

When a work of art is commissioned for The Art in Public Places program, the grant provides matching funds for community initiated public art projects. The grant is not awarded directly to the individual; rather it is awarded to an organization such as a museum, city, and federal agency.

Another aspect of public art is integrating esthetic concerns as part of a community's development. A percent-for-art law evolved as part of urban revitalization strategies. This law insures that art works will be included in new public construction and, often, for privately funded construction, too. A full explanation of such programs and their ramifications since their introductions can be found in reports from the National Endowment for the Arts.

These public art projects are a lifeblood for sculptors who can deal with the many and various disciplines involved. Such commissions usually require maintaining a sustained interest in a large sculpture for months, sometimes years, from inception to completion. The artist must consider much more than the artistic concept; he must also be able to present his ideas well, deal with committees, be flexible, and able to alter a concept if unforeseen events occur.

Why has public art become so essential? Galleries are down-sizing the amount of space they have for large sculptures so the audiences for them dwindle. Even when a sculpture is not large, its perception of bulk seems to psychologically fill up a gallery space more than a show of paintings and other media. The nature of sculpture, the materials, techniques, delivery, and installations are costly. Moving pieces about is physically demanding, compared to other media. Because of this, sculptures require special attention that many gallery directors would rather avoid.

Today, some moneys allocated for public art have shifted focus to reflect the importance of the burgeoning effect of technology on the arts. Some funding is being extended to Internet site development that will display the work of organizations and artists. The National Endowment of the Art's Internet site sets an

example at *www.art.endow.gov* . Results of such funding can be seen at *www.sculpture.org*.

### First Review Process

Monies allocated to a community for public art projects usually require that matching funds be raised. That involves several steps generally beginning with a design review process by a committee that considers the overall options for the facilities or the properties in the community. The committee considers the potential for enhancing the architectural environment, the applicability of a project to the site, and initiates feasibility studies.

### Artist Selection

Next, a general call for samples may be followed by an open competition. An arts commission, a peer group, or a committee of specialists may serve as the selection committee. Selected artists are invited to make a proposal for the specific project. Other methods for selection may be used, but this general overview remains one of the most likely processes involved. Depending on the site, budget, function, and other factors, the artwork may be a sculpture, fountain, monument, architectural façade, or other environment enhancement. The piece, or pieces, could be for exterior or interior projects. Often, the competing models are displayed and community reaction and feedback are invited.

### The Artist's Involvement

Ideally, the artist becomes involved in the design phase of the site and works closely with the architects and builder when a new building project is begun. This trend is growing but it doesn't always occur. The artist may be asked to create a piece for an existing site, or in conjunction with the construction, but he may not be involved in the design process.

Without exception, every artist interviewed had a saga related to the public art commission experience. There are the viewpoints of the commissioning body and the artist. All agree that careful documentation and attention to contractual details are essential. There are so many people involved in a large project and so many behind the scene considerations that the artist must have the temperament to function on multiple levels. This may involve dealing with art consultants, art commissioners, risk managers, project managers, architects, landscape architects, insurance agents, public works departments, builders, review committees, lawyers, and more. It's not unusual to work with eight to ten different departments in a town or city on any one project.

Additionally there are questions of weather, wind, earthquake readiness in some areas, building codes, and always, politics, bureaucrats, and people's tastes that can be as unpredictable as the weather. Essentially, the artist is collaborating with all these people. At times, things go beyond one's control. Said one artist, "I go into a meeting asking myself what would I be able to give up and what won't I give up if there are problems. Someone, very often the mayor of the city, must be able to get his or her way and I have to be prepared to negotiate."

### Dealing with Controversy

Abraham Lincoln talked about fooling people but the same applies to pleasing them. Here's the quote slightly paraphrased: "You can please all the people some of the time, some of the people all the time, but you can't please all the people all of the time." Keep that in mind if and when controversy rears its head as it does in almost every project. Some will love it, some will hate it, some will vacillate between one side and the other, but never will all the people be in agreement all the time. Unless an artist and the appropriate committee can defuse flare-ups, a project can go awry before, during, or even after, it is installed. There have been cases where the completed public artwork has been removed. Potential exigencies must be covered in a watertight contract. Amid such distractions, and possible derisive innuendoes, the artist must have a thick skin if controversy flares about a commissioned project. He must meet the terms of the contract and insist that others do the same.

Generally, most projects proceed in relatively smooth relationships with problems easily worked out between reasonable people.

Not all large sculptures are commissioned under the National Endowment of the Arts aegis or The Art in Public Places programs. Projects that are installed in large indoor or outdoor spaces may be on private grounds such as sculpture gardens, corporate properties, memorial sites, hospitals, restaurants, indoor atria, and elsewhere. The examples shown are meant to serve as an overview of projects that have made it through all the processes and are happily installed on their sites. The series by Rod Baer provides insight into the techniques, equipment, and space involved, and the reason that fees for large pieces may range from $10,000 to $100,000.

The artist must often rent heavy equipment, have one or more assistants, contract out some portions of the job, have concrete poured for foundations, and pay liability insurance for a year even if the job takes only two or three days. There are often unplanned exigen-

cies that can end up costing more than budget allowances, and those costs may be passed on to the artist unless contract terms cover anything and everything that one may never anticipate. Add to the artist's costs the advice of a lawyer knowledgeable in writing such contracts.

### Sculpture Parks and Gardens

Sculpture gardens and parks are not a recent phenomenon, but oh, how they have changed. Gone are the formal, "do not touch the sculpture," gardens. Today's sculpture environments may be small and intimate like the one behind the Carlsbad Art Office in Carlsbad, California, or they may be extensive such as the sculpture garden of the Hirshorn Museum in Washington, D.C. Classic gardens of old may have sculpture strategically installed so as to prevent contact with the viewer. A large sculpture may be surrounded by bushes and plants, and often is in the center of a pond.

The contemporary sculpture park or garden may feature pieces that you can get close to, touch, perhaps sit and climb upon and through. Recent installations by Nicki de Saint Phaelle consist of large tile-encrusted pieces installed in Jerusalem, Israel, and elsewhere. They are often laden with climbing children or people peering through the negative areas so friends can photograph them.

In the sculpture garden surrounding the Albuquerque, New Mexico, Museum of Art, a bench composed of seated figures puts you in the scene if you decide to sit down and rest. These enhanced public spaces are so popular that the number of sculpture parks and gardens is growing throughout the world. The International Sculpture Center (ISC) published its first Directory of Sculpture Parks and Gardens in 1987 containing 97 entries. By 1996, the number included 195 and, at this writing, the figure was over 250 with more scheduled to open in the new millennium. The list can be found on the Internet at *www.sculpure.com* (the ISC

site). In October 1999, the ISC held a special conference devoted to Sculpture Parks and Gardens.

Today's sculpture parks and gardens fall into four broad categories: 1) "open air" collections, 2) "museum gardens," 3) "aristocratic" gardens, and 4) "ancient sculpture sites." These may be further categorized into public, private, corporate, and institute collections such as those at universities or hospitals. Sometimes a park will be devoted to one person's work or to a single theme. Funding may be the result of public, private, and corporate largess.

No matter the name, or who is paying for the artwork, sculpture parks and gardens are an increasingly attractive venue for sculptors. As in public art spaces, sometimes the artists become involved with the park's design from the beginning; other times sculptural work is placed on consignment for a temporary exhibition or, if it's a popular piece, it may be purchased outright from the artist.

Some cities consider their whole community as a park and display sculpture throughout. One such city is Brea, California. There is so much sculpture on public and corporate sites that the city provides a map to all the places. Often buses, filled with art loving tourists, can be seen making the rounds of the sites. The park areas near the capitol buildings in Ottawa, Canada, are a virtual playground of sculpture for children and adults to enjoy. Big cities such as Chicago, Illinois; Philadelphia, Pennsylvania; Manhattan, New York; and Seattle, Washington; have been displaying modern monumental public art for decades.

For additional information about sculpture gardens, sign on to *www.sculpture.org*. There is a world map citing countries that have sculpture parks and there are Internet links to various sculpture garden sites. Some sculpture gardens exist only in Cyberspace, but the work exhibited may be purchased in whatever medium is used by the artist.

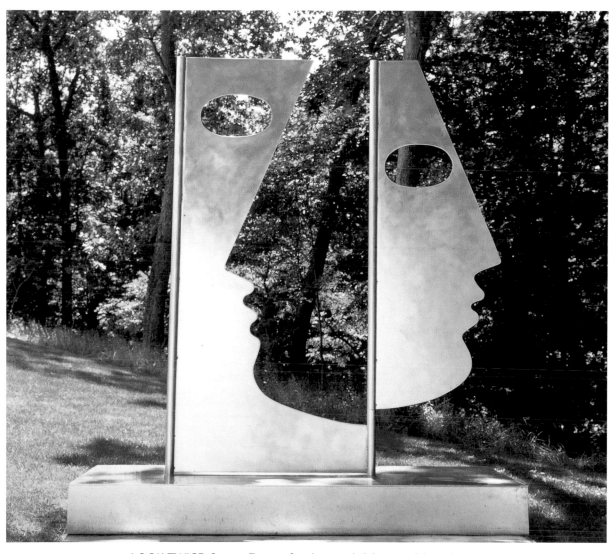

LOOK TWICE. Strong-Cuevas. Stainless steel. A large mobile with one
moving element. 8.5' high, 8.5' wide, 8.5' deep.

*Photo, Renate Pfleiderer*

THE WAY. Alexander Liberman. Eighteen salvaged steel
oil tanks assembled and painted in an abstraction of
classical ruins of post and lintel architecture. Liberman
referred to this as "free architecture" having the impact
of temples or cathedrals. 65' high, 102' wide, 100' deep.
*Collection, Laumeier Sculpture Park, St. Louis, Missouri,
with the support of a gift from Alvin J. Siteman and through
funds from the National Endowment for the Arts*

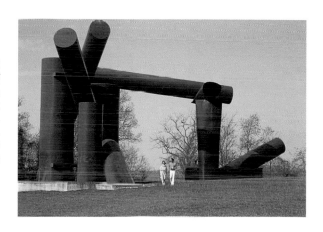

In Ottawa, Ontario, Canada, sculptures installed on Parliament Hill are meant to be interactive. Children climbing on the sculpture appear to become part of the piece.
*Photo, author*

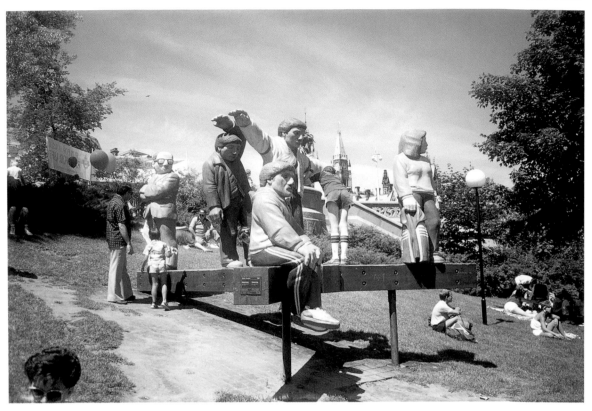

Sculptures are installed throughout the campus at the University of California, Los Angeles, in a classic installation of public art.     *Photo, author*

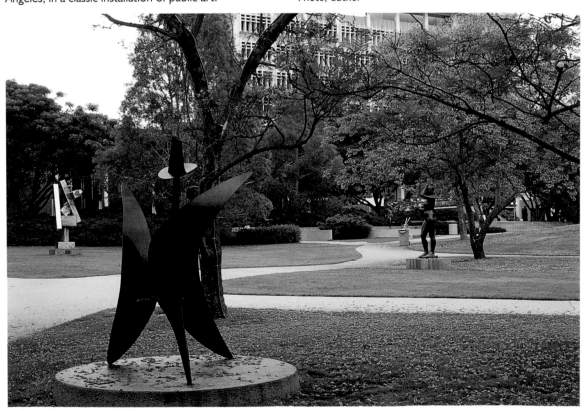

TOTEM POLES. In reality, public art isn't so new  In many cultures, the ritual items of the people became their public art as in these totems and other pieces by the Northwest Coast Natives of Victoria, Vancouver Island, Canada.
*Photo, author*

THE FLOATING CLASSROOM. Rod Baer. A one-year temporary installation commissioned for California State University, Bakersfield, California. Chalkboard and furniture are welded steel. Each element of the faux classroom has its own separate floor with sections linked via underwater cables, anchors, and floats. The grid system maintains the aisles while each desk responds to wave and wind motion independently. 8' high, 16' wide, 20' deep.
*Photo, artist*

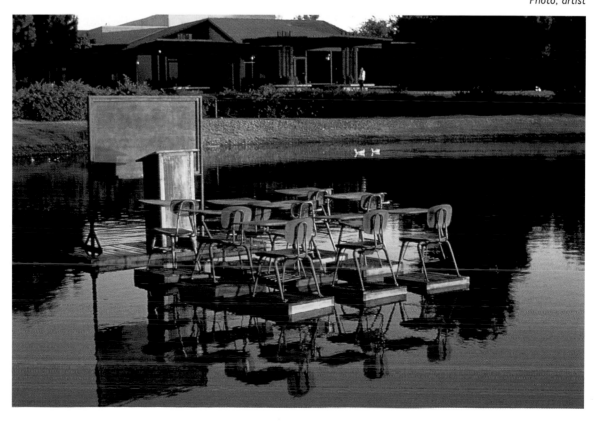

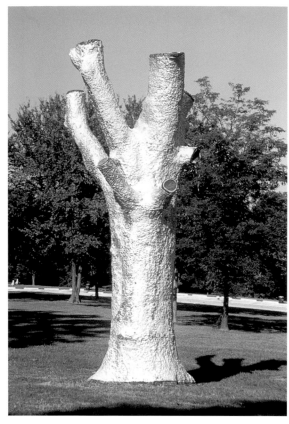

*Top left:* THE PALM AT THE END OF THE PARKING LOT. Robert Lobe. Aluminum over a tree trunk and a stainless steel base. Panels of aluminum are wrapped and formed around the upright trunk and branches of a dead walnut tree with a pneumatic hammer. His combination of nature and technology becomes a new statement that is as modern as it is classical. 17' high, 8' diam.

> *Courtesy, Laumeier Sculpture Park, St. Louis, Missouri Commission.*

*Top right:* WELDED TREE IN LANDSCAPE. Italo Scanga. Expanded metal, glass, and chain. 9' high, 11' wide, 2.6" deep.

> *Collection, Pilchuck Glass School, Washington, Photo, Roy Porello*

*Bottom right:* MALCOLM BRUCE COURTYARD with Gate and Yin and Yang fountains. Russell Jaqua. An architectural commission for a public space may include an entire environment. The courtyard for the Jefferson General hospital, Port Townsend, Washington, includes two fountains that are linked by a pathway of pavers and river rock. A large gate leads into the courtyard. Contrasting forms, textures, and water activity portray the concept of a yin/yang relationship. The design challenge was achieving a balance between the metal design and controlled water activity appropriate to the metal forms. Underground engineering allows for the "laminar flow" of the Yin fountain and the "cascading flow" of the Yang fountain.

> *Photo, Robert Gibeau*

YIN FOUNTAIN and GATE. Russell Jaqua. Spun, forged, and fabricated bronze with a patina on a spun mild steel base, galvanized. The mild steel gate has stamped medallions with a rust patina. Yin Fountain 32" high, 72" diam. Gate 8' high, 20' wide.

*Photo, Robert Gibeau*

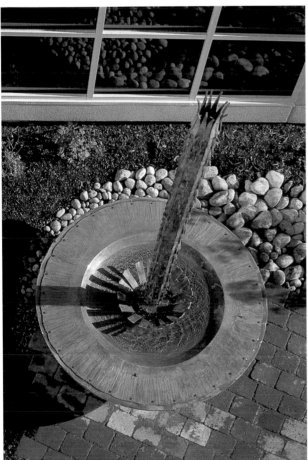

YANG FOUNTAIN. Russell Jaqua. Spun, forged, and fabricated bronze with a patina on a spun mild steel base, galvanized. 32" high, 72" diam

*Photo, Robert Gibeau*

IN CONTEMPLATION OF MISSING TEETH. Rod Baer. 1. The original sculpture, "In Contemplation of Missing Teeth" is a wheel with different iterations of chairs affixed to the circumference and other chairs scattered nearby. Here, it is installed on a street in Los Angeles, California. After its purchase by a large corporation, additional related pieces had to be created for the larger grounds. The single circle was expanded into an entire mechanism of a wheel and gears. The new installation called for various fragments and arcs of chairs and cogs partially buried in and around the landscape of numerous buildings within the corporate retail complex. See following phot series. 60' high, 30' wide, with scattered chairs, wheel is 27' diam.

*Tri City Corporate Centre, San Bernardino, California.*
*All photos, Rod Baer*

2. I beams were commercially curved. Depending on size, they were either fitted and drilled for future connection, or welded together at the studio. Chairs were spaced and fitted onto the double hoop configuration. Small reinforcing crossbars were added to the larger circle for increased stability against earthquakes and the region's high winds. A large, well equipped studio or work space is a must for such projects.

3. The large sculpture had to be transported in sections, then assembled using a roped off empty parking lot as an assembly area. Gusset plates were bolted together for proper positioning. Chairs and sections were sanded clean with small disk grinders, and then welded into place.

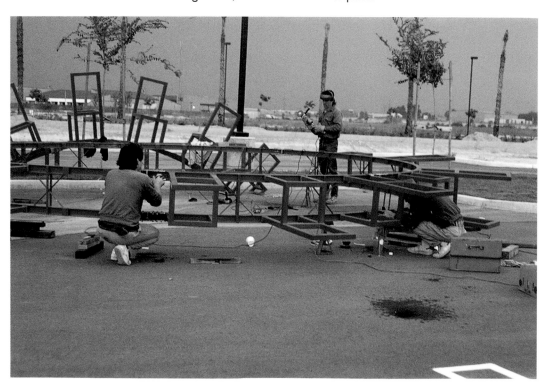

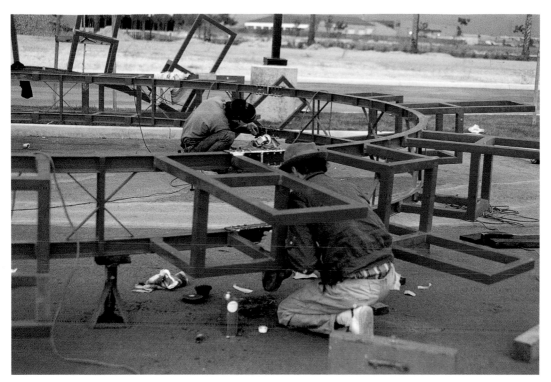

4. Assistants cleaned the welds and any burnt areas. Joined areas were primed and painted.

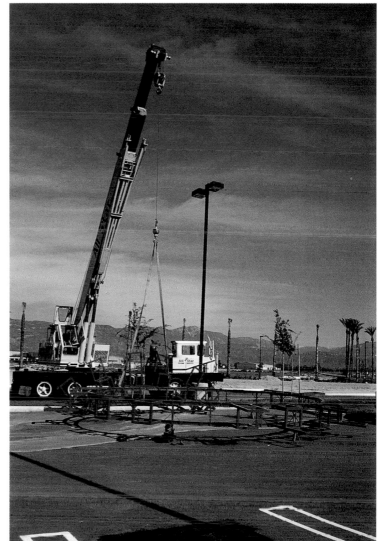

5. Bolts on the underside kept everything rigid because a crane was used to flip the sculpture for welding on the reverse side.

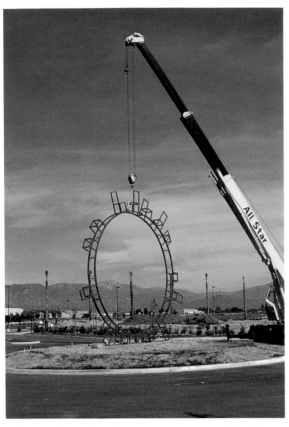

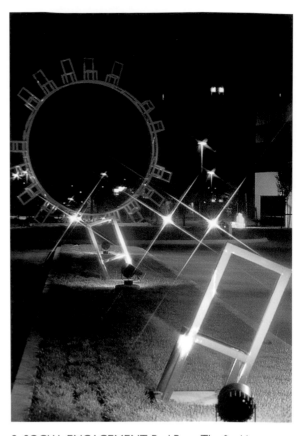

6. On installation day the crane was again used to lift everything as one unit and carry it to its final position within a traffic circle on the median in front of the main buildings.

8. SOCIAL ENGAGEMENT. Rod Baer. The final large sculpture, re-titled, creates an entrance landmark approximately three stories high. Chairs are all slightly larger than life size. The piece was painted to visually distinguish it from surrounding buildings. The high gloss catalyzed polyurethane coating also reduces maintenance; without a coating it would oxidize and rust. Lighting engineers planned spots for dramatic night lighting.

7. The piece had to be bolted to a poured concrete formation.

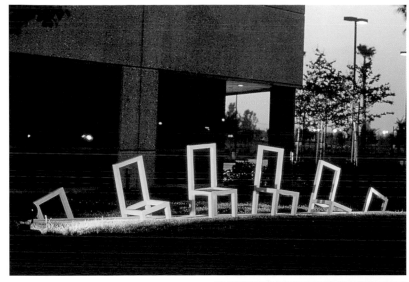

9. A smaller arch of chairs sits in front of another entrance.

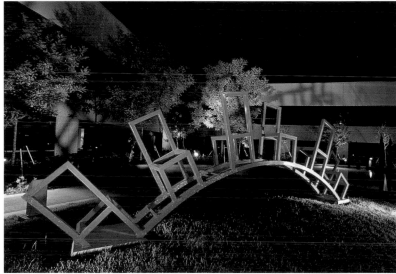

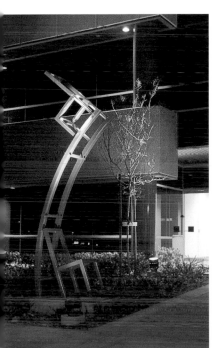

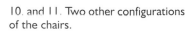

10. and 11. Two other configurations of the chairs.

*Photo series, Rod Baer*

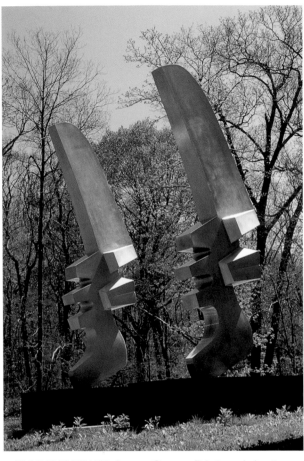

RUNNING HEADS. Strong-Cuevas. Fabricated aluminum. Each piece is 16' high, 4' wide, 7' deep.
*Photo, Renate Pfleiderer*

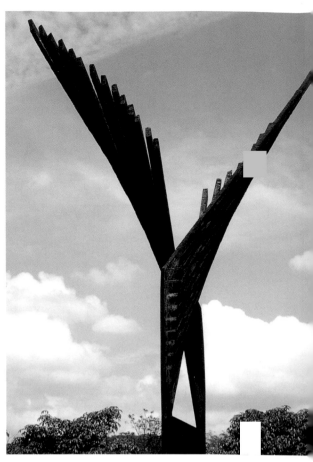

NEW IDENTITY. Simon Benetton. Cor-Ten steel. The campus of the Collezione Centro University, San Paulo, Brazil. 21' high, 7.5' wide.

*Courtesy, artist*

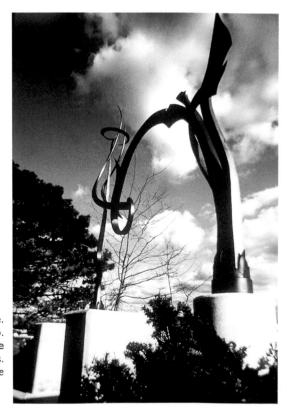

HALFSIDE JACK. John Medwedeff. Steel arch sculpture.
23' high, 17' wide, 3' deep.
Adjacent to the Illinois Artisans Building, Illinois State
Fair Grounds, Springfield, Illinois.
*Photo Jeff M. Bruce*

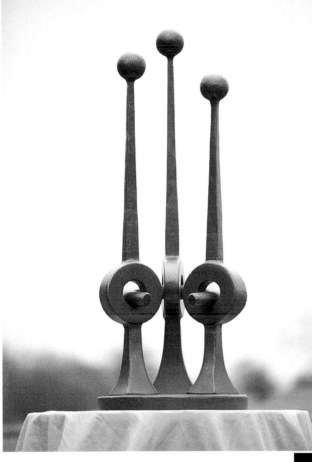

CONNECTED. Paul Margetts. The sculpture is an entrance feature for a company specializing in communications systems. The theme is a group of people "connected."

*Photo, artist*

SCULPTURE AND FENCE. Paul Margetts. One of two family groups at an entrance to a footpath leading from a car park to the Bescot Railway station. The design concept was to "populate" a rather isolated area. 14.75' high.
*Commissioned by Centro Transport, West Midlands, England. Photo, artist*

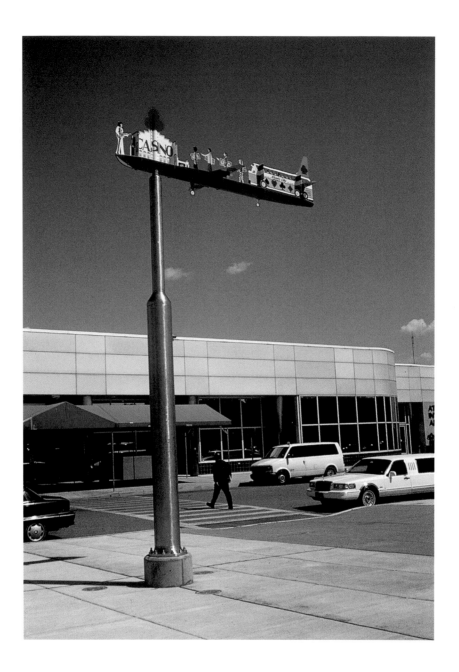

## George Greenamyer's Wind Sculptures

The clarity and seeming simplicity of the George Greenamyer story public art sculptures belie the technology and planning involved in creating them. They must be large so that they can be read from their 20-ft. height; each wind indicator is 12' long. They involve mechanics and, often, internal lighting. There are bearings, load limits, fiber optics, and a lot of "inventing on the spot" involved to make the pieces kinetic. Greenamyer works out his designs in his head and sometimes makes patterns, but not always. The finishes, as well as being painted, must be weatherproofed and rust proofed.

ATLANTIC CITY AIR; CASINO. George Mossman Greenamyer. Wind indicator sculpture fabricated from aluminum with a stainless steel support. One of three wind indicators that tell a story of the city. The pieces were funded by the New Jersey State Council of the Arts. Sculpture 20' high. Each figurative element is 3' high, 12' long, 4' deep. Atlantic City International Airport, Pomona, New Jersey.

*Photo, Beverly Burbank*

ATLANTIC CITY AIR; MR. PEANUT and
the MISS AMERICA PAGEANT. George
Mossman Greenamyer. One of three
wind indicators showing the painted
details of the story. Aluminum and
stainless steel. Sculpture 20' high. Each
story telling part is 3' high, 12' long, 4'
deep.

*Photo, Beverly Burbank*

SCHOONER HERITAGE. George
Mossman Greenamyer. A commemora-
tive whirligig sculpture depicting a
narrative story of the Schooner Heritage,
a windjammer. The story depicts the
client as a child playing with her parents,
her dog, and other people in her life. The
ship is in safe hands with the mother and
father at the tiller. Height above the
ground is 17'. The whirligig is 6' high, 8"
wide, 6'.7" long.
*Courtesy, Laumeier Sculpture Park.*
*Commissioned by Deb Lukin.*
*Photo, Sarah Carmody.*

LANDSCAPE I SCULPTURE. Brian F. Russell. Steel, copper, bronze, and gold leaf. Outdoor wall mounted piece. 9' high, 5' wide.
*Photo, artist*

FLYING SHADOWS. Jan Sanchez. Steel. Three canopies from a series of twelve for the Carlsbad Public Library, Carlsbad, California.
*Courtesy, artist*

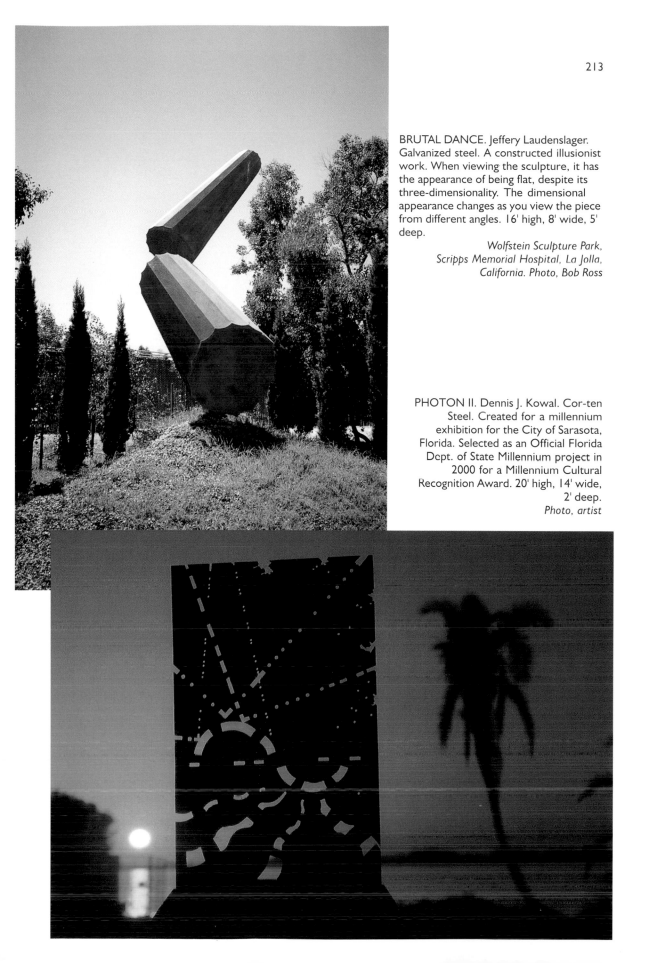

BRUTAL DANCE. Jeffery Laudenslager. Galvanized steel. A constructed illusionist work. When viewing the sculpture, it has the appearance of being flat, despite its three-dimensionality. The dimensional appearance changes as you view the piece from different angles. 16' high, 8' wide, 5' deep.

*Wolfstein Sculpture Park, Scripps Memorial Hospital, La Jolla, California. Photo, Bob Ross*

PHOTON II. Dennis J. Kowal. Cor-ten Steel. Created for a millennium exhibition for the City of Sarasota, Florida. Selected as an Official Florida Dept. of State Millennium project in 2000 for a Millennium Cultural Recognition Award. 20' high, 14' wide, 2' deep.
*Photo, artist*

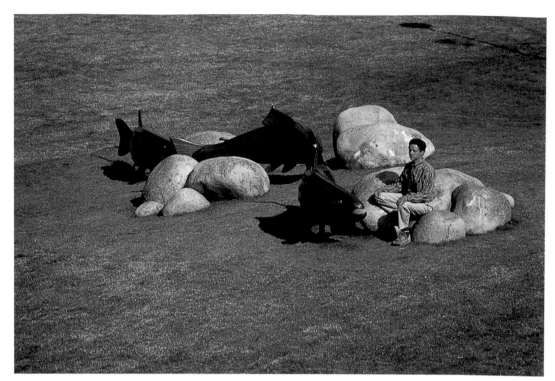

RETURNING. Jeffrey Funk. Fish forged from steel plates and fabricated are combined with rocks. Installed in a park in Missoula, Montana, people enjoy sitting on the rocks and watching the fish. Each trout is about 10' feet long.
*Photo, Gerald Askevold*

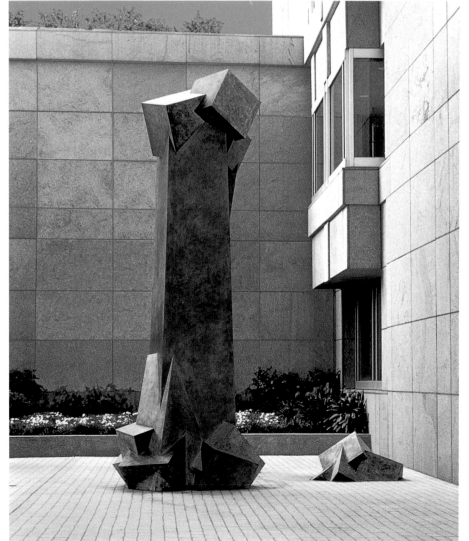

GUARDIAN. Bruce Beasley. Bronze. Although this piece is not "direct metal" it is an outgrowth of the artist's earlier pieces in stainless steel. His dynamic forms are based on simple geometric structures. 204" high, 132" wide, 108" deep.
*Courtesy, artist*

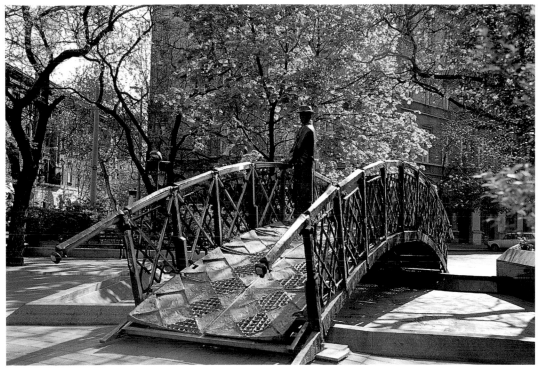

IMRE NAGE. Tamás Várga. 1996. Cast and fabricated memorial sculpture to the Hungarian prime minister whose decision to defect from the Communist Party to the side of the people was a protest that cost him his life.

*Photo, author*

MEMORIAL OF THE HUNGARIAN JEWISH MARTYRS. Imre Várga. 1991. A tribute to the Holocaust victims of World War II in the courtyard of the Great Synagog, Budapest, Hungary. The symbolic weeping willow has the names of the 600,000 Budapest citizens killed during the Holocaust inscribed on the leaves.

*Photo, author*

218

IGNITER The sparker used to light the flame on a torch.

INNER CONE The brilliant short part of the oxy-acetylene flame immediately adjacent to the hole of the welding tip or the preheating holes of the cutting nozzle.

IRON A common and useful metallic element which is gray in color.

JIG Mechanical device for holding metal in position.

KERF The space resulting when a cut is made in metal. The oxidized metal has been removed by the jet stream of oxygen from the cutting torch.

LASER Laser welding will accomplish every welding mission required today. It provides strength, speed, precision, controllability, and is an alternative to TIG/MIG welding, resistance welding, brazing, soldering and adhesive bonding.

LEAD A heavy, easily melted metallic element, bluish gray in color.

LEAK Gas which escapes through partially closed valves, hoses, or regulators.

LINEAR Term used to describe elements of a sculpture which resemble the line used in drawing techniques.

MALLEABLE The capability of metal to be worked by hammering or rolling.

MELTING POINT That degree of temperature when a metal turns into a liquid state.

MIG (Metal Inert Gas) A versatile gas welding technique suitable for both thin sheet and thick section components.

MIXER The part of the blowtorch which contains oxygen and acetylene and mixes them together so they can be ignited.

MOLD A negative shape made of heat-resistant materials which can contain molten metal.

NEGATIVE SPACE Term used in sculpture to define the open spaces which allow "air" to penetrate through the sculpture.

NEUTRAL FLAME An oxyacetylene flame obtained by burning a one-to-one mixture of oxygen and acetylene and characterized by a small blue inner cone surrounded by a long colorless outer envelope. Used for most ordinary welding operations.

NON-FERROUS Any metal or alloy that does not contain iron.

NOXIOUS Fumes that are harmful or poisonous and that sometimes occur when working with certain metals or acids.

OPEN SCULPTURE Sculpture that has more negative space than tangible surface.

ORGANIC Form derived from living matter, i.e., human, plant, or animal shapes.

OXIDE The substance that forms when oxygen combines chemically with metal or another element. When the combination occurs, the metal is said to oxidize, and if the oxidation is rapid, the metal or other substance will burn.

OXYACETYLENE A mixture of oxygen and acetylene used to create high heat for welding. May also be used for some soldering and brazing techniques.

OXYGEN A colorless, odorless, tasteless gas present in the atmosphere to the extent of approximately 21 percent.

PASS The metal deposited by one general progression along the line of a weld.

PATINA The color of the metal surface which is caused by oxidation, application of acids, or impurities.

PILLETS Small pieces of solder.

PLANISH To even out the surface of metal which has been hammered into a shape.

PLASMA ARC (See TIG)

PLATE Any sheet metal thicker than 1/8" is usually referred to as plate.

POSITIVE SHAPE The solid tangible area of a sculpture.

PREHEAT Heating a metal before welding or cutting. It can be done with a torch, in a permanent oven, a temporary brick furnace, or a forge, built around the part using a fuel other than acetylene.

PRESSURE The force per unit of area of gas in the cylinders or in the regulators.

PUBLIC ART Artwork in any media that is installed in public spaces and may or may not be funded by public agencies.

PUDDLE The pool of molten metal formed during welding.

PURE METAL An element that has not been mixed with other metals or substances.

QUENCHING Cooling a heated metal suddenly by frequently dipping it in oil or water. This action usually makes the metal more brittle.

RAISING Forming a piece of sheet metal by hammering over a shaped form.

REGULATOR An adjustable mechanical device that raises or lowers the high pressure of gas in the

cylinder to a working pressure in the torch.

REPOUSSÉ  Shaping metal by hammering from front and back with hammers of different shapes.

ROD  A wire, stick, or rod of metal of special composition used as a filler metal in welding and brazing

RUST  The reddish-brown color that forms on ferrous metals when exposed to weather and corrosion.

SHEET METAL  Any flat rolled piece of metal up to 1/8" thickness. An instrument for bringing together and properly mixing oxygen and acetylene gases so that, when ignited, a controlled flame results which emits intense heat. Also called a blowpipe.

SINKING  Hammering a sheet-metal form into a depression in wood to create concave shapes.

SLAG  Scum and non-metallic foreign matter that rise to the surface of molten metal and harden upon cooling.

SLAG HAMMER  Hammer with a blade-like head used for cleaning off slag.

SOLDERING  A relatively low-temperature form of fusing metals. Hard soldering employs a solder which melts between 1200° and 1300° F. while soft solder melts below 700° F. Both solders melt below the temperature required to melt the base metal.

SPARKER  The igniter used to light the flame on a torch.

STEEL  An alloy consisting essentially of iron and carbon.

TANK  A term used for the cylinder which contains gases such as acetylene and oxygen.

TEXTURE  The surface forms of a sculpture. These forms often have a tactile appeal.

TIG (Tungsten Inert Gas) and plasma arc. Arc welding procedures in which the arc is formed between the tungsten electrode and the work piece with an inert gas.

TINNING  Coating a base metal with another metal for protection or appearance.

TIP  The removable or forward head of the torch containing the hole through which the gases issue.

TORCH  An instrument for bringing together and properly mixing oxygen and acetylene gases so that, when ignited, a controlled flame results which emits intense heat. Also called a blowpipe.

VOLUME  The space occupied by a sculpture.

WATER JET  High-pressure water-jet cutting is a technique with which materials are cut or machined by a jet of water forced from a nozzle at a speed three times that of sound. To achieve this speed, the water has to be raised to a high pressure) by a special pump. For cutting hard materials like stone, glass, steel and non-ferrous metals, an abrasive medium (silica sand) can be added to the water before it strikes the material to be cut.

WELDING  The process by which two pieces of metal are united by heating them to melting temperatures and causing them to flow together and fuse.

# Resources

With Internet access almost universally available by individuals, in libraries, and at Internet Cafes it is more effective to list World Wide Web locations than lengthy supplier listings. These may change in time, but there are enough forwarding addresses and links to a variety of sites that one can find almost anything with a little research ingenuity.

The following sites will help facilitate your research and clue you in to the variety and types of sites available. In addition, many artists maintain their own sites and one can find them easily using a meta-browser such as *Ask Jeeves, 4Anything, Findspot, Profusion*, and others, as well as individual search engines: *Yahoo, Lycos, MSN, AOL,* etc.

## Organizations

ABANA - Artist-Blacksmith's Association of North America
PO Box 206
Washington, MO 63090
314-390-2133
http://www.abana.org

American Craft Council (ACC) Information Center
72 Spring Street
New York, NY 10012
212-274-0630

Australian Blacksmiths Association
RMB 1155 Tongala
Victoria, Australia 3621
03-58-590736
Wake@River.net.com.au

BABA - British Artist Blacksmith Association
111 Main Street
Ratho, Newbridge, Midlothian. EH28 8RS.
Scotland
E-mail phil@rathobyres.demon.co.uk
Fax: 01-31-333-3354
http://www.baba.org.uk

Crafts Council of Great Britain
44a Pentonville Road
Islington
London N1 9BY, England
United Kingdom
0171-278-7700
http://www.craftscouncil.org.uk.

Irish Blacksmith Organization
Anna O'Donoghue
21 Healy Terrace
Bellina Co. Mayo, Ireland
Fax: 353-96-72666
Tel: 353- 96 70998

International Sculpture Center
14 Fairgrounds Rd., Suite B
Hamilton, NJ 08619-3447
Phone: 609-689-1051
Fax: 609-689-1061
http://www.isc.org
isc@sculpture.org

The National Ornamental Metal Museum
374 Metal Museum Drive
Memphis, TN 38106-1539
901-774-6380
http://memphisguide.com/NOMN.html

National Sculpture Society
1177 Ave. of the Americas
New York, NY 10036
212-761-5643
http://www.orgsites.com/ny/sculpture

NOMMA-National Ornamental & Miscellaneous
Metals Association
532 Forest Parkway, Suite A
Forest Park, GA 30297
404-363-4009   Fax 404-366-1852
http://www.nomma.com

## Internet Resources

These sites provide links to a variety of other
related sites, host chat and discussion groups,
tutorials, current events, photos of work, artist
listings, book lists, suppliers, and more.

Amazon Books
http://www.amazon.com

Anvil Fire! A complete source for blacksmithing activity
http://www.anvilfire.com

Artcyclopedia  Search for artist names by country, by
states in the US.
Search for art museums of the world by name and topic
or type of collection.
http://www.artcyclopedia.com

Art History- Gateway to art History
Complete outline and study guide
Http://witcomb.sbc.edu

Art Metal Village; portfolios and biographies of artists,
tutorials, links.
http://www.artmetal.com

Art Net Web: a site for artists to place slides and biographies.
http://www.artnetweb.com

ArtSource.com. A selective guide to art and architecture sites.
http://www.artsource.com

Metal Web News
http://www.mindspring.com/~wgray1/

Musee Orsay virtual tour of the gallery
http://www.smartweb.fr/orsay/

ISC Sculpture.org. Site of the International Sculpture
Center. A comprehensive resource for sculptors including artist listings and bios, job information, books, magazines, organizations, schools, suppliers, and links to
other sites. Also a listing of Sculpture Parks and Gardens.
http://www.sculpture.org

MuseumNetwork.com is a portal to the world's museums.
http://www.museumnetwork.com

University of Georgia Center for Continuing Education.
Forge & Anvil: a television series on blacksmithing 1966.
http://www.gactr.uga.edu/forge/

Winikoff's Virtual Junkyard For Blacksmiths; resources
and artist's listing around the world
http://www.keenjunk.com

WWW. Virtual Library: Museums Around the USA
http://vlib.org

## Touchmark Registration

anvilfire! Touchmark Registry
1684 Mitchell Mill Rd.
Gladys, VA 24554-2938
www.anvilfire.com

222

## Publications

The Anvils Ring- published by ABANA (see organizations, above)
*Hammer's Blow* - published by ABANA (see organizations, above)

Anvil Magazine
P.O. Box 1810
Georgetown, CA 95634
800-94-ANVIL

*ARCHI-TECH* Magazine
P.O. Box 10915
Portland, ME 04104
207-761-2177    Fax 207-761-5921
http://architechmag.com

Art World News
P.O. Box 129
Rowayton, CT. 06853
203-854-8566
http://www.artworldnews.com

Blacksmith's Gazette
950 Falcon Road
Camano Island, WA 98292
P/f 360-387-0349
Fholder@sos.net
http//:www.skagit.com/blacksmith

Blacksmith's Journal
P.O. Box 193
Washington, MO 63090
800-944-6134
http://www.blacksmithsjournal.com

Fabricator
National Ornamental & Miscellaneous Metals Association
532 Forest Parkway, Suite A
Forest Park, GA 30297
404-363-4010  Fax 404-366-1852
http://www.nomma.com

Metalsmith
710 East Ogden Ave., Ste. 600
Naperville, IL 60563
630 579-3272   Fax 630 369 -2480

Traditional Building Magazine
69A Seventh Avenue
Brooklyn, New York 11217
718-636-0788   Fax 718-636-0750
http://www.traditional-buiding.com

## Marketing

The Guild
931 E. Main Street, #106,
Madison, WI 53703-2955
800-969-1556 or 608-256-1990
Fax 608-256-1938
info@guildsourcebooks.com
http://www.guildsourcebooks.com/contact.htm

## Suppliers

Your best up-to-date sources are the sculpture publications and searches on the Internet for iron, metal, and the type of equipment desired. The Artist-Blacksmith's Association of North America (ABANA), Anvil Fire, Winikoff's Keenjunk.com (see resource listing), and magazines, provide current listings.

# Index